# The Art Teacher's Guide to the Internet

# The Art Teacher's Guide to the Internet

## Craig Roland

**Davis Publications, Inc.**
Worcester, Massachusetts

Library of Congress Control Number: 2005927198
ISBN 0-87192-695-4
10 9 8 7 6 5 4 3 2 1
Printed in the United States of America

Illustration credits appear on page 260.

Publisher: Wyatt Wade
Managing Editor: David Coen
Production & Manufacturing Manager: Georgiana Rock
Production Assistance: Victoria Hughes Waters
Editorial Assistance: Jillian Johnstone, Katherine Kane, Sarah Messier, and Missy Nicholson
Design: Marifely Argüello, Doug Barrett, Tse-Ming Huang, and Craig Roland

# Contents

# Introduction

We shape our tools and afterwards
our tools shape us.
• **Marshall McLuhan (1964)**

In a world in which the Internet and World Wide Web have become indispensable tools for communication and information gathering, teachers are being called upon to integrate these new technologies into classroom instruction and students' learning experiences. Many art teachers, however, find themselves having to respond to this far-reaching demand without the necessary resources to assist them.

This book attempts to partially fill that void by showing how use of the Internet can enhance teaching and learning in an art classroom. Its overall aim is to help new and practicing K–12 art teachers develop a pragmatic approach to the Internet in the classroom and integrate its unique capabilities and resources into their curriculums in relevant and meaningful ways.

The phenomenal growth of Internet connectivity in America's public schools over the past decade has generated considerable discussion within the education community regarding the potential benefits and perils of introducing information technologies into the classroom. Between all the hype and skepticism, there is growing consensus that features of the Internet such as e-mail and the World Wide Web will prove to be worthwhile educational tools only if driven by challenging curriculum goals and sound pedagogical practices.

As this book will demonstrate, there are many ways that the Internet can help you as an art teacher, and many ways that your students can use online tools and resources to augment their learning in art class. Ultimately, though, it is up to you to decide what will work best in your particular classroom situation.

## Essential questions

The idea of using the Internet in the classroom with students can seem overwhelming, at first. I am sure you have many questions such as

- Why should I integrate the Internet into my teaching and curriculum? What benefits will I see? What will my students gain by using the Internet in art class?
- What do I need to use the Internet effectively in my classroom? What online resources are available that relate to my curriculum?
- How do I prevent misuse of the Internet in the classroom and protect students from potential online dangers?
- What obstacles will I have to overcome?
- What are other art teachers doing with the Internet in their classrooms?
- How do I get started? Where can I find additional information and help?

These and similar questions are at the heart of this book, which is primarily concerned with transforming existing Internet resources and art curriculum goals into workable pedagogical strategies and classroom projects for students.

## How to use this book

This is an introductory book, which examines a broad range of topics related to Internet use in an art classroom. While some readers may proceed through this book in a linear fashion, it is likely that most will consult one part or another at different times. Given this, there is some intentional overlap between the chapters of this book to prevent the reader from having to flip back and forth to grasp the desired information.

In writing this book, I have assumed that the majority of its readers have had some prior experience with using e-mail and the Web and would now like to learn more about the Internet and how they can use it in the classroom. At the same time, other readers will come to this book with more extensive Internet experience and different needs. Therefore, I have written this book so as to accommodate these various needs.

Chapter 1, "Teaching Art in a Wired World," provides the foundation you will need to decide what role the Internet will play in your teaching. Chapters 2 through 4 cover the basic components and features that make up the Internet, its history, how the Web works, and how to more effectively search for online information. I recommend that you read these chapters in their entirety. Work through the activities labeled "try this" and take time to visit the featured Web sites that most interest you. The more you know about the Internet environment, the more creative you can be in integrating its unique features into your classroom.

Chapters 5 through 7 explore ways that art teachers can use the Internet to further their professional development, to improve their classroom presentations, and to promote their art programs on a global scale. Learning to use the Internet for personal and professional purposes is an important step for teachers. It is easier to develop your technology skills when there is a real personal need and purpose for doing so. It is also important, however, to move beyond your

own personal needs and look for opportunities to use the technology with students.

The last three chapters concentrate on implementing student-centered approaches to Internet use in the art classroom through activities and projects that involve online research, collaboration, and electronic publication. The idea of allowing students to work on the Internet intimidates some teachers, for various reasons, and prevents them from realizing its full potential in the classroom. These chapters describe a variety of strategies that can help you to make the first experiences of using the Internet with students in the classroom positive and productive.

Throughout this book, you will find testimonials written by art teachers who have successfully incorporated the Internet into their programs, helpful tips, thoughtful quotes, as well as references to print and online resources that offer additional material for further study. I've also included annotated references to Web sites of interest to art teachers and students. In determining which sites to include, I chose those that I felt were reputable, informative, easy to use, and likely to remain stable on the Web for some time.

To provide additional assistance to readers, I've created a companion Web site for this book, where you will find updates on defunct sites, news items, additional classroom resources, and more. Readers can also submit comments about this book on the site and suggest improvements for future editions.

**The Art Teacher's Guide to the Internet companion Web site**

www.artjunction.org/atgi

Visit *The Art Teacher's Guide* companion Web site for book updates, news items, project ideas, additional classroom resources, and more.

## Before you read any further

Reading this book will not teach you all there is to know about using the Internet in your classroom; it will, however, provide a good introduction. As you begin the process of working through this book, I encourage you to get online and visit some of the Web sites and try out a few of the strategies included in its chapters. Doing so will spark ideas on how different Internet tools and resources might best help you as an art teacher. Ultimately, that is the main goal of this book—to get you thinking about what is important about this exciting medium and exploring ways that you can use it with students in your own classroom.

# Teaching Art in a Wired World: New Possibilities and Challenges

## CHAPTER 1

New technology is common, new thinking is rare.
• **Sir Peter Blake**

The technological advancements of the past decade have produced many unique and exciting possibilities for expanding and transforming the learning environment in art classrooms through the use of the Internet and an array of digital technologies. Successfully integrating these new technologies into the classroom, however, requires considerable thought, experimentation, and planning on the part of the art teacher.

There is a good chance you already use the Internet to some degree for personal, professional, or instructional purposes. But if you are hungry to know more about the possibilities of teaching art in a wired world, you will find much food for thought in the following pages.

This chapter will assist you in making informed decisions about what role the Internet will play in your classroom. It first summarizes recent developments in the field of art education and points to several emerging curricular goals that the Internet can support in order to foster student learning. It then discusses some of the more common obstacles that teachers face when attempting to integrate the Internet into their classroom activities and suggests ways to overcome these impediments to success. Lastly, it offers both general guidelines and specific recommendations to help you make the most of the Internet in your classroom, whether you have one computer available or several computers.

## What are we teaching in art classrooms today?

In order to make a place for the Internet in the art classroom, we must first be clear about the educational purposes we want it to serve. Classroom applications of technology and curriculum goals are inextricably intertwined. The Internet should not be used simply because it is available but because it can help build a richer teaching and learning environment in which you and your students actively pursue worthwhile curriculum goals. Thus, any decisions regarding use of the Internet in your classroom need to be anchored in what you hope to accomplish with your students.

Although art teachers have considerable autonomy in planning and implementing their curriculums, they are generally expected to align their lesson plans with state achievement standards that identify what students are supposed to know and be able to do within the subject area. The Florida Sunshine State Standards in Art, for instance, specify the expectations that each student

- Understands and applies media, techniques, and processes.
- Creates and communicates a range of subject matter, symbols, and ideas using knowledge of structures and functions of visual arts.
- Understands the visual arts in relation to history and culture.
- Assesses, evaluates, and responds to the characteristics of works of art.
- Makes connections between the visual arts, other disciplines, and the real world. (Florida Department of Education, 1996).

The art learning outcomes outlined in Florida's standards are comparable to those used in other states and reflect a discipline-based approach to art education, commonly known as DBAE (Greer, 1984). In DBAE classrooms, students typically study Western exemplars of fine art, pursue an understanding of their formalistic and expressive properties, consider the historical and cultural contexts from which these works emerged, learn about the artists who created the works, and then create their own works of art that explore or expand upon the styles or themes of the artists studied.

While DBAE has been the predominant model for curriculum development among art teachers in the United States for more than two decades, it is not the only approach to teaching art being practiced in classrooms today (Eisner, 2002). With the rise of postmodern theoretical approaches to art and art education in the 1990s, many art teachers have moved away from a strict DBAE model to explore other, more interdisciplinary, culturally sensitive, socially responsive, and collective approaches to making and interpreting art in contemporary society. These developments have, in turn, led to a broadening of art curriculums in many American schools to include the study of ethnic, folk, non-Western, and popular arts; works by women artists and artists of color; art created with new media; as well as art in community and everyday life.

> Like a collage, education from a postmodern perspective is full of multiple, complex, and nonlinear meanings.
> • **Arthur Efland et al. (1996)**

In contrast to DBAE, with its focus on teaching students to think like experts within the four art disciplines, postmodern art classrooms are seen as sites for knowledge building in which teachers and students work in partnership to examine, question, and ultimately construct meaning for themselves. They inquire together into the vast diversity of art practices that exist today and, in doing so, recognize that there are multiple ways of understanding and representing the world visually. There is also an emphasis placed on the role of art and art education in the social and cultural life of students. Teachers and students jointly explore personal, community, and global issues (e.g., identity, body, race, gender, sexual orientation, family, community, equality, social justice, homelessness, violence, and ecology) within the context of contemporary art making and discourse.

## The emergence of visual culture

More recently, there has been increasing interest among art educators in teaching about "visual culture" in the classroom. The emergence of this new paradigm, which some refer to as "Visual Culture Art Education" (VCAE), represents a concerted effort on the part of many theorists and practitioners to draw attention to the broader visual record of human experience within the art curriculum (e.g., Freedman, 2003a; Boughton et al., 2002; Duncum, 2001).

There is no denying the power and pervasiveness of the visual as a means of conveying meaning in contemporary global culture. Students today are exposed to thousands of images every day from magazines, books, advertising, movies, television, comic books, theme parks, billboards, video games, Web sites, DVDs, and more. These images greatly influence the way students think about the world and themselves. Proponents of VCAE argue that there is a dire need to expand the art curriculum to include study of these rich and influential visual resources and to "educate learners to interpret and create visual culture in ways that help them to understand the range of its forms, meanings, and purposes" (Boughton et al., 2002).

**Merchants of Cool**

www.pbs.org/wgbh/pages/frontline/shows/cool
According to the PBS Frontline video documentary *The Merchants of Cool*, children view an average of 3,000 commercials a day, which amounts to 10 million segments viewed by the time they reach adulthood. These commercials dictate how they should look, how they should act, and what they should buy. What can you do to help children and teens become conscious and critical consumers of media? Find out on this Web companion site.

Teachers should not perceive the study of visual culture as a threat to, or replacement for, the study of traditional fine art practices, but rather as an invitation to think and teach about art from a broader perspective. Kerry Freedman, a leading proponent of VCAE, suggests that teachers may need to reexamine the purposes and processes involved in student artistic production in light of the influence of contemporary visual culture in their daily lives. She recommends that, rather than viewing students' art productions solely in terms of formal or technical development, they be seen as opportunities for students to explore and construct their own personal identities; to engage in social commentary or critique; and to pursue individual or group investigations into their own interests, including those that relate to the visual culture they encounter in daily life (Freedman, 2003b).

As we deliberate over what to teach students in art classrooms today, strong consideration needs to be given to the fact that, in many ways, what they learn from everyday life experiences has a more profound effect on their understandings and attitudes than what they learn inside our classrooms. Whereas most people over a certain age still rely on printed materials like books, newspapers, and magazines for information, many people today respond to visuals and depend heavily upon television and digital technologies like the Internet to gather information and communicate with others around the world.

> Teachers have been steeped in a visual culture, but today's students, with their exposure not only to TV but also the Internet and video games, have been deluged with this culture.
> **• Mary Burns & Danny Martinez (2002)**

What can art education contribute to teaching students about this new digitally mediated, visual environment? What do students today need to know and be able to do to successfully interpret and contribute to contemporary culture? What do they already know? How can we use this personal knowledge to expand their visual frames of reference? I encourage you to reflect upon these questions as you consider what is worth teaching in your classroom, and what role the Internet might play in the teaching/learning process.

## Where does the Internet fit into the art classroom?

Why should you integrate the Internet into your classroom? What can it contribute to accomplishing your curriculum goals? Before considering these two important questions, it may be helpful to pause and examine our relationship with technology in general.

It is common nowadays to think of technology only in terms of the digital and electronic devices (like the Internet, computers, cell phones, digital cameras, and so on) that have invaded our lives over the last twenty years or so. However, if we think of technology as "the practical application of knowledge" or as "a manner of accomplishing a task especially using technical processes, methods, or knowledge" (Merriam-Webster's Collegiate Dictionary, 11th Ed.), two things seem evident.

First, technology is much more than a collection of gadgets. It encompasses all of the tools, techniques, methods, processes, and systems that we use in our lives to extend our abilities and solve emergent problems. Secondly, technology has been with us, and we have been making use of it in our classrooms, for a very long time (Stankiewicz, 2003). While some art teachers may harbor an aversion to *new* technology, consider that the potter's wheel, loom, printing press, pencil, tubed paint, camera, art reproductions, and even linear perspective were all considered revolutionary technologies at one time, though few would question their place in art classrooms today.

> Technology will be fully integrated into the curricula and instruction of the schools by December 31, 2006.
> **• U.S. Department of Education (2002)**

If we were to peek into an art classroom today, we would likely see a very dynamic, interactive learning environment in which the students and teacher are actively engaged in creating or studying works of art. Depending on the moment we observe, we might see the teacher leading a class discussion about a work of art being projected on an overhead screen; groups of students talking about various art prints laid out before them on tables, or individual students working on their own watercolor paintings using paint sets and brushes. The technologies in use would probably be less apparent to us than what is actually going on in the classroom. That is the way it should be!

Our primary interest, as educators, in any new technology that comes along should be in what it enables us to do better or differently than we do now. Implicit in this statement is the assumption that the adoption of new technology in the classroom requires change. Yet teachers are generally resistant to change (Hubbard, 1995). For change to take place, teachers need to understand its relevance for themselves (and their students); believe that the change is good and feasible; and be given adequate time, training, and support in order to implement the change in their classrooms (Evans, 2001). With this in mind, let us now return to the two questions posed earlier. Why should you integrate the Internet into your classroom? What can it contribute to accomplishing your curriculum goals?

Broadly speaking, the Internet can enhance the intellectual life of the classroom by (1) expanding the informational resources currently available to you and your students; (2) opening up new avenues for communication and collaboration with students, teachers, and experts all over the world; and (3) providing students with multiple ways to learn, to express their ideas, and to show what they know and are able to do. But you probably have heard all that.

Let's look at this matter instead from the vantage point of recent curriculum developments in art education. How can the Internet help to develop in students the kinds of multifaceted understandings of art within contemporary culture that are now essential?

Our earlier review of contemporary art education literature suggests several underlying principles that are shared by many art educators today: first, the need to situate what happens in the art classroom within a real-world context; second, the need to make curricular connections to students' everyday lives; third, the need to promote understanding of, and respect for multiple perspectives or voices; and, fourth, the need to recognize students as knowledge builders. When used effectively, the Internet can make significant contributions in each of these areas.

**A Nebraska elementary art teacher describes some of the ways that digital technology is used in her classroom . . .**

I am fortunate to teach some wonderful students how to be creative, stay open-minded, discover new possibilities, acquire technical skills, explore art around the world, develop critical thinking skills, investigate art history, learn about other cultures, and cross over all areas of curriculum through the arts. Technology can help with all of this; however, we must remember that without a strong art curriculum, technology would be worthless.

Through the use of computers and the Internet, I have introduced my students to online museums, Web-based learning activities, interactive kid-friendly art sites, digital photography, digital video, and multimedia presentations. As every art teacher knows, saving students' artwork is a constant struggle, with limited space and students moving all the time. I have resolved this problem by having my students produce digital portfolios. We use these portfolios for positive critiques, presentations on parent nights, and archival purposes. Students enjoy being able to share their artwork with each other, and the digital format is an easy way to help with critiques and assessment.

Some other ways I use digital technology in my classroom include: creating instructional videos to show students how to score and slip clay pieces; allowing students to search Web sites to get ideas for their Surrealism paintings; and using iMovie software to produce claymation videos and student-directed commercials about our school and its Character Counts curriculum program. Every year, I take pictures of students and their artwork to show in an iPhoto presentation at the end of the course. I also use the computer and a projection screen to review what was learned last time to start off each class, list supplies for the day, show images to inspire ideas, and write out key words to help students learn about the art project and what will be accomplished.

In addition, I designed the Lincoln Public Schools Art Web site where teachers create and share lesson plans based on the National Standards in Art as well as pictures, digital movies, classroom handouts and PowerPoint presentations. We currently are working on adding link pages to help our district teachers find information on artists, kid-friendly sites, and other art-related material on the Web.

You can visit our Web site at http://artweb.lps.org/art/index.html. Remember, though, that it is a work in progress, so keep checking back.

Susan Carlson
Art Teacher, Zeman Elementary School
Lincoln, Nebraska

## Making real-world connections

Paul Bolin wrote in a September 2000 editorial in the journal *Art Education*, "As art educators, we should strive to empower students in building critical connections between what they encounter outside of class, and what they see, do, and learn in the art classroom" (p. 4). This could mean getting your students out into the local community to engage in art-related projects that serve to bring public attention to local issues or problems. Conversely, it could also mean bringing the world inside through classroom art projects that utilize various forms of technology, including the Internet. Whenever possible, of course, you want to do both—combine the global with the local.

One of the most touted benefits of Internet access in the classroom is the opportunity it provides for students and teachers to work with up-to-date information, real-time events, and people from different geographic locations. Linking the Internet's global reach with student activities at the local level (e.g., through individual or group art projects, interviews with community members, on-location shooting of video footage, and so on) creates a richer learning experience for all those involved.

The issue before us now is how to make good on the Internet's promise for learning.

- **Web-Based Education Commission to the President and Congress of the United States (2000)**

## Connecting to students' everyday lives

The blending of emergent digital media technologies (e.g., computers, digital video, multimedia software, and the Internet) with art curriculum goals enables students to engage in unique and exciting forms of communication, learning, and visual expression with contemporary media deeply rooted in their everyday lives. This is not to say that conventional media such as crayons, clay, paint, pencil, and the like are any less worthy for not being cutting-edge technologies. All media technologies have a place in our art programs, provided that they can help to promote the ends of art education. Digital technologies, however, deserve special attention in that they collectively constitute a new genre of contemporary art forms that are dramatically altering our cultural landscape (Lister et al., 2003; Wilson, 2002; Lovejoy, 1997).

Students today are drawn to the Internet for several reasons: its interactive and multimedia features; the vast amounts of varied information it provides; and its capacity to instantaneously connect them with people, places, and ideas around the world. They have grown up in a technology-rich environment and have an inclination to use the Internet for a variety of academic, personal, social, and recreational purposes, including homework and personal research; downloading music and other data files; creating personal Web sites and Web logs; online gaming; Web browsing; and for e-mailing, chatting, and instant messaging with their friends and peers (Rushkoff, 1999; Tapscott, 1998). Recognizing that the Internet and other digital media provide a direct link to the non-school culture of students, we can (and should) make use of these technologies to bridge the gap that exists between what happens in our classrooms and what happens in our students' everyday lives.

**The Digital Disconnect**

www.pewinternet.org

According to a 2002 study by the Pew Internet & American Life Project, there is a noticeable "digital disconnect" between teachers and students that is preventing kids from maximizing the educational value of the Internet for classroom work. The study's researchers interviewed 136 middle and high school students from across the U.S. and found that virtually all of them use the Internet outside the school day to do research for classroom papers and projects. However, these students repeatedly told interviewers that the quality of their Internet-based assignments in the classroom was generally poor and uninspiring. They want to be assigned more—and more engaging—Internet activities that are relevant to their lives. In fact, many asserted that doing so would significantly improve their attitudes toward school and learning. You can read the complete report on the Pew Internet & American Life Project's Web site.

### Respect for multiple perspectives

Another recurring theme in recent art education literature is the need to expand the art curriculum in order to foster a respect for the contributions of different groups to world culture, especially those that have been previously marginalized by Western society. Putting the Internet to work in your classroom can add a completely new dimension to learning about and from the art of *other* cultures.

The Web offers unprecedented access to the work of countless artists from historically underrepresented cultural and ethnic groups, here and abroad. This global, inclusive reach enables students to study a much greater range of artists and visual forms of representation than ever before. When coupled with appropriate curriculum objectives and pedagogy (e.g., Chalmers, 1996; Congdon, 1989), the Web can become a viable component of a classroom learning environment in which teacher and students are jointly engaged in inclusive, ongoing research exploring the commonality and diversity of art practices around the world.

## Students as knowledge builders

A fourth postmodern principle that guides the thinking of many art educators today is that there is no single truth or right way to know something; rather, there are many ways to know or interpret things, each having its own validity. Each of us constructs our own individual truths or meanings from the world, based upon a myriad of factors such as our gender, race, sexual orientation, ethnicity, social class, prior knowledge, and the cultural context in which we live.

This basic premise is central to social constructivism, which holds that learners actively construct their own knowledge as they interact with others and their environment (Bruner, 1996; Vygotsky, 1978). They make meaning of new information and experiences by connecting it to their prior knowledge and establishing relationships among ideas. Teachers play a strategic role in this deliberative process by providing learners with the tools, materials, experiences, and guidance they need to make worthwhile and lasting connections (Prater, 2001).

Applying constructivist theory to art education, Simpson (1996) states, "Teaching children about the meaning of art and artists is making connections and linking ideas about art to their personal worlds and, often, to other academic subjects through verbal and visual expression" (p. 54). If you agree with Simpson, then you will find that the Internet—especially the Web—can support your students in making all sorts of connections by

- providing them with access to an abundance of primary source materials in a variety of formats;
- offering a diversity of perspectives from which to view almost any given situation;
- presenting multiple paths of inquiry at any given time;
- encouraging associative and non-linear thinking by linking seemingly disparate bits of information in a hypertext environment; and
- empowering them to become producers and publishers of knowledge, rather than as simply knowledge gatherers.

The Web encourages self-directed learning by providing a stimulating multimedia environment with multiple sources of information and opportunities for students to find their own answers to questions. When appropriate, the Web also offers more structured, online art learning activities that students can explore at home or at school, with or without a supporting lesson.

By giving students access to and training in the Internet, we empower them to become active learners.
- **Al Doyle (1999)**

**Best of the Web: Six online art learning resources for students**

The Web offers many online art learning activities that students can explore on their own. Here are six great examples.

**Art of the Stamp**

www.postalmuseum.si.edu/artofthestamp

Elementary students can read about how stamps are designed, the history of some famous stamps, and design their own stamps on this site from the United State's Postal Service.

**Hands on Crafts**

www.handsoncrafts.org

Elementary and middle school students will enjoy trying their hands at throwing a pot online, learning how to make a slab self-portrait, and more on this interactive site from the Mint Museums and Public Library of Charlotte and Mecklenburg County, North Carolina (Figure 1.1).

**Portrait Detectives**

www.liverpoolmuseums.org.uk/nof/portraits

This site features six portrait paintings from the Walker Museum in Liverpool, England. Students can either take a guided tour of each painting or search for clues on their own that reveal the identity and lifestyle of each sitter.

**The Renaissance Connection**

www.renaissanceconnection.org

Educational Web Adventures collaborated with the Allentown Art Museum in designing this award-winning Web site for middle school students and teachers, which explores Renaissance visual arts and innovations and their role in the making of the modern world.

**SmARTkids**

smartmuseum.uchicago.edu/smartkids

Designed by the University of Chicago's David and Alfred Smart Museum of Art, this interactive Web site invites elementary and middle school students to look at different artworks, learn the language of art, explore art materials, and unravel clues about the history of selected artworks (Figure 1.2).

**Timeline of Art History**

www.metmuseum.org/toah

The Metropolitan Museum of Art's curatorial, conservation, and education staff collaborated to produce this interactive time-line that middle or high school students (and their teachers) can use to research the history of world art from prehistory to the nineteenth century. Works in the timeline can be approached from a chronological, geographical, or thematic context. Each image is accompanied by extensive supporting material and can be enlarged for closer inspection.

**Figure 1.1** Students can practice throwing a virtual pot on the Hands on Crafts Web site.

**Figure 1.2** SmARTkids encourages students to think about and respond creatively to art.

**Twelve good reasons to use the Internet in the art classroom**

Once your art classroom is connected to the Internet, you can

1. Network and share ideas with other art educators around the globe.

2. Collaborate with other art teachers on student art exchanges and joint classroom projects.

3. Participate in professional development courses and workshops offered over the Internet.

4. Download and incorporate online tools, images, and curricular resources in your lesson presentations.

5. Promote your art program on a global scale by posting curriculum materials and student work on your school's Web site.

6. Take your class on a virtual field trip to art museums or other public art sites around the world.

7. Promote student research into art and visual culture using online tools and resources.

8. Foster student dialogue and collaboration with their peers from other schools.

9. Build connections to other subject areas in the school curriculum.

10. Expose students to a variety of viewpoints and ways of visually representing the world.

11. Allow students to learn online from artists and other art professionals.

12. Empower students to use the Internet as a medium for personal expression, communication, and lifelong learning.

## Obstacles to integrating the Internet

The Internet engenders both enthusiasm and apprehension among teachers. While many teachers are comfortable using the Internet for personal and professional purposes, they often wince at the idea of using the Internet in the classroom with students. Why the reluctance?

Besides expressing anxiety over the uncontrollable nature of the content posted online, teachers often cite additional obstacles to effectively integrating the Internet into their classrooms, including a lack of adequate computers or Internet access, technical support, professional development, and most important, a lack of time (NetDay, 2001; Smerdon et al., 2000; Heise & Grandgenett, 1996). Let's examine each of these issues.

### Risks

Concern over pornography and other inappropriate materials posted online keeps many teachers from allowing their students to use the Internet in the classroom. Some worry that students will divulge personal information while they are online, become distracted, or get lost in a virtual maze of useless information.

Careful planning and supervision will greatly reduce many of the risks associated with Internet use in the classroom. Most school districts have Acceptable Use Policies (AUPs) and procedures in place to address inappropriate use of computers and the Internet in classrooms. Many also use firewalls or filtering software to block classroom access to "undesirable" Web sites.

But no firewall or filtering software is foolproof and there is always the chance that a student may access inappropriate material online—either intentionally or unintentionally. While it is impossible to eliminate all the potential risks, teachers can take steps to minimize these occurrences in the classroom and teach students to use the Internet in a safe and responsible manner (see page 18).

**What is an AUP?**

A school district's Acceptable Use Policy (AUP) is a written agreement in the form of guidelines or rules, signed by students, their parents, and teachers, outlining the terms and conditions of Internet use in the district's schools.

**What is a firewall?**

A firewall is a network security device or program that monitors all incoming and outgoing traffic on an Internet server. Depending on its configuration, a firewall can prohibit certain types of online activities such as downloading software from the Web, opening e-mail attachments, or accessing certain Web sites.

## Seven steps to safe and responsible use of the Internet in the classroom

**Step One:** Review your school's Acceptable Use Policy (AUP) before engaging students in online work. Also, find out from your network administrator what security measures are in place (such as a firewall, filtering software, or virus protection software) to ensure the safe use of the Internet in classrooms.

**Step Two:** Discuss your school's AUP with students and the consequences of violating this policy, before they go online. It is now common practice in schools to have students sign an Internet User Agreement Form and their parents to sign a Consent Form indicating that they have read the school's AUP and agree with its terms and conditions. Make sure these signatures are on file for each student before starting any online project in your classroom.

**Step Three:** Decide what you want students to do and to learn while they are on the Internet. Your curriculum goals should define what students will be searching for online and what they will do with the information they find. By focusing on the content and skills students need to attain, they are more likely to stay on task and to use the Internet in productive, meaningful ways.

**Step Four:** Ensure that students have a clearly defined task or research question before they go online to search for information. Allowing students simply to surf the Web without a curriculum-specific purpose in mind opens the door to possible misuse of the technology.

**Step Five:** Make certain that suitable online resources are available for students to use. Always preview Web sites before sending students to visit them. Set bookmarks or create a "hotlist" of sites you want students to use for classroom research, especially with younger students.

**Step Six:** Provide an appropriate level of supervision when students are using the Internet. Any computer with Internet access should be facing the classroom so that the screen is visible, to aid in monitoring its use. Encourage students to put their time on the Internet to good use and warn them against divulging any personal information while they are online.

**Step Seven:** Encourage students to be critical and responsible consumers of information. Teach them how to evaluate information they find on the Internet and how to properly cite the sources of information and the pictures they incorporate into their research.

## Access

Having adequate access is obviously a critical factor in determining how and to what extent you are able to integrate the Internet into your art curriculum. While classroom access to the Internet has greatly increased in recent years, from the point of view of many art teachers it is far from adequate. Art classrooms are typically equipped with only one Internet-connected computer, which can present a formidable challenge when you are faced with the task of scheduling time for twenty to thirty students to use it. Further compounding the issue is the fact that many of the computers being used in art classrooms are from an earlier generation of technology—computers that are unable to handle the heavier volumes of data and multimedia features to be found on Web sites today.

Many schools have fully equipped computer labs with Internet access for student use. But these labs are often available only at certain times during the school day, with priority given to subjects like science, math, or technology education. Ideally, schools should provide teachers in every subject with all the technology necessary to create an optimal learning environment for students within the classroom. Otherwise, the scheduling of a school's computer lab should permit equal access to all its teachers who wish to make use of the technology to support student learning.

## Technical support

The unpredictability of technology discourages a number of teachers from using the Internet with students in the classroom. They know that a promising lesson can quickly grind to a halt when a server goes down or a computer screen freezes up and no one is around to fix it. Few teachers are adept at troubleshooting the technical problems that unexpectedly occur when students are using computers in the classroom. Technical support staff may be available in the school to resolve such problems; however, they are rarely able to respond immediately to a teacher's request for assistance. Many teachers turn to their students for assistance when the technology fails to work properly.

While technical problems can be a source of frustration, they come with the territory. The best way to prevent these problems is through routine computer maintenance and updating of software, which is usually done by a school's technical support staff. Beyond that, teachers need to learn how to solve simple technical problems when they occur—for example, restarting a frozen computer. It is also a good idea to always test the available hardware and connectivity prior to using the Internet with students. Most important, be sure to have a backup plan in case the technology fails to work properly.

## Professional development

It is widely recognized that many teachers today lack the knowledge and skills necessary to effectively integrate the Internet into the classroom environment. This is especially evident among veteran teachers who have had little, if any, exposure to computers or the Internet prior to entering the workforce.

While school districts typically offer Internet training workshops for their teachers, these infrequent sessions usually focus on basic technology skills and seldom address the curricular or pedagogical needs of teachers in special subjects like art. Improving teachers' technology skills is just the first step in ensuring effective use of the Internet in the classroom. Teachers need models of how the Internet can enhance student learning in their classrooms. They also need time to learn these models and ongoing support as they try to put them into practice.

Clearly, schools need to make a greater commitment to providing the kind of quality professional development and technical assistance that enables teachers (and students) in all subject areas to realize the full benefits of the Internet in their classrooms. Short of that, schools should provide incentives for teachers to participate in technology-related workshops or courses offered over the Internet, at professional conferences, or through a local university.

West Virginia art teachers participating in a computer workshop at a recent state conference.

## Time

Of all the obstacles to Internet use in the classroom mentioned thus far, time represents the largest challenge for many teachers. Teachers frequently declare that there simply is not enough time in the school day to allow students to use the Internet in the classroom. Given the demands of school testing and overstuffed curricula, this concern of many teachers is certainly understandable. Planning and implementing Internet-related learning activities do require a considerable time commitment, and teachers are often reluctant to take on the additional work in their busy schedules.

In order to use the Internet effectively with students, teachers need time to learn and to experiment with the technology, time to locate appropriate online resource for classroom use, and time to prepare lessons that integrate these resources and address curriculum goals. Likewise, students need time to work through Internet-related activities; time to explore, process, and assimilate new information and ideas; and time to complete their projects in class.

Some schools provide teachers with release time to attend Internet-training workshops and to plan lessons that involve the use of technology and online resources. Unfortunately, these schools are an exception, not the norm. More often, teachers have to be willing to devote personal time to becoming students themselves and learn how to use the Internet effectively in their classrooms on their own.

Many art teachers are doing just that! They are investing time and effort to participate in online Internet-training courses and workshops (Rockwood, 2002); to learn new pedagogical methods for incorporating online art resources into their curriculums (Erickson, 2001); and to plan innovative art courses that engage students in art historical research using the Internet and other forms of digital technology (Halsey-Dutton, 2002; Harrell, 2000). My hope is that these pioneers will inspire other art teachers to do the same.

As art teachers and students grow more comfortable with the ever-evolving possibilities of the Internet, they will surely continue to develop innovative ways to use the technology.
- **Mary Erickson (2001)**

## Guidelines for integrating the Internet into the art curriculum

The Internet is a highly flexible medium that can serve a number of different needs and purposes in the art classroom. It can provide access to a wealth of valuable art resources and authentic cultural materials in many formats, which can be useful to both teachers and students. It can also assist in promoting purposeful and meaningful learning in a real-world context through online exchanges and collaborations that reach beyond the classroom walls.

Contemporary art education pedagogy strongly advocates both the use of authentic cultural materials and the promotion of purposeful learning in a real-world context. However, as we have seen, making use of the Internet to realize these and other goals requires effectively negotiating a number of obstacles that arise from introducing new and powerful tools into a conventional school context.

Given that the supports and constraints in each classroom and school are different, no two art teachers who set out to integrate the Internet into their curriculums will follow the exact same path. Each of us who decides to use the Internet in our classrooms will shape it according to our own curriculum and students' needs, taking into account the particular circumstances in which we find ourselves.

Regardless of your technology skill level or classroom situation, there are a number of ways that you can begin making use of the Internet to support your curriculum goals. The toughest part may be getting started. To ease the transition, the following guidelines will help you plan a course of action, implement your ideas, and assess your accomplishments.

### Take stock

Make an initial assessment of the technology that you have available in your classroom and school. How current are the computers? How accessible are they to your students (during school and after hours)? How reliable is the Internet connection? What software is on hand? What other digital tools are available? What kind of technology support is available in your school? Who can you turn to if you have questions or are in need of technical assistance? Having some idea of what technology resources you and your students have to work with will lay the groundwork for deciding what you will ultimately do with it.

### Stick with the program

Keep in mind that the Internet is a means to an end, and not the end itself. Your curriculum goals should guide your decisions about how students will use the Internet in the classroom. By clearly defining the educational outcomes of your program, you will be in a better position to determine how the Internet can serve your particular curricular needs.

### Learn from other teachers

Explore school Web sites to see how other art teachers are using the Internet in their classrooms. Online discussion groups are another great source for ideas, where you can ask other teachers how they use the Internet with their students and learn what works for them. Consult with other subject area teachers in your school building or district who use the Internet regularly in their classrooms. Their insights may be applicable to your own classroom situation. Lastly, if your school has a technology coordinator ask them for guidance.

## Set reasonable goals

Do not try to integrate the Internet into your art curriculum in one dramatic swoop! Rather, begin by enhancing one of your existing lessons with an online resource and build from there. For instance, you can augment a lesson on Renaissance art by having students visit the Renaissance Connection Web site. Once you have become familiar with a few online art resources, and experimented with them in your classroom, you will be ready to try a more time-intensive project like setting up an e-mail or art exchange with a school in another country.

## Create a time schedule with equal access

Very few art teachers have enough computers available in their classrooms for an entire class of students to be on the Internet at the same time. If only one or two computers are available in your classroom, consider creating a round robin schedule so that everyone in class gets a chance to use the Internet for at least one assignment during the semester. Avoid using the computer only as a reward for those students who complete work early. It is important to guarantee every student has equal access to the Internet.

## Try something new, something old

Consider the benefits of both new and conventional media technologies in deciding what is best for your students. There are times when using the Internet will make a lot of sense, and there are times when a CD-ROM, the school's library, or an art history textbook will better suit your students' needs. Whenever appropriate, have students use online and local resources (e.g., library books, CD-ROMs, personal interviews with community artists) as well as digital media and conventional art media to accomplish their project goals.

## Plan for assessment

If the Internet is to have a long-term, viable role in the art curriculum, we need to know that its use results in student learning. If you link an online activity or project to certain curriculum goals or performance standards, then you should be able to design an assessment strategy that will gauge students' success in meeting each goal. The more varied assessment strategies you employ, the better. These strategies might include the use of video to capture learning moments on the computer, student action plans, self-evaluation forms, attitudinal surveys, rubrics, student portfolios, journals, and, of course, the work that results from the activity or project.

## Be flexible

Integrating the Internet into your art curriculum is both exciting and challenging, because it is such an open-ended enterprise. Consider that we are all still novices to some degree in the online environment. As your students begin working with computers and the Internet, you will probably be uncertain about such things as their computer skills or how long it will take them to complete an online activity. You will need to learn from experience what works best with your students and in your classroom. Meanwhile, be flexible about deadlines, make adjustments, and provide extra assistance to students as needed.

## Collaborate with your students

Think of your students as partners in learning how to work with the Internet in the classroom to achieve the best results. Take time to discuss with them various aspects of the online activities and projects you have introduced into the curriculum. Their feedback will help you to shape a more effective pedagogical approach to the Internet for future students.

## Become informed

Familiarize yourself with the online security measures taken by your school district to protect students and teachers from any misuses or abuses because of their experience with the Internet. Find out how the filtering software in use works. Who decides which

Web sites are available to students and which sites are blocked? What can you do when the filtering software prevents students from accessing legitimate sites that you want them to visit?

Besides security matters, a number of ethical and legal issues surround use of the Internet in schools, including intellectual property rights, plagiarism, privacy, and equity of access, to name a few. I know it is a lot to take in at first, but learning more about these issues will better prepare you to make informed decisions regarding the Internet's role in your classroom.

## Conclusion

How can we use the Internet to enhance and re-envision teaching and learning in art classrooms? The challenge posed by this question is both intriguing and daunting at the same time. While the Internet offers us greater opportunities for communication, collaboration, and informational retrieval than ever before, it also raises a number of concerns and controversial issues associated with its use as an educational tool in the classroom. Consequently, art teachers who take up the challenge of weaving Internet tools and resources into their curriculums will find the journey to be an adventure.

The ways in which art teachers and students use the Internet may vary from classroom to classroom, grade level to grade level, and school to school, but the ultimate goal should always be the same: to use whatever technology resources are available to actively engage students in authentic and meaningful learning activities in which they use their critical thinking skills to construct their own knowledge of the subject matter at hand. The ideas, resources, and strategies presented in the rest of this book will help you to work toward achieving this goal.

## Useful Web sites

### Center for Children and Technology (CCT)
www2.edc.org/CCT

CCT investigates the roles that technology can play in improving teaching and learning inside and outside the classroom. Their site contains a number of research reports and featured articles regarding various issues related to technology use and education.

### Digital Divide
www.pbs.org/digitaldivide

This PBS series and companion site explores the role computers play in widening social gaps throughout our society in terms of education, employment, race, and gender.

### NetDay Compass
www.netdaycompass.org

This site serves as a clearinghouse of information resources for technology decision makers working in K–12 schools, with numerous links organized under topic headings such as planning, infrastructure, grants and funding, classroom support, and best practices.

### TechLearning.com
www.techlearning.com

Sponsored by Technology & Learning magazine, TechLearning.com contains hundreds of articles, technology tips, how-to guides, and other useful resources contributed by K–12 teachers, administrators, and experts in the field.

### TeenSites.com—A Field Guide to the New Digital Landscape
www.centerforsocialmedia.org/htmlresources/teen_sites.htm

This report, from the Center for Media Education, surveys the ways in which teens are both shaping and being shaped by the electronic culture that surrounds them.

# Untangling the Net

## CHAPTER 2

### What is the Internet?

While the Internet can seem huge and perplexing at first, it would be useful to remember some basic things about it.

- **The Internet is a global network of networks.** It is a vast telecommunications system that joins thousands of different computer networks together, thereby connecting millions of computer users to each other throughout much of the world.
- **The Internet is governed by a set of universal standards that enable data to be exchanged among different types of computers.** Internet protocols (such as FTP and HTTP) are universal standards that enable various network components to work together to transmit data between computers.
- **No one "owns" the Internet.** Although a number of companies and agencies help manage the different parts that make up the Internet, there is no centralized authority or governing body that runs it or controls the content that is available on it.
- **The Internet is basically people sharing ideas and information with other people.** The Internet is used daily by people of all ages and from all walks of life to communicate, to collaborate with one another, to share resources, and to access information of all kinds from computers all over the world.

Fish don't know they live in water.
- **Zen saying**

In a little over a decade, the Internet has arisen from near anonymity to become a global phenomenon. Hardly a day goes by without some sign of the Internet's presence in our lives whether it is at home, in the office or classroom, in the morning newspaper, or on the evening news. Despite its pervasiveness, the Internet remains an enigma for many people. If you count yourself among the bewildered, this chapter will be especially beneficial to read. It examines some of the basic concepts and technologies behind the Internet, how it got started, and what it enables you to do once you connect to it. Even if you think you know all about the Internet, you may learn something new in this chapter.

## A brief history of the Internet

The ideas that launched the Internet had their origin during the 1960s in one of America's Cold War think tanks, the Rand Corporation. Recognizing that a catastrophic event such as a nuclear attack could devastate existing computer networks with a centralized authority, a new decentralized network model was designed so that each computer node within the system could originate, deliver, and receive messages even should other parts of the network be destroyed

The first decentralized computer network, called the Advanced Research Projects Agency Network, or ARPANET, for short, was built for the U.S. Department of Defense in the late 1960s to enable defense researchers and contractors in different geographical locations to share information and valuable technology resources. During the 1970s and '80s, additional networks including USENET, BINET, and NSFNET came online and were linked by ARPANET—which began to be called the Internet. USENET served special interest newsgroups while BINET and NSFNET served members of the academic community. Similar networks across the globe joined the Internet as well.

The 1980s saw the introduction of several universal protocols such as TCP/IP and FTP that significantly enhanced the Internet's capabilities as a medium for communicating and transferring data across great distances. As more and more people became aware of the usefulness of the Internet, demand for online connections significantly increased in commercial and private sectors. Originally restricted to education, research, and governmental uses, the doors of the Internet were flung wide open in 1991 to allow for commercial uses, clearing the way for electronic commerce. At about the same time, the World Wide Web burst on the scene and launched a new era of electronic communications by giving the Internet a user-friendly interface that appealed to the general masses.

Once considered the exclusive domain of nerds and geeks, the Internet entered the mainstream of public consciousness during the mid-1990s. Fueled by the explosive popularity of the World Wide Web, traffic on the Internet increased dramatically as millions—young and old alike—rushed to get online and to create their own homepages. Commercial networks such as America Online, CompuServe, and Prodigy flourished, providing online access to anyone willing to pay for it. Virtual communities popped up everywhere on the Internet, allowing people with common interests to meet, debate, share ideas and information, socialize, and collaborate with each other through online chat rooms and discussion boards. Meanwhile, investors and venture capitalists poured billions of dollars into Internet start-up companies, resulting in a deluge of "dot-coms."

As the new millennium began, the Internet's population skyrocketed to over 400 million users worldwide (*Computer Industry Almanac*, April 24, 2001). With high-speed broadband access on the rise, streaming audio and video, music-file sharing, interactive gaming, unified voice and e-mail, and video-conferencing have now become essential parts of the daily online activities of a growing number of residential consumers. Undaunted, the Internet industry has labored to keep pace with the increasing demands of today's wired society, albeit not without experiencing growing pains.

The exuberance showered on "dot-coms" just a few years ago quickly dissipated, and many once promising Internet businesses have since folded or merged with other companies. Recent court battles over Napster's online music sharing service and Microsoft's anti-competitive business practices played out on the evening news. More troubling have been reports of stalkers and pedophiles using Internet chat rooms to lure children into face-to-face encounters, online pornography and hate-based Web sites, identity theft, hacking, and computer viruses spreading over the Internet. A source of widespread consternation, the presence of these and other unsavory elements on the Internet has led many to take a second look at its value and its place in our businesses, homes, and schools.

No longer infatuated with its bells and whistles and made wary by its many abuses, we now recognize that the development and rapid growth of the Internet has brought us mixed blessings. Though we may marvel at the Internet's ability to bring the world's cultural resources to our fingertips, it has left us awash in a sea of information, pop-up ads, and unsolicited commercial e-mail, or spam. We may appreciate the convenience of online shopping, yet abhor the massive commercialization of the Internet. We may support the notion of free speech on the Internet, but find the uncensored, unfettered nature of the medium at times disturbing or even threatening. Still, even with these perceived liabilities, the Internet remains a useful and powerful medium with many great resources that millions of people around the world use daily for communication, education, research, entertainment, and commerce.

While future innovations will continue to propel the Internet into the mainstream of daily life, there are plenty of things to see, do, and learn online right now. In order to take advantage of these opportunities, it is important to know the basics of how the Internet operates and the types of software you need to utilize the services it provides.

The Internet may fairly be regarded as a never-ending worldwide conversation.
- **U.S. District Judge Stewart Dalzell (1996)**

## Try This: Internet metaphors

Metaphors help us describe, visualize, and make sense of the world around us, especially things that are unfamiliar and incomprehensible. In this exercise, we will examine different ways that people think about and visualize the Internet.

**Directions:** The Internet is frequently referred to as the "information superhighway" and sometimes as a "giant library." What words or phrase would you use to describe the Internet? Complete the following sentence:

**The Internet is . . .**

What does the Internet look like to you? How do you visualize it in your head? In the space below, draw an image that represents the Internet to you.

If possible, share and compare your Internet metaphors with those of others. Discuss how these metaphors relate to the ways in which people use the Internet.

## Getting connected to the Internet

To get online from your home, you need to connect your computer to an Internet Service Provider (ISP) via a telephone modem, a cable modem, or a Digital Subscriber Line (DSL) and to install software on your machine that will allow you to send e-mail and access the World Wide Web. New computers today usually come with modems and Internet software already installed; still, you may want to explore other Internet connection options in your area.

Dial-up connections are typically found in homes where a telephone modem is used to dial into a large computer (belonging to an ISP) that is connected to the Internet itself. The majority of these modems transfer data at a rate of 56 KB per second, which can be painfully slow when you're downloading large files from the Internet, such as software or Web pages with multimedia elements.

In recent years, several alternatives to dial-up connections have emerged that offer the advantage of direct, high-speed Internet access. These broadband connections are nearly ten times faster than telephone modems, so you do not have to wait forever for things to download from the Internet. They are more expensive than conventional dial-up Internet service, but are worth checking into if you or your family members spend a lot of time online. Most local cable TV and telephone companies offer broadband Internet connections along with technical support services to help you install the necessary hardware and software as well as to assist with any problems you might encounter once you are hooked up.

If you own a laptop or handheld computer, you might consider "going wireless," another increasingly popular high-speed Internet option these days. Wireless Internet access uses radio frequency signals to exchange information between your computer and the Internet. While wireless technology offers the advantage of

mobility by eliminating the need for a cable or telephone line to connect your computer to the Internet, you still have to remember to always recharge the batteries in your laptop overnight.

If you do not own a computer, and never intend to, you can still gain high-speed access to the Internet through WebTV that uses a set-top box and a satellite dish to turn your television set into an Internet browser. With WebTV, you can "surf the Web" and send e-mail from the comfort of your armchair. But you cannot download software or access some Web applications that use Java programming scripts or streaming media. While WebTV's chief advantages are its low initial cost and convenience, be wary of the possibility of incurring long-distance telephone charges if you live outside the area where your WebTV provider has dial-up service.

The type of connection most commonly found in schools these days occurs through a local area network (LAN) where every computer on the network regardless of location has direct high-speed access to the Internet at all times. Some schools have adopted broadband wireless Internet connections, and more will likely do so as the technology becomes widely available.

Although the number of classroom connections in America's public schools has increased significantly in recent years, many teachers and students have to gain access to the Internet using computers in a central school lab, media center, office, or library. As an art teacher, you may need to be proactive in convincing your school administration of the need for Internet access in your classroom. Hopefully, this book will provide you with ample support for presenting your case.

## What can you do on the Internet?

With the appropriate software installed on your computer and an active Internet connection, you may take advantage of any or all of the following online tools and services.

### E-mail

Electronic mail, or e-mail as it is known, comprises the vast majority of Internet usage today. E-mail allows you to send and receive messages to and from any person on the Internet as well as to exchange messages with a group of people via a mailing list. E-mail can also be used to send and receive various forms of digital files (including Word documents, PDF files, photographs, and compressed video) as attachments over the Internet.

Teachers often have two e-mail accounts including one through their school district and then a personal account they pay a monthly fee for through a local ISP. There are also several free Web-based e-mail services that are quite popular among teachers. These include MSN Hotmail and Yahoo! Mail.

**Free e-mail services**

**MSN Hotmail**
www.msn.com

**Yahoo! Mail**
www.yahoo.com

## File Transfer Protocol (FTP)

With this service, you can transfer or download files (such as free or inexpensive software, electronic books, maps, software updates and documentation, sound files, graphics, and more) from FTP sites on the Internet to your own computer. FTP is also used to upload files from your computer to a host computer on the Internet.

Many FTP sites allow you to login anonymously and to download copies of their public-accessible files at no charge. FTP is one of the easiest and most efficient ways to distribute updated copies of software and accompanying documentation, or any other type of file containing large amounts of data.

Today, you can download files from most FTP sites using a Web browser like Internet Explorer or Netscape Navigator. However, it is still advisable to install an FTP software program on your computer for use in such circumstances as when uploading Web pages you create to a host computer on the Internet. Two popular FTP programs are WS_FTP for Windows computers and Fetch for Macintosh computers.

**FTP software**

**Fetch** (for Macintosh computers)
Fetch Softworks
www.fetchsoftworks.com

**WS_FTP** (for Windows computers)
Ipswitch
www.ipswitch.com

### Internet chat

Internet chat is a generic term that refers to communicating with others over the Internet in real time by using your keyboard to type messages. There are several kinds of Internet chat services available today.

**Internet relay chat (IRC)** is the oldest form of real-time chat service on the Internet and is still in wide use today. IRC allows multiple users to meet in certain locations (called channels or chat rooms) on the Internet and to "talk" instantly with one another by typing and reading text messages. IRC chat rooms are very popular places on the Internet, in that they are essentially free-for-alls where any number of people can participate. While some are intended for general conversation, others may be designated for specific topical discussions or age groups. IRC chat rooms designed for youngsters are monitored and are usually considered safe. Due to the unfettered nature of most chat rooms, however, some school districts have banned their use entirely from classrooms. Teachers should check their school's Acceptable Use Policy before proceeding in this area with their students.

To participate in IRC chat rooms, you need to use an IRC client software program like mIRC for Windows computers or Ircle for Macintosh computers. These programs can be downloaded free of charge from the Internet.

**Web chat** works much like IRC, only users do not need to have the same special software in their computers to communicate with one another. Anyone with a Web browser can participate in a Web chat. Unlike IRC chats that occur in a small window on your computer screen, Web chats take place within your browser window.

There are literally thousands of Web chat rooms on the Internet, the most popular of which are those supported by Internet companies like Yahoo! and America Online (AOL). To participate in Web chat rooms on Yahoo!, you must first register on the site and get a Yahoo! ID, which is free. To do so on AOL requires paying a yearly subscription fee.

If you are looking to chat with other teachers on the Internet, there are a number of places to go that cater to the education community. For instance, Teachers.Net offers a number of Web chat rooms as a courtesy to teachers and others in the field of education. In addition to general interest forums, there are also weekly chats scheduled for teachers in different subject areas such as art. Meeting times are posted on the Teachers.Net Web site and participants can easily log into or leave the chat board at any time.

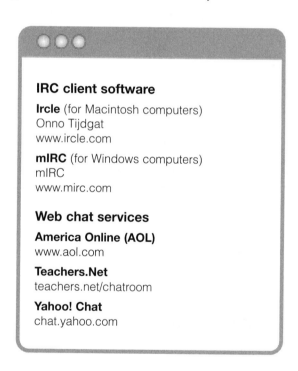

**IRC client software**

**Ircle** (for Macintosh computers)
Onno Tijdgat
www.ircle.com

**mIRC** (for Windows computers)
mIRC
www.mirc.com

**Web chat services**

**America Online (AOL)**
www.aol.com

**Teachers.Net**
teachers.net/chatroom

**Yahoo! Chat**
chat.yahoo.com

**Instant messaging (IM)** has become one of the hottest Internet trends in recent years. IM allows two or more people to instantaneously exchange messages over the Internet, but only as long as all parties are online at the same time and are using the same instant-messaging software program. IM programs operate much like IRC client programs, but they are easier to use.

One of the benefits of using IM to converse with others online is that your conversations can easily be kept private. IM programs allow you to maintain a list of people that you wish to chat with. Depending on the IM program you use, these lists are called your "Buddy List" or "Friends List." You can only send and receive messages to those people on your list, but you can add or delete names from this list at any time.

While IM typically occurs between two people, you can also carry on group conversations with up to four "buddies" or "friends" in the same window simultaneously. In addition to sending instant messages back and forth, most IM programs allow you to share Web links, images, and sound files, plus conduct video conferences using a Web cam, or voice chats using a microphone and your computer's speakers in much the same way you use a telephone.

There are several instant messenger programs available today including AOL Instant Messenger, iChat, ICQ, MSN Messenger, and Yahoo! Messenger. All can be downloaded from the Internet at no charge. To use any of these programs, you will need to first register on the company's Web site and obtain a user-name and a password.

---

**Instant messaging software**

**AOL Instant Messenger**
America Online
www.aim.com

**ICQ**
ICQ
www.icq.com

**MSN Messenger**
Microsoft
messenger.msn.com

**Yahoo! Messenger**
Yahoo!
messenger.yahoo.com

**MUDs, MOOs, and MUVEs** are interactive multi-user environments in which participants from different locations can communicate and interact with one another or with various objects placed in rooms. These virtual environments function much like Web chat rooms in that they allow for synchronous interaction among several participants and are, for the most part, text-based; however, they are definitely more dynamic than Web chat rooms and typically require a little more time and patience to find your way around and become skilled at using them.

MUDs, short for Multi-User Domains, became popular years ago on the Internet for their ability to simulate virtual reality games like Dungeons and Dragons. Hence, they became known as Multi-User Dungeons.

MOOs, short for Multi-User Object-Oriented environments, are used more often today to create interactive gaming and distributed learning communities on the Internet. Like MUDs, MOOs are built around a basic theme or metaphor (like a college campus, school, classroom, conference center, or auditorium) and can accommodate any number of users simultaneously. Once in a MOO space, each user is represented by a virtual persona that can either be a projection of his or her real self or a made-up character. MOO participants are able to create their own virtual spaces with various objects that others can enter and interact in. Since text is used to describe personas and spaces as well as to communicate with others, the richness of a MOO experience is largely dependent on each participant's imagination and creative writing skills.

Several educational MOOs, or eduMOOs, as they are called, exist on the Internet today where teachers and students can hold conferences, participate in online courses, engage in collaborative work, meet colleagues and peers from around the globe, or simply practice their creative writing and programming skills. If you are interested in giving one a try, check out Virtual University or schMOOze University. For kids ages thirteen and under, there is Moose Crossing, which requires a special client software program that can be downloaded at no charge from their Web site.

MUVEs, short for Multi-User Virtual Environments, are a recent development on the Internet that add several new elements to the traditional MUD/MOO experience, including increased interactivity, a graphical (2-D or 3-D) Web interface, easier navigation, and multimedia components. Depending on the purpose and design of the MUVE, a variety of virtual objects or tools may be available to facilitate communication, collaboration, and interaction among participants, including shared white boards, chat rooms, slide projectors, textbooks, or tape recorders.

Interactive telecommunications is a technology that empowers the individual to connect with others.
• **Roy Ascott (1991)**

Like its predecessors, a MUVE has three main components: personas, places, and objects. In Web-based MUVEs, various elements are represented by pictorial images. By issuing simple commands (like GO, SAY, LOOK, and FIND), participants can easily navigate from place to place, while talking to people and interacting with objects in each space. MUVEs are being used today in a wide variety of disciplines and educational situations to enhance student learning, provide professional development for teachers, and foster collaboration. One of the best examples of the potential of MUVEs to support educational goals and practices is Tapped In, a Web-based campus and virtual conference center that serves a growing online community of education professionals from around the world (Figure 2.1). In Chapter 5, we will take another look at Tapped In.

**MOOs, MUDs, and MUVEs**

**Moose Crossing**
www.cc.gatech.edu/elc/moose-crossing

**Tapped In**
www.tappedin.org

**shhMOOze University**
members.tripod.co.jp/schmooze

**Virtual University**
vu.org

**Figure 2.1** A bird's-eye view of the Tapped In campus

## Online discussion groups

There are literally thousands of special interest discussion groups, covering every topic imaginable, on the Internet today. While these groups vary in operation and size, they all follow the same principle that each member can post messages or ask questions and others in the group can read and respond to them as they wish. Before joining one of these groups, it is advisable to find out how messages are distributed to participants and what options you might have available for receiving these messages.

In newsgroups (Usenet), messages are posted and accessed in a central place rather than sent to your personal mailbox. To participate in a newsgroup, you need to use the special newsreader program available with your Web browser. Newsgroups have been around on the Internet since its inception and continue to be one of the most popular ways to share information with others of similar interests. However, it is important to note that newsgroups are unmoderated and thus messages may contain frivolous or objectionable content. Also, they seldom provide actual "news."

In groups called mailing lists, mailrings, listservs, or e-groups, messages are usually distributed by an automated mailing service (called a listserver) to individual member's mailboxes. Some mailing lists are moderated with someone filtering messages before they are posted to the group, whereas others are more open and unregulated.

To join a mailing list, you send an e-mail message to a listserver or list administrator requesting that you be added or "subscribed" to the list. Typically, you will receive a quick, automated response asking for confirmation of your request and then a follow-up message that provides important information on how to post messages to the list, various options you may have in how you receive mail from the list, as well as directions on how to unsubscribe from the list. It's important to save this information on your computer for future reference.

Joining an online discussion group is a great way to exchange ideas with other teachers or people who share similar interests. Depending on the size of the discussion group, the amount of mail you receive can vary from as little as a few messages per week to several hundred messages per day. If the number of messages becomes overwhelming or if you find out the discussion isn't what you expected, you can unsubscribe at any time.

Since 1995, the J. Paul Getty Trust Foundation has sponsored the most popular art education discussion group on the Internet, TeacherArtExchange (previously called ArtsEdNet Talk). There is also a mailing called ArtEducators available through Yahoo! Groups and an Art/Arts & Crafts mailring that you can join on Teachers.net. In addition, check with your state art education association to see if they sponsor an electronic mailing list for their membership. Chapter 5 provides further information and suggestions on joining an online discussion group.

**Online discussion groups**

**Art/Arts & Crafts Mailring**
teachers.net/mailrings

**ArtEducators**
groups.yahoo.com

**TeacherArtExchange**
www.getty.edu/education

## Telnet

Telnet, also referred to as "remote login" or "long-distance computing," allows you to connect to a large computer at a distant site and to use it as though you were there. For example, you can use Telnet software to access university campus information systems, to conduct an online search at major libraries, to browse CD-ROM catalogs online, and to take advantage of countless other online services.

Telnet was an impetus behind ARPANET, the forerunner of today's Internet, permitting scientists and programmers to make use of powerful supercomputers a continent away. With the arrival of the World Wide Web, which offers an easier way to access distant computers, Telnet software is used less frequently today.

## Videoconferencing (VC)

This service combines the benefits of Web chats and instant messaging with real-time visual communication. All you need to participate in this popular form of online communication is an inexpensive video camera or Webcam connected to your computer, videoconferencing software, and, of course, an Internet connection. If your computer is equipped with a microphone and speakers, you can also add voice to your videoconferencing capabilities.

VC allows people in different locations to see each other in small windows on their computer screens while they type instant messages back and forth on a shared chat window. It is being used in countless schools today to offer teachers and students new opportunities for distance learning through online courses, tutoring, virtual field trips to distant sites, connections with remote experts and guest speakers, multi-school project collaborations, and professional development seminars.

The costs of a VC setup in a classroom can vary from as little as $50.00 to as much as $20,000 or even higher. The more expensive setups provide increased capabilities such as sharing software applications, exchanging digital files, or even working together on the same file concurrently, along with the benefits of a high-speed Internet connection.

If you're looking for VC software to work with a Webcam on your Windows-based computer, you can download the latest version of the popular CUseeMe software program when joining CUworld, which provides meeting rooms, periodic online events, and various support services for a monthly membership fee. A popular alternative for both Windows and Macintosh computer users is iVisit, which can be downloaded from the company's Web site at no charge.

The Global Schoolhouse sponsors an online discussion group for teachers interested in videoconferencing along with a Classroom Conferencing Directory, where you can search for other schools that use videoconferencing. If your school has (or is thinking about)

VC capabilities involving high-speed Internet connections, Pacific Bell's *Videoconferencing for Learning* is an exceptional online guide intended to assist educators and students in using ISDN-based video-conferencing technology effectively. Global-Leap.com also offers a range of online support services for schools with ISDN-based videoconferencing technology.

If you do not see VC as a part of your Internet initiatives in the near future, you can still bring the world into your classroom by visiting any of the thousands of live Webcam sites available on the Internet. For instance, AbcParisLive.com offers live shots of the Eiffel Tower in Paris (Figure 2.2) whereas Libertycam.com offers a live shot of the Statue of Liberty in New York Harbor. To locate live Webcams, try searching Earth-Cam, which offers a subject directory of thousands of live Webcams worldwide including the Warhol Cam at the Andy Warhol Museum in Pittsburgh.

---

**Videoconferencing resources**

**CUworld** (for Windows computers)
www.cuworld.com

**Global-Leap.com**
www.global-leap.com

**Global Schoolhouse**
www.globalschoolhouse.org/cu

**iChat AV** (for Macintosh Computers)
Apple
www.apple.com/ichat

**iVisit**
iVisit
www.ivisit.com

**Pacific Bell's**
**Videoconferencing for Learning Page**
www.kn.pacbell.com/wired/vidconf

Students can also enter the day-to-day life of artists who install Webcams in their studios that display continuously updated pictures of works in progress. Miami artist Xavier Cortada offers an excellent illustration through his WebStudio, which uses two Webcams, a chatroom, and a discussion board to engage visitors in his creative art-making process (Figure 2.3). Visit his WebStudio archives to see documentation and a virtual gallery of Cortada's previous Internet-based projects, including several mural painting projects accomplished in collaboration with Miami-Dade County students.

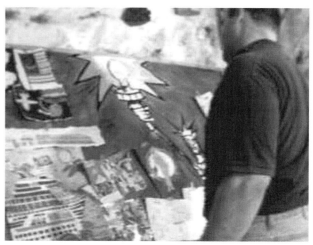

**Figure 2.3** A Webcam shot of Miami artist Xavier Cortada working in his studio

**Figure 2.2** A Webcam shot of the Eiffel Tower

**Live Webcams**

**EarthCam**
www.earthcam.com

**EarthCam for Kids**
www.earthcamforkids.com

**Leonard's Cam World**
www.leonardsworlds.com

**Xavier Cortada**
www.cortada.com

**Warhol Cam**
warhol.earthcam.com

# What can you do on the Internet?

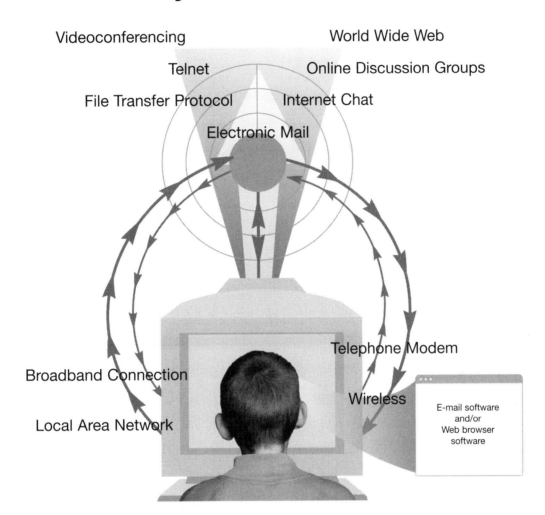

Videoconferencing

World Wide Web

Telnet

Online Discussion Groups

File Transfer Protocol

Internet Chat

Electronic Mail

Telephone Modem

Broadband Connection

Wireless

Local Area Network

E-mail software
and/or
Web browser
software

**Getting connected to the Internet**

## World Wide Web

The World Wide Web, also known as the Web or WWW, is the most significant recent development on the Internet in that it has made almost any type of information or online service easily accessible through a point-and-click graphical interface. Often confused with the Internet itself, the Web is actually just a small part of it. The boundaries between the two have become increasingly blurred as all of the Internet services previously discussed are now available through the Web. While much of our attention today is focused on the Web, we should keep in mind that the Internet provides the "physical backbone" upon which the Web and other online services operate.

The Web was invented in 1990 when Tim Berners-Lee, a computer scientist working at CERN (the European Organization for Nuclear Research), developed a system to facilitate collaboration and information sharing among physicists working in different universities and research labs all over the world (CERN, 2002). Working with a colleague, Berners-Lee wrote a computer program (the precursor to today's Web browser) using Hypertext Markup Language, or HTML for short, which allowed documents stored in his computer to be linked together by highlighting certain keywords, phrases, or images. Thus, clicking on a highlighted item in one document caused the program to find another document containing additional information and more than likely other highlighted items. At that point, it became possible to link documents stored in different computers around the world that were connected to the Internet. Berners-Lee called his invention the "World Wide Web."

Realizing that the Web could revolutionize the world of information and that the CERN team could not do all the work needed to develop the system further, Berners-Lee called on other developers to become involved. In 1993, CERN opened the Web up to anyone who wanted to use it, no fee required.

While Berners-Lee is credited with the invention of the World Wide Web, it was a research team working at the National Center for Supercomputing Applications (NCSA) at the University of Illinois that made the Web widely accessible. In 1993, NCSA released the first version of their user-friendly graphical Web browser, called MOSAIC, for X Window System computers followed by versions for the popular PC and Macintosh computers—all of which could be downloaded from the Internet at no charge.

The impact on the expansion of the Web was immediate. Suddenly, everyone with MOSAIC in their computers and a telephone modem was learning HTML and putting up Web pages on the Internet. Other browsers and related technologies quickly appeared, leading to further development of the Web.

In 1994, MOSAIC spawned Netscape Navigator, which was made freely available on the Internet for academic and nonprofit use as well as for evaluation purposes. Then, in 1995, Microsoft released their Web browser, Internet Explorer, which was designed initially to work with their Windows 95 operating system on PC computers and then later for Macintosh computers as well.

With advances in compression technologies, Web pages started to contain audio and video files in addition to text and graphics. As the use of Web browsers became increasingly widespread, more and more individuals, groups, and institutions staked out territory on the Web. Recognizing the tremendous potential of the Web to reach consumers on a global scale, businesses and companies quickly joined in. Consequently, Web pages began to proliferate on the Internet at an astounding rate.

From these beginnings, the Web has grown into the huge international system we know today. It has become an indispensable tool for millions of people in all walks of life and professions. In short, it has become one of the most crowded places on earth.

Just how big is the World Wide Web? Because the Web is so large and is constantly changing, reliable statistics are hard to come by. In 1999, researchers at the NEC Research Institute projected there were some 800 million pages of information on the Web, a significant increase over the 320 million Web pages they estimated in 1997 (Lawrence & Giles, 1999). In a 2000 University of California, Berkeley, study it was estimated that the publicly accessible Web consists of approximately 2.5 billion documents, with a rate of growth of 7.3 million pages per day (UC Berkeley, 2000). More recent estimates of the total number of publicly-accessible pages on the Web vary from 4 to 8 billion, vividly demonstrating the Web's phenomenal growth and its enduring importance as a medium of information exchange and knowledge sharing.

**Web browsers**

**Internet Explorer**
Microsoft
www.microsoft.com/windows/ie

**Netscape Navigator**
Netscape Communications
channels.netscape.com/ns/browsers

The development of the World Wide Web is a great example of human endeavor in which many people participated, driven by individual excitement and a common vision.
• **Tim Berners-Lee (2002)**

## The Web in the classroom

Regardless of what size or shape the Web takes in the future, we need to keep the inventor's original purposes in mind as we learn to utilize it in our classrooms today.

- **The Web was developed as an easy way to access information.** Granted, with so much extraneous material available on the Web today it is a real challenge to locate useful information on it. To assist in this task, Chapter 4 discusses a number of online search strategies and tools plus emphasizes the importance of evaluating the resources and information you find on the Web.

- **The Web was developed as a tool for collaboration.** The Web has been hugely successful in opening up new avenues for individuals and groups in different geographic locations to share resources and work together toward common goals. We will examine the potential of the Web for fostering collaboration in the art classroom in Chapter 9.

- **The Web was developed to allow individuals to publish their work and share it with others.** Given the lure of reaching a global audience and the ease with which one can create Web pages, it is not surprising that so many people around the world have taken to publishing their ideas and work online. This feature of the Web lends itself to a number of applications in art education and will be discussed in greater detail in Chapter 7 and then again in Chapter 10.

## Conclusion

The Internet is more than computers, software programs, and modems. It is more than wires, cables, and routers transmitting data at breakneck speed around the world. The Internet is also a place where people go to seek entertainment, to gather in groups, to teach and to learn, and to conduct business. In sum, the Internet is not only a technological phenomenon; it is a sociocultural one as well.

## Useful Web sites

### Internet 101
www.internet101.org
This site provides an overview of different ways to connect to the Internet, plus useful information on safe surfing, viruses, browsers, e-mail, Web searching, and more.

### Internet Primer
www.thirteen.org/edonline/primer
Sponsored by wNetSchool, this site is designed to assist K–12 teachers in learning how to get the most out of the Internet and World Wide Web in the classroom.

### Nerds 2.0.1
www.pbs.org/opb/nerds2.0.1
This site, sponsored by PBS, provides a layperson's view of the history of the Internet.

### webTeacher
www.webteacher.org
This comprehensive set of online tutorials covers just about everything a teacher needs to know about the Internet and the World Wide Web.

# How the Web Works

## CHAPTER 3

### What is a Web page?

A Web page is a document, usually consisting of text and graphics, which is stored on a computer (called a Web server) that is connected to the Internet. The vast majority of Web pages are written with HTML tags, or commands, that tell your browser how to display the contents of a page on your computer screen (Table 3.1). These HTML tags remain invisible to the casual Web user, but can be viewed by telling your browser to display the Page Source (Figure 3.1).

Web pages typically include hyperlinks, or "hot spots," that connect the page you are on to other Web pages or files containing related content (Figure 3.2). When you click on a hyperlink, your Web browser locates the necessary files, downloads a copy of them to your computer, and then displays them on the screen. This data may be stored on the same Web server or on an entirely different server halfway around the world.

Thus, with a few clicks of your mouse button, you can move from Web page to Web page, and Web site to Web site in a matter of seconds. It is important to understand this concept, as the Web is made up of millions of pages, many of which are interconnected by hyperlinks.

Any smoothly functioning technology will have the appearance of magic.
• **Arthur C. Clarke (1984)**

The arrival of the World Wide Web in your classroom brings with it animation, graphics, video, sound, virtual worlds, interactivity, as well as immediate access to a host of online resources and experts that can both inform and inspire your students. In this chapter, we go behind the scenes to examine how all this gets to your computer screen, taking a look at the key components of the Web and your Web browser. Because technology does not always work the way it should, we also look into some of the technical problems encountered on the Web and what to do about them if they happen to you.

## Anatomy of a simple Web page

The following illustration shows how HTML can be used to create a simple Web page.

Tells the browser that the data to follow is in **HTML** format.

Tells the browser that the following data is the file's **header** and the **title** of the page.

Tells the browser to **load a specific graphic** on the page and indicates its alignment and size.

Indicates the typeface **font** and size for the text that follows.

Indicates a **text** or **graphic link** to another Web page.

Indicates the end of the **body** of the Web page.

Indicates the end of the **HTML** instructions.

Indicates the end of the **header/title** data.

Indicates the following is the **body** of the Web page and the background is white.

Everything following the **CENTER** tag is centered on the page.

Introduces a **space** (line break) in the page layout.

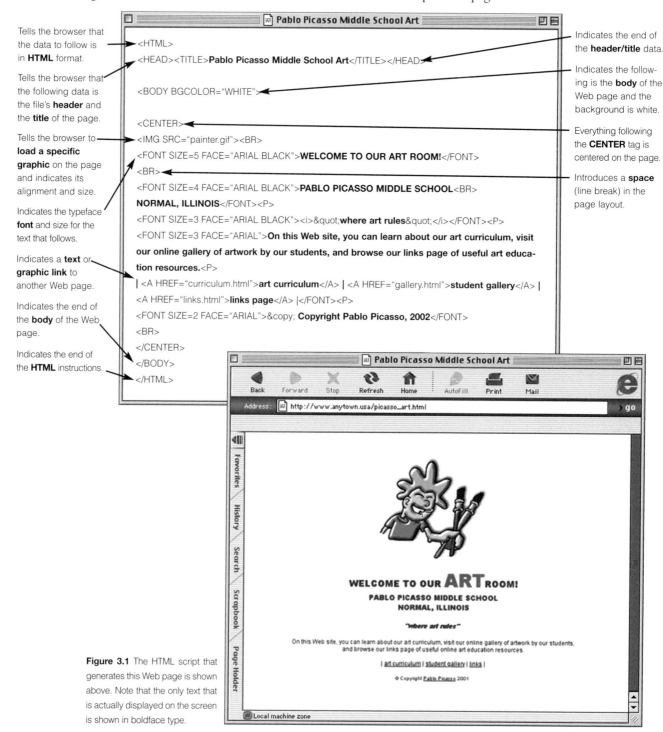

**Figure 3.1** The HTML script that generates this Web page is shown above. Note that the only text that is actually displayed on the screen is shown in boldface type.

Graphic Link

Hypertext Link

**Figure 3.2** Hyperlinks connect the Web page you are on to other pages containing related content.

The eureka moment for most of us came when we first clicked on a link, and found ourselves jettisoned across the planet.

• **Steven Johnson (1997)**

| HTML Tag | Description |
|---|---|
| **\<HTML> \</HTML>** | These tags, placed first and last in the document, indicate that the enclosed data is in HTML format. |
| **\<HEAD> \</HEAD>** | These tags contain descriptive information about the page, such as its title. |
| **\<TITLE> \</TITLE>** | These tags indicate the name of the Web page. |
| **\<BODY> \</BODY>** | Everything that shows on the Web page is placed within these two tags. |
| **\<CENTER> \</CENTER>** | Anything placed within these two tags will be centered on the Web page. |
| **\<IMG SRC=" ">** | This tag tells the browser to load a specific graphic on the Web page. |
| **\<FONT> \</FONT>** | This tag tells the browser what kind of typeface, color, and size to make the enclosed text. |
| **\<BR>** <br> **\<P>** | This tag inserts a line break in the page layout. <br> This tag inserts a paragraph break in the page layout. |
| **\<A HREF=" "> \</A>** | This tag links either text or a graphic to another Web page. |

**Table 3.1** Basic HTML tags

## What is a Web site?

A Web site is a collection of related pages and files stored on a Web server. The entry page of a Web site is referred to as its "homepage" or "splash page." This opening page usually includes the name of the site's author, the date it was created, when it was last updated, and links to other pages and resources on the site. (Figure 3.3)

**Figure 3.3** From a homepage you can go to other pages on a Web site.

## What is a Web browser?

Simply put, a Web browser is a software program that allows you to view files stored on the World Wide Web. Internet Explorer and Netscape Navigator are the most popular browsers in use today. New computers typically come with one or the other browser installed, and the most recent versions of both can be downloaded from the Internet at no charge.

Regardless of which browser you use, each offers similar tools for navigating the Web (Figure 3.4). In addition to accessing Web documents, you can use your browser to communicate with others via e-mail, mailing lists, and chat rooms; to download content you find on the Web to your hard drive; and to design your own Web pages and upload them to the Internet.

If you are unfamiliar with your browser, it is a good idea to spend some time learning how to use it. See page 59 for online tutorials that will introduce you to the basic tools and operations of Internet Explorer and Netscape Navigator.

Pull-down Menus → **File   Edit   View   Go   Favorites   Tools   Window   Help**

Title Bar

Address Bar

Tool Bars →

Status Indicator

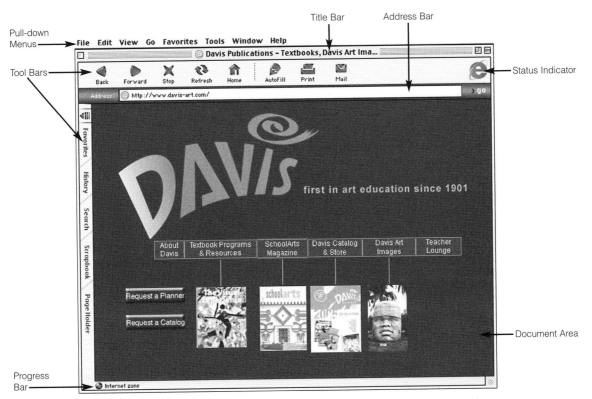

Document Area

Progress Bar →

**Figure 3.4** Internet Explorer provides a number of navigational tools along the top and left-hand side of the screen.

## How does a browser locate a Web page?

Each Web page has a distinct address, called a Uniform Resource Locator (or URL for short) that identifies its location on the Internet. For instance, the following URL identifies the location of the NGAkids page on the National Gallery of Art Web site (Figure 3.5).

URLs typically consist of four parts separated by slashes.

1. The **transfer protocol** (or scheme) tells your browser what sort of document you are attempting to access and how to interpret it. Because most Web pages are hypertext documents, http is the most commonly used protocol. Other widely-used protocols include mailto for sending e-mail messages and ftp for transferring large files like software programs. Each URL begins with a transfer protocol followed by a colon and two slashes (://).

2. The **domain name** tells your browser the designation and location of the computer that hosts the document you are seeking on the Internet. Most domain names begin with www, but not all do. For example, www.nga.gov is the domain name of the National Gallery of Art in Washington, D.C., whereas insea.unb.ca is the domain name for the International Society for Education Through Art Web server in Canada.

3. The **directory** tells your browser where the document you are looking for is located on the host computer. Think of a directory as a folder in a filing cabinet. A URL may have several directories, or none at all. A long URL with several slashes indicates the desired file is in a subdirectory on the server (i.e., a folder within a folder).

4. The **file** tells your browser the name of the document you are seeking. Most file names end with either .htm or .html, but you might also encounter suffixes such as .phtml, .shtml, .cfm, .pdf, and others.

If you know the URL for a Web page you want to visit, carefully type it into the Location or Address box on your browser's navigational bar and press the Return or Enter key. In a few moments, you will be there.

**Tip**

You can leave off the "http://" part of the URL for a Web page when typing it into the Location box. Your browser will automatically insert it.

**Figure 3.5** NGAkids, sponsored by the National Gallery of Art in Washington, D.C., offers a number of art activities and projects for kids to do, including several art interactives in the Art Zone area.

## What is Web browsing?

Web browsing is a way of experiencing the online information environment growing up around us. Using a browser allows you to travel from Web page to Web page, and Web site to Web site, by clicking on hyper-links. Web browsing is a serendipitous activity in that you are casually looking for something of interest. It is like rummaging in the booths at a giant flea market in search of an unusual item to purchase. You may not know exactly what you are looking for, but you will know it when you see it.

### Try This: Web browsing activity

One of the great things about browsing the Web is that it is so easy to do. You just click on a link and you're off to the next page. Still, because the Web is so vast, with millions of sites and pages, you might ask yourself "Where do I begin?" One of the best places to begin browsing is on a popular Web directory or index that contains lists of selected sites organized by subject areas.

**Directions:** Choose one or more of the sites listed below, type the corresponding URL into your browser's Address or Location bar, press the Enter or Return key, and begin browsing the Web for sites that interest you.

| Web site | URL |
|---|---|
| Artcyclopedia | www.artcyclopedia.com |
| Art History Resources on the Web | witcombe.sbc.edu/ARTHLinks.html |
| Blue Web'n | www.kn.pacbell.com/wired/bluewebn |
| Kathy Schrock's Guide for Educators | school.discovery.com/schrockguide |
| Yahoo! | www.yahoo.com |

While you are browsing, if you find a site that you would like to return to later, add it to your favorites list or bookmark it (see next page).

## How can you remember where certain Web pages are located?

Let's say you found a Web site that you will want to visit again. While you can jot down the site's URL on paper, there are quicker ways to recall the location of the site using your browser's tools.

Both Internet Explorer and Netscape Navigator allow you to quickly return to a Web page you have just visited through the "Go" pull-down menu that displays a list of all the pages you have been to during the current session. Both browsers also keep records in the "History" list of all the pages you have visited, which can be found through your browser's tool bar. Clicking on any link in your History list will take you back to the corresponding Web page.

To maintain a permanent record of Web pages you intend to revisit often, you can "bookmark" them in Netscape Navigator or add them to your "favorites" list in Internet Explorer (Figure 3.6). With either browser, the sites marked in this way remain available until you manually remove them. For information on managing your bookmarks (or favorites), consult one of the browsing tutorials listed at the end of this chapter.

**Figure 3.6** Bookmarks (or Favorites) provide a quick way to return to marked Web pages in future sessions.

## Troubleshooting problems on the Web

Considering the fleeting nature of the Web, the variety of computer systems and different versions of browsers being used today, and how often Internet-based technologies change, it should come as no surprise that people encounter problems when they are on the Web. While it is impractical to try to describe or to offer solutions for all of the possible difficulties one might run into on the Web, here are some of the more common ones.

### Server not found

While there can be several reasons for this happening, it is likely that the Web server has been taken offline temporarily for maintenance. Try again later.

### File not found

This problem occurs often and for several possible reasons. You may have typed in the URL incorrectly. The page you are looking for may have been moved to a new location, or it may have been removed from the Web entirely. Keep in mind that directory and file names are case-sensitive, so make sure you type in the complete address in the correct case (upper or lower). If the page still is not found after you recheck your typing and try it again, go back to the server it was placed on (by eliminating all of the URL except the domain name) and see if there is an indication of its new location. If neither of these solutions resolve the problem, you might try searching for the title of the page through a search engine like Google to see if it's been moved to a new Web server entirely.

### The host computer refuses your request

If you get this error message, it may mean that the site's Web server is overloaded with too many requests. It might also mean that the Web itself is currently congested with a lot of online traffic. Try again later.

### Web page is taking too long to load

This is another recurring problem that is sometimes due to the design of the Web page. Web pages that contain a lot of graphics or large multimedia files take some time to download to your computer. Since you have no control over the design of the page, your solutions are limited. If you wish, you can set your browser to disregard any images when loading Web pages. The problem, however, may lie with your modem, your ISP, or your computer. If you are using a 56 KB modem to connect to the Internet, you are at the mercy of Web designers who create sites that require a high-speed broadband connection. Also, smaller ISPs and some school district servers are unable to handle the large amount of Internet traffic that often occurs during school hours.

If you go online during peak hours, the time it takes to download Web pages may become dreadfully slow. Still another possible reason for a slow-loading Web page is that the computer you are using is outdated. Older computers generally lack the power or speed necessary to handle the multidimensional nature of the Web today. If you spend a lot of time on the Web at home or in your classroom, it may make sense to invest in a new computer or a faster Internet connection. Otherwise, you simply have to wait for slow pages to download.

## Annoying pop-up advertisements appear

With a huge part of the Web being commercially oriented today, you are likely to encounter this problem often. Newer versions of Web browsers allow you to control (either allow or suppress) pop-ups and pop-under ads through the Pop-up Window Controls preference panel. But, suppressing pop-ups may interfere with your ability to access some Web sites, which use pop-up windows to display content.

There are also several software programs available that will eliminate these pesky ads from appearing on your screen. For instance, WebWasher can be downloaded for educational use at no charge. FilterGate, another program that blocks pop-ups, is reasonably priced but is only available for Windows computers.

**Pop-up ad blocking software**

**FilterGate** (for Windows computers)
FilterGate
www.filtergate.com

**WebWasher**
Webwasher
www.webwasher.com

## A window appears saying you need a plug-in

If you are currently using an older Web browser, chances are you will encounter sites that require a plug-in or two to fully experience all they have to offer. Animation, video, sound, music, and interactivity are thriving on the Web today. These multimedia features greatly enhance the Web's potential as a teaching and learning tool. But older browsers are usually unable to handle these added dimensions.

Plug-ins* are small application programs that you can download freely from the Web and install on your computer to enhance the multimedia capabilities of your browser. Newer versions of Internet Explorer and Netscape Navigator come with most of the plug-ins required to access multimedia resources on the Web.

Table 3.2 on the next page lists several essential plug-ins and where to get them. Each plug-in listed is available for both Macintosh and Windows computers. Be sure to check the system requirements (usually indicated on the download page) for any plug-in before you download it, so you avoid installing a plug-in on your computer that will not function properly.

## Your browser keeps crashing

If you are using an older browser, try upgrading to the latest version. Another possible reason for frequent crashes is that you may have recently installed a plug-in that is incompatible with your browser. In this case, the plug-in will need to be uninstalled. If you are on a Macintosh computer, try increasing the memory allocated to the browser by clicking once on its icon and then selecting the Memory option under "Get Info" in the File pull-down menu on your desktop. This may resolve the problem.

---

\* The term *plug-ins* is used here to refer to all application programs that can be used to enhance your browser's capabilities.

| Plug-in and Source | Description |
|---|---|
| **Acrobat Reader**<br>Adobe Systems<br>www.adobe.com/products/acrobat | These two plug-ins add animation, music, and advanced interactivity to Web sites that support them. |
| **Cosmo Player**<br>Silicon Graphics<br>www.sgi.com/products/evaluation | This all-in-one player supports a number of multimedia technologies including Netshow, RealVideo/Audio, MPEG, and QuickTime files. |
| **Flash Player and Shockwave Player**<br>Macromedia<br>www.macromedia.com | This viewer is for applications written in Virtual Reality Modeling Language, currently the standard for 3-D Web content. |
| **QuickTime Player**<br>Apple Computer<br>www.apple.com/quicktime | This plug-in allows you to read Portable Document Format (PDF) files that preserve all of the fonts and graphics of the original source document. |
| **Windows Media Player**<br>Microsoft<br>www.microsoft.com/windows/mediaplayer | With this plug-in, you can experience QuickTime video clips, animation, audio clips, and virtual reality objects on the Web. |

**Table 3.2** Recommended plug-ins

It was its capacity to display various media types (not just text) that catapulted the Web into public awareness.
• **David Thornburg (1996)**

## Want a cookie with that Web page?

While you may consider your time on the Web as being spent in anonymity, it is not. One way information is collected on your Web activities is with "cookies." When a Web server delivers a page to your computer, it may place a small text file, or cookie, on your hard drive for future reference. This file contains user-specific information such as your username and type of computer. If you return to the same Web site, the server looks for the cookie and collects this information. In short, the cookie acts as your personal ID card and tells the Web server you are back.

Cookies serve many useful purposes on the Web. For instance, cookies are used to store usernames and passwords on Web sites requiring registration; thus, people do not have to register each time they revisit these sites. Cookies also allow Web users to personalize search engines and other online services. If you shop online or register a recently purchased product through a company's Web site, cookies are used in the process.

Should you be concerned about cookies? It depends. Cookies cannot cause any damage to your computer or hard drive. They cannot search for information on your hard drive or transmit computer viruses. Then again, some cookies track users' browsing habits. Furthermore, the storage of a cookie on a hard drive and access to it by a Web server goes undetected by the casual Web user.

If you are uneasy about being monitored while on the Web, you can tell your browser to not accept any cookies, or at least to alert you each time a cookie is offered. Both Internet Explorer and Netscape Navigator allow you to block all cookies offered, to monitor their placement on your hard drive, and to delete them from your system. However, if you do choose to block all cookies from your computer, some Web sites and online services will not be available to you.

Also, blocking cookies in your browser does not give you complete anonymity on the Web. It just makes it a little harder to identify you or track your activities on a Web site.

## What is spyware?

The term *spyware* refers to software placed on a computer surreptitiously to gather information about the user for later retrieval by whoever controls the spyware. Some marketing companies use these covert programs, also called adware, to track customers' browsing habits or online purchases and then send advertising tailored to their particular interests. Unlike cookies, which are simple text files, spyware are programs that run on your computer in the background, recording and reporting information about your online activities to a remote server. Although the information transmitted is usually harmless in nature, some spyware programs are capable of retrieving sensitive data such as e-mail addresses, keystrokes, passwords, social security numbers, and telephone numbers. If used maliciously, these programs can permit identity theft. At the very least, they constitute an invasion of privacy.

How does spyware get on a computer? They typically come attached to free software programs, games, utility programs, and screensavers that people download to their computers from the Web. Consequently, you want to think twice about taking advantage of any free offers you find on the Internet. If you suspect that you may have inadvertently downloaded spyware from the Web, you can use a spyware detection program like Ad-Aware or MacScan to see if you have any such programs and remove them from your computer.

**Spyware detection software**

**Ad-Aware**
Lavasoft
www.lavasoft.de

**macScan**
SecureMac
macscan.securemac.com

## Conclusion

Knowing how the Web works can help you to make more effective use of it as a teaching and learning tool in the classroom. In essence, the Web is a vast collection of interconnected pages of information that are stored on computers around the globe. The most important feature of the Web—hypertext—makes it possible to combine text, graphics, animation, audio, and video into a single Web page and to link to other Web pages anywhere in the world.

The decentralized nature of the Web encourages non-linear, constructivist learning, and exploration of ideas. It allows students to choose their own paths through material and to probe a subject from different points of view. The challenge for teachers is to provide enough guidance and a learning structure so that students are able to discover things on their own without getting lost, and to build appropriate conceptual links between information from different sources. The project and lesson ideas described later in this book show how you can structure students' online activities to promote this type of inquiry.

## Useful Web sites

### Basic Internet Explorer Tutorial

www.newbie.net/internet_explore

This site will help you learn and understand the basic operations and functions of Internet Explorer.

### Browser Central—Netscape

browsers.netscape.com/browsers/using/main.tmpl

This site offers a collection of tutorials, tips, and answers to FAQs on using Netscape's 6.0 browser.

### IE5 in the Classroom

www.actden.com/ie5

This tutorial is designed to show K–12 teachers how to use Internet Explorer 5.0 in the classroom.

### W3C Web Accessibility Initiative (WAI)

www.w3.org/WAI

This site offers a collection of links to information and technology resources involving alternative browsing methods for people with disabilities.

### World Wide Web Consortium (W3C)

www.w3.org

W3C was created in 1994 to promote the growth of the World Wide Web by developing technical specifications and reference software that will be freely available to everyone.

# Finding a Needle in a Virtual Haystack

## CHAPTER 4

Internet information seems to be standing on shifting sand—now you see it, now you don't.

• **Lois Swan Jones (1999)**

A key to using the Internet as an educational tool is learning how to find useful information on the World Wide Web. While just poking around the Web can lead to interesting discoveries, it is not the most productive or efficient way to locate the information you need for classroom or personal use. Moreover, allowing your students to roam aimlessly on the Web consumes valuable classroom time and raises the possibility that they will access inappropriate or offensive materials along the way.

Fortunately, there are a number of online search tools to assist you and your students in finding relevant information on the Web. This chapter will help you to understand how online search tools work, some of their benefits and limitations, as well as how to more effectively use them to conduct online research. It also calls attention to the importance of evaluating the quality of information you find on the Web and provides a list of criteria for making informed judgments.

## All search tools are not alike

If you have already had some experience using different online search tools, you've probably discovered they produce mixed results. One search tool might turn up only a few potentially relevant Web sites to your query, whereas another might generate a lengthy list of Web pages, including anything even remotely related to your topic. Why? One reason may be a faulty search strategy. Another reason may lie with the search tool you are using.

There are two major categories of online search tools, including search engines and Web directories. Knowing how search tools operate and when to use a search engine as opposed to a Web directory can maximize the potential of your online searches and help you to avoid poor search results.

### Search engines

Search engines use "spiders" (sometimes called "crawlers" or "bots") to scour the Web on a regular basis for URLs, page titles, text, links, and other data that is used in responding to keyword searches. This

information is automatically indexed according to the words contained in the file and then stored in the search engine's database.

One of the problems with using these autonomous programs to locate relevant content on the Web is that they do not distinguish between, say: Leonardo da Vinci, the artist; Leonardo Fibonacci, the mathematician; Leonardo DiCaprio, the actor; and Leonardo, New Jersey. Thus, conducting a simple keyword search on a search engine like AltaVista Search or HotBot can produce an endless list of Web pages containing the word *Leonardo*.

Then there are the meta-search engines like Dogpile, Mamma.com, MetaCrawler, and Vivísimo that submit your request to multiple search engines simultaneously and then automatically assemble, filter, and report their results. Meta-search engines have no internal databases of their own; rather, they depend on the contents and reliability of other search engines.

Search engines are becoming increasingly more sophisticated in their features and in how they report results. For example, after you post an initial query, some search engines offer a "related searches" option that provides a number of associated terms and phrases to click on and launch a new search. Search engines like Google Search and Teoma Search use "popularity" techniques to rank search results; consequently, you are more likely to find pages that are useful to your research. Some newer search engines like AlltheWeb use a "clustering" technique to group diverse results by topics, making it easier to locate relevant material and refine your search further. For those who get frustrated with keyword search procedures, Ask Jeeves allows you to submit your search requests in the form of questions.

Due to advances in search technologies, finding images and multimedia files on the Web is now much easier with a number of search engines dedicated to this task, including All the Web, Ditto, and Google Image Search. The Amazing Picture Machine offers access to a wide range of selected images on the Web, suitable for classroom use.

**Search engines**

**AlltheWeb**
www.alltheweb.com

**AltaVista Search**
www.altavista.com

**Ask Jeeves**
www.ask.com

**Dogpile**
www.dogpile.com

**Google Search**
www.google.com

**HotBot**
www.hotbot.com

**Mamma.com**
www.mamma.com

**MetaCrawler**
www.metacrawler.com

**Teoma**
www.teoma.com

**Vivísimo**
vivisimo.com

**Image search engines**

**All the Web**
multimedia.alltheweb.com

**Amazing Picture Machine**
www.ncrtec.org/picture.htm

**Ditto**
www.ditto.com

**Google Image Search**
images.google.com

## Web directories

Web directories contain databases of Web sites and pages grouped according to broad topic categories and, in some cases, specific subcategories. The chief advantage of Web directories is their user-friendliness. They are menu-driven, and users are often able to locate relevant topical information with just a few clicks.

Web directories are managed by teams of specialists who evaluate the merit of the sites submitted by Web site owners to determine if and where to list them in their databases. Your chances of finding useful information on a topic of general interest through a Web directory are greater than with a search engine. On the other hand, Web directories are typically narrow in terms of the focus and the scope of their listings, which consist primarily of popular subject matter. They cover a much smaller percentage of the Web than search engines and may not include recent Web sites or pages in an area.

The most widely used Web directory is Yahoo! Other popular Web directories include About.com, the Internet Public Library, LookSmart, and the dmoz Open Directory Project (Figure 4.1).

**Figure 4.1** The Open Directory Project is maintained by a global community of volunteer editors.

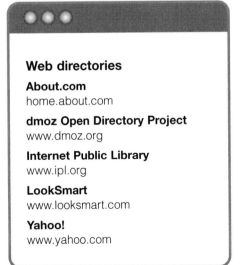

### Web directories

**About.com**
home.about.com

**dmoz Open Directory Project**
www.dmoz.org

**Internet Public Library**
www.ipl.org

**LookSmart**
www.looksmart.com

**Yahoo!**
www.yahoo.com

## Comparing apples and oranges

Search engines and Web directories share certain similarities, including

- **Users are able to conveniently search a large database**. Search engines and directories both allow users to browse a large amount of information stored in their databases in a reasonable amount of time.
- **Both provide similar search options**. Most search engines and directories offer similar "basic search" and "advanced search" options. Some include additional options such as "related searches" or "search within" features.
- **Their coverage of the Web is limited**. While search engines and directories allow a large amount of online material to be conveniently searched, they both encompass only a small fraction of what is actually on the Web today. Most search engines are unable to index multimedia resources or files stored in the "Deep Web," which consists of online databases and password-protected sites. Search engines also generally exclude Web pages that are not linked to other pages. Similarly, Web directories typically limit their listings to sites that have been submitted by the owners and that have been reviewed by staff members.
- **Both turn up dead links**. Given the constantly changing nature of the Web, it is not unusual to find links in search engines and directories to pages that have been moved or removed on the Web.

For many Web users, the distinction between search engines and directories is a fuzzy one. This is understandable given that many search engines now provide directories that allow for browsing the links in their databases by topics. Alternatively, most Web directories offer a keyword search option, a feature more commonly associated with search engines. Further blurring the boundaries is the fact that many of the major online search companies have formed alliances that make their databases and services available to users on each other's sites. Still, it is important to understand how these two types of search tools—search engines and directories—differ, especially with regard to using them to conduct classroom research.

The primary difference between search engines and directories is in how they acquire the information stored in their databases. Search engines retrieve information automatically (and pretty much indiscriminately) from the Web, whereas specialists review and select the sites included in Web directories. Hence, it is important to remember when using online search tools in the classroom that

- **Search engines do not censor information**. An innocent keyword search on an unfiltered search engine might turn up inappropriate or offensive material. Although the major sites are typically unfiltered, many offer a filtered, or "safe search," option that removes potentially objectionable material from search results.
- **Web directories focus on topics of general interest**. Because of the editorial process employed, directories typically offer better quality of content and fewer irrelevant results than do search engines; however, they are not always the best place to start in locating harder-to-find information.

## What is a Web portal?

Web portals offer one-point access to a broad range of online services such as a search engine, a directory of links organized by content areas, up-to date news items, shopping, e-mail, a chat board, spe-

cial interest discussion groups, and other features, depending on the nature and size of the intended audience. Some portals offer these services at no charge, whereas others require paying a modest monthly fee. While portals provide an excellent starting point for exploring and using the Internet, they are designed to give users a managed online experience that more often than not serves commercial interests. Popular Web portals include AOL, MSN, and Yahoo!

**Web portals**

**America Online (AOL)**
www.aol.com

**MSN.com**
www.msn.com

**Yahoo!**
www.yahoo.com

## Kid-friendly search tools

A major concern surrounding use of the Internet in classrooms involves the possibility of students accessing inappropriate materials on the Web. While no filtering system is absolutely foolproof, the search tools listed in Table 4.1 below restrict access to unsuitable Web content or limit their listings to Web sites that contain kid-friendly information.

| Search Tool and URL | Description |
|---|---|
| **Ask Jeeves for Kids**<br>www.ajkids.com | This search engine lets kids look for online information by asking questions. |
| **Awesome Library**<br>www.awesomelibrary.org | This K–12 directory contains over 22,000 carefully reviewed Web resources. |
| **Berit's Best Sites**<br>www.beritsbest.com | This Web directory is intended for children up to age 12. |
| **CyberSleuth-Kids**<br>cybersleuth-kids.com | This K–12 Web search guide is managed by volunteer educators. |
| **FirstGov for Kids**<br>www.kids.gov | This is the U.S. government's gateway to the Web for kids. |
| **Kids Click!**<br>sunsite.berkeley.edu/KidsClick! | This site, created by librarians, provides links to valuable and age-appropriate Web sites (Figure 4.2). |
| **Kids Space**<br>www.ipl.org/div/kidspace | This is a search engine and Web guide for kids from the Internet Public Library. |
| **Yahooligans!**<br>www.yahooligans.com | This directory for young surfers also offers an excellent teachers' guide. |

**Table 4.1** Kid-friendly search tools

**Figure 4.2** KidsClick! was created by librarians to guide young users to valuable and age-appropriate Web sites.

Many of us are tempted to run an Internet search, look at the first screen results, and assume we've seen the best the Internet has to offer on our topic.
• **Paul Gilster (1997)**

# How to make your Web searches more productive

What is the best way to search for information on the Web? It depends, of course, on what you are seeking. The following seven tips offer general guidelines for conducting online searches that will produce relevant results more often than not.

## Frame your research

Good researchers in any field understand the importance of focusing their investigations before they begin. This practice is vital when conducting online research. With such a vast amount of information readily available through the Web, it is easy to become sidetracked exploring various Web sites of peripheral interest to your topic. Starting your search by identifying a key question (or questions) such as "Who were the leaders of the Impressionist movement?" and staying focused on finding answers to that question(s) is a good habit for both you and your students to practice.

## Get to know your tools

Test out different search engines and directories and learn how to use their advanced search options. Try using the same keywords in a number of different search tools to compare their features and results. Most offer online help, answers to Frequently Asked Questions (FAQs), or tips on how to conduct searches with their service. Read this information to find out if their searches support the use of Boolean terms (and, or, not, and near), if they are case sensitive, if they support the use of "+" or "−" to filter results, or

if the use of quotes around your query terms will only return documents that have those words in the specific order given. Rules for conducting searches vary somewhat from tool to tool. Once you find one or two search tools that give you good results, be sure to bookmark them in your Web browser for future use.

## Choose the right tool for the job

A general rule is that if you are looking for information of common interest (e.g., art museums, art periods and movements, or famous artists), begin your search on a Web directory; whereas, if you are looking for specific information (e.g., a school or person's Web site; a particular work by an artist; an art textbook; instructions for Japanese bookbinding; or a particular Web site), consult a search engine first.

Moreover, if you are looking for online information in a specific field of study, a search tool devoted to that subject is often the best place to begin your research. The chief advantage of using these specialized search tools is that experts within the particular field manage them, and their listings include resources that have been reviewed for content validity. (See Table 4.2 on the next page for a list of specialized search tools in the field of education.)

I find that it is both a curse and a blessing to have access to such a vast array of information.
• **Bonnie Halsey-Dutton (2002)**

## Start broad, and then narrow your search

Suppose that you are searching the Web for information on Claude Monet. Starting at the Yahoo! homepage, you would select the "Arts and Humanities" category, click on "Art History," then "Artists," and lastly "Claude Monet." You end up with seventeen Web sites dedicated to Monet.

Applying a similar approach on a search engine, suppose you are looking for art lesson plans on the Web. Starting at the Google Search homepage, you type "art lesson plans" into the search box, click on "search," and end up with about 659,000 hits. You might start browsing these results for useful material—a daunting task to say the least. Or, you could be more descriptive about what you are seeking.

Let's say you only want to see lesson plans based on the work of Monet. Using the "search within results" option on Google Search, you type in "Monet," click on "search," and you eliminate 655,440 items from the original search results and end up with some 3,560 possible sources.

Continuing to restrict your search further, you use the "search within results" option again and add "middle school" to the list of key words. You end up with some 1,470 hits. Next, you add "watercolor" to your "search within" parameters and wind up with 161 possible sources. Finally, let's say you want to see which of these lesson plans include an assessment rubric. Adding "rubric" to the search leaves you with 12 possible sources for lessons.

| Search Tool and URL | Description |
|---|---|
| **The Educator's Reference Desk** <br> www.eduref.org | This site includes over 3,000 resources on a variety of educational subjects and issues. |
| **Blue Web'N** <br> www.kn.pacbell.com/wired/bluewebn | This is a searchable database and directory of over 1,700 educational Web sites. |
| **EDSITEment** <br> edsitement.neh.gov | This is a searchable database of online educational resources in the Humanities. |
| **Education World** <br> www.education-world.com | This portal includes a topical guide to more than 500,000 education-related resources, Web site reviews, and much more. |
| **Federal Resources for Educational Excellence** (The Arts) <br> www.ed.gov/free/s-arts.html | This site offers an extensive collection of links to online governmental resources that support arts education (Figure 4.3). |
| **Gateway to Educational Materials** <br> www.thegateway.org | This site is designed to assist teachers in finding lesson ideas and instructional resources on U.S. governmental Web sites. |
| **Kathy Schrock's Guide for Educators** <br> school.discovery.com/schrockguide | This site provides links to over 1,600 handpicked online educational resources. |
| **SearchEdu.com** <br> www.searchedu.com | This site offers a searchable database of over 15 million educational resources ranked in order of popularity. |

**Table 4.2** Specialized search tools in education

## Be precise

When you know exactly what you are looking for, using more descriptive query terms will lead to better search results. For example, when searching for information about acrylic painting, enter the search terms "acrylic painting" rather than "acrylic" or "painting." Also, avoid using popular terms such as "art education" that may produce too much irrelevant material. Instead, a phrase like "elementary art lessons" or "high school art curriculum" is likely to return fewer and more pertinent results.

**Tip**

You can locate keyword(s) or phrase(s) within a Web document using the Find command in the Edit menu of your browser.

**Figure 4.3** FREE consists of links to online educational resources developed by U.S. governmental offices and agencies, grouped according to subject matter.

## Cast a wide net

When your research calls for a comprehensive study of a topic, combine multiple search engines to increase Web coverage. In this situation, using a meta-search engine is a good place to start. For example, entering the query terms "Early 20th Century Art" on Dogpile turns up thirty-six hits combined from five different search engines.

## Ask someone

Keep in mind that the best resource available on the Internet is other people. If you belong to an art teachers' discussion group or exchange e-mail with other art teachers, these individuals can often be of great assistance in locating relevant online art resources and other materials on a specific topic of mutual interest.

## Try This: Practice your online research skills

**Directions:** Using two or more of the online search tools listed in this chapter, conduct a search of the Web on an art-related topic that interests you. Try to incorporate some of the previously discussed tips into your research.

### Suggested Topics and Questions

Pinhole Photography
- How can I make a pinhole camera?
- Where can I see pinhole images on the Web?

Art Movements
- Which artists' works were included in the first Impressionist exhibition?
- What did art critics have to say about this exhibit?

Net Art
- How are artists using the Internet in their work today?
- What have critics written about Net art?

Deborah Butterfield
- How does Butterfield create her horse sculptures?
- What have art critics written about Butterfield's work?

Current Art Exhibitions
- What exhibitions are currently on view in Chicago?
- Where can I see work by Vincent van Gogh?

Public Art
- How does the U.S. government support public art?
- What public art can I see if I go to New York City?

### Document Your Search

Make notes about such things as which search tools you used, the number of hits returned with each tool and query, and the title and location of any relevant sites you retrieved. Compare the results you get back with each search tool. When reflecting on the success of your search efforts, consider the following questions:

1. How easy or difficult was it to frame your search?
2. What keywords and phrases did you use in your search?
3. How helpful was the online assistance available on the search site?
4. How many results did you get with each query and search tool?
5. What proportion of the results were pertinent or useful to you?
6. What features added to, or detracted from, the search tool's effectiveness for you?

## Becoming Web savvy

Given that the Web makes it possible to travel around the globe in an instant and visit world-class museums, libraries, universities, famous landmarks, and the like without ever leaving your classroom or home, it is understandable why people become so enamored with the technology. When you add to its global reach, its immediacy and richly diverse digital resources, and its elements of video, audio, animation, and interactivity, the Web is undeniably a medium that offers tantalizing and unprecedented capabilities as an informational resource. Still, we must not be so easily smitten with its appearances.

Whether you are browsing, searching, or just poking around the Web, it is important to keep in mind that just about anyone can publish material on it. And, indeed, just about everyone is doing so—from grade school children to university professors, from political extremists to Nobel laureates. Furthermore, there is no editorial policy, peer-review process, or screening mechanism in place to ensure the quality or accuracy of much of what is placed on the Web. Thus, the old axiom of "user beware" is vital to remember when you are on the Web. Not only must we learn to find information on the Web, we must also learn to be Web savvy.

Becoming Web savvy takes effort and thought. It requires exercising critical thinking in decoding and judging the worth of any digital information found on the Internet. In practice, this means questioning anything you find online.

> ● ● ●
>
> The network will never do our thinking for us—for which we should be thankful.
> • **Paul Lévy (2001)**

Here are seven key questions to guide you in your Web excursions.

1. **Who created this site or page?** How credible is the author? When assessing the worth of any information, one must first consider the credibility of the source. However, identifying the author of a Web site or page and his or her qualifications is sometimes no easy task. Typically, this information can be found by clicking on the "About Us" link on a Web site's homepage. If adequate information about the author is not readily available, you may have to dig deeper into the site or search the Web for other documents that the author has published. Otherwise, you should continue your appraisal of any information provided with a healthy degree of skepticism.

2. **Why is this information posted on the Web?** What are the purposes or goals of this Web site? What underlying interests, biases, or motives of the author are evident? What does the author have to gain by publishing this material on the Web? Many Web authors offer a mission or goal statement that may provide insight into their motives or the purpose of their sites. Another way to determine a Web author's intentions is to examine the domain name where the site is being stored. For instance, if a Web site is a "dot com" that is maintained by a commercial business, you can bet they are trying to promote their products or sell you something.

3. **What is the relative value of the content provided?** How reliable or accurate is it? How comprehensive is it? How accessible is it? How relevant is it? How useful is it? How dated is it? Knowing who published the material

71

on a Web site or page is certainly helpful in assessing its worth. For example, information posted by a high school or college student for a classroom assignment may not be as reliable as information provided by a museum or library. As David Warlick (1999) points out, questions regarding the reliability or correctness of information must also be considered in context. What is perceived as truth in one culture may not be so in another culture. Likewise, what is "true" today may not be so tomorrow. Warlick further suggests that any evaluation of information found on the Web (or elsewhere for that matter) must take into consideration how it will be used. This means not only looking at the information itself and its source, but also at the reason(s) that brought you to the information in the first place and what you hope to accomplish by using it.

4. **Who is the intended audience?** Is the content directed at a specific group or a broad audience? How inclusive is the site's content with respect to a global audience? There is no doubt that many Web sites are clearly intended for specific audiences. Still, given the global nature of the Web, it is important to consider the inclusiveness of the material being presented on a site—especially one with an educational mission or goal. Web sites that reflect different cultural and ethnic groups in the examples given, that are accessible using the most basic personal computing power, and that offer alternative ways of accessing and viewing the material presented will appeal to a broader audience.

5. **How does the design of the site influence your experience?** When you first arrive at the site, how easily are you able to determine what it is about, its purpose, or what you will find there? How easy is it to navigate through the site? How easy it is to find what you are looking for? Is there a site map? Do you end up at dead ends or at "dead" links? Do screens pop up unexpectedly? Do pages download relatively quickly? Are the pages well designed or are they too busy with no clear hierarchy? Is the text easy to read? Is the information presented in a well-organized, digestible form? Are graphics or images used effectively? Is the site design consistent throughout? The bottom line here is to make some assessment of the user-friendliness of the site and the relationship between form and content.

6. **How effectively does the site utilize the Web for information delivery?** Are interactive or multimedia elements present and used appropriately? Are you a passive or an active viewer on the site? To what extent did the site designers take into consideration the interconnectedness of the Web by offering links to related sites? How recently has the site been updated? Could the information on the site be presented just as easily in print media or does the site offer something more? Interactive elements on a Web site may range from the ability to contact the author via e-mail to the use of chat rooms for online discussions; from tutorials and activities that actively engage viewers to ways for viewers to themselves contribute content to the site. Multimedia elements such as video, audio, and animation can further enhance the viewer's understanding of the content presented, but only if they are used effectively. Too often the desire to be on the cutting edge leads Web designers to neglect intelligent informational design for the sake of the latest bells and whistles.

**7. Would you recommend this site to others?** Why or why not? What are the positive and negative aspects of this site? Once you have been through the site and considered all its features, it is time to determine whether this is a site you want to return to and whether it is worth sharing with others.

## Teaching students to become Web savvy

The Web is a great place to publish and find information on a wide range of topics. Nonetheless, given its lack of quality control, those of us who traverse the Web regularly need to be cautious and savvy in how we interpret and make use of the digital information found there. As educators, developing these critical habits in youngsters (as well as in ourselves) is perhaps our greatest challenge in the information age.

With more and more classrooms going online, all teachers have an important responsibility in helping students become critical consumers of information. This obligation cannot be met in just one lesson, nor should it be assigned solely to the school's media specialist or librarian. It is a process applicable to all subjects and should be taught on an ongoing basis.

As the Web become an integral part of learning activities in your classroom, it becomes necessary to teach your students to

- determine the credibility of the source of any information they find online;
- distinguish between facts and opinions;
- differentiate between relevant and irrelevant information;
- judge the worth of information they find on the Web in terms of its intended use;
- discriminate between good and bad information design;
- recognize when they need to continue searching for information;
- understand the importance of consulting both print and electronic resources; and
- cite the sources of any information they use in school projects and reports.

Acquiring these skills will enable your students to analyze and use information wisely, which is an essential part of becoming productive and effective citizens in today's information-saturated world.

## Conclusion

The Web has become a primary source of information for many people. A 2003 survey by Search Engine Watch found that over 62 million searches were being performed on the major Web search engines each day (Sullivan, 2003). Clearly, searching the Web is not only a popular activity but also a fundamental skill in our information-driven society. The skills and abilities required to find information on the Web have become essential. These include the ability to use search tools, knowledge of search strategies, plus the ability to evaluate and organize information from different sources.

## Useful Web sites

### Bare Bones 101

www.sc.edu/beaufort/library/pages/bones/bones.shtml

This site includes twenty simple lessons that cover just about everything you need to know about searching the Web.

### Checklist of Internet Research Tips

library.albany.edu/internet/checklist.html

Included on this site are twenty excellent tips on using directories, search engines, and the "Deep Web" to locate online material.

### Critical Evaluation Surveys

by Kathy Schrock (2003)

school.discovery.com/schrockguide/eval.html

This site includes several survey instruments that students can use in evaluating Web sites.

### Evaluating Quality on the Net

by Hope N. Tillman (2003)

www.hopetillman.com/findqual.html

This theoretical discussion covers a range of topics related to evaluating the quality of information found on the Web.

### The Good, The Bad, & The Ugly

by Susan E. Beck (2002)

lib.nmsu.edu/instruction/eval.html

This site presents five criteria for evaluating Web sources with links to illustrative examples in addition to suggestions on offering Internet assignments.

### Search Engine Watch

searchenginewatch.com

This is the premiere site for news and information about search sites on the Internet.

### Spider's Apprentice

www.monash.com/spidap.html

This guide will help you to understand and use search engines.

### Webby Awards

www.webbyawards.com

The Webby Awards are the preeminent honors for Web sites—the "Oscars of the Internet." Winners are selected in over sixty categories that include the arts, education, and kids.

### WWW CyberGuides from CyberBee

www.cyberbee.com/guides.html

Three simple rating scales are provided for use in evaluating Web content and design.

# Online Professional Development for Art Teachers

## CHAPTER 5

## Meeting other art teachers online

Art teachers who go online no longer work in academic isolation. They soon discover that the Internet is a powerful vehicle for sharing information, developing creative solutions, and forming new friendships with other art teachers around the globe. Interpersonal communication is at the very core of the Internet—people sharing ideas and information with others.

Through e-mail correspondence, chat boards, online discussion groups, and Web logs, many art teachers exchange curriculum ideas, lesson plans, and instructional strategies. They also receive early notification of national and state developments in education, news from the world of art, and pending governmental legislation; get assistance with digital technologies; gain access to current educational research, grant opportunities, and other support services; and perhaps most importantly, share in the joys and pains of being art educators. If you are interested in meeting other art teachers online, consider joining one of the following discussion groups.

Professional development is the critical ingredient for effective use of technology in the classroom.

- **Web-Based Education Commission to the President and Congress of the United States (2000)**

This chapter profiles a number of online learning opportunities and resources that can assist art teachers in meeting their professional development goals. Areas of coverage include networking with colleagues and other art professionals from anywhere in the world, exploring Web sites and portals dedicated to helping all teachers in their work, plus locating useful online tutorials and courses on art, pedagogy, technology, and other pertinent topics.

## Art/Arts & Crafts

To join this mailring sponsored by Teachers.net, go to the Teacher Mailring Center and select the Art/Arts & Crafts box under "Subject Mailrings." Next, type your e-mail address into the box provided and click on "Subscribe." An e-mail message will be sent immediately to your mailbox asking you to confirm that you indeed want to subscribe to the mailring. Reply to this message as instructed and shortly thereafter you will receive a Welcome message with instructions for posting messages to the "art-teacher" list and for unsubscribing to the list if you choose to do so at a later date.

## ArtsEducators

This discussion group started up on Yahoo! Groups during the summer of 2001 when ArtsEdNet Talk went off-line for an extended period. Although much of the dialogue has since returned to the Getty's mailing list, ArtsEducators remains an active discussion group where members share ideas, lessons, and support for each other. To join this mailing list, you need to first register for a personal Yahoo! account. To do so:

1. Go to Yahoo! Groups.
2. Click on the "register" link for new users on the left side of the screen.
3. You will be prompted for information that will allow you to get a free Yahoo! ID and password.
4. Once you have completed your registration and submitted it, a confirmation notice will be sent to your e-mail mailbox.
5. You can now sign in under "Registered Users" on the Yahoo! Groups page with your new ID and password.
6. Type "ArtsEducators" into the search box under "Join a Group."
7. On the next page, click on "ArtsEducators" and then follow the instructions on joining the group and posting your own messages.

8. As with ArtsEdNet Talk, previous messages posted to ArtEducators are archived and available for viewing, but by members only.

## TeacherArtExchange

Previously called ArtsEdNet Talk, this popular online forum, sponsored by the J. Paul Getty Trust Foundation, has close to a thousand members from all over the world who regularly exchange ideas and information on a wide range of topics of mutual interest. To become a member of TeacherArtExchange, go to the Getty's Education Web page and click on "For Teachers" and then " TeacherArtExchange," where you will find instructions on joining the mailing list as well as the TeacherArtExchange archives, which contain a wealth of practical information on contemporary art education practices.

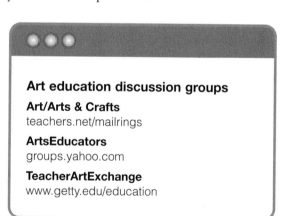

**Art education discussion groups**

**Art/Arts & Crafts**
teachers.net/mailrings

**ArtsEducators**
groups.yahoo.com

**TeacherArtExchange**
www.getty.edu/education

**Tip**
Browsing a mailing list's archives is a good way to discover whether the discussion will be of interest to you.

## Meeting other art professionals online

In addition to online discussion groups devoted to art education, there are hundreds of mailing lists and online forums on such art-related topics as aesthetics, animation, art criticism, art history, book arts, ceramic arts, computer graphics, design, photography, and postmodernism. Joining one of these groups offers the opportunity to interact with other art professionals and to stay informed of trends and issues in the world of art. Following are a few of the more popular art-related mailing lists on the Internet today.

### Aesthetics-L

Aesthetics-L is an online forum for the exchange of ideas and information about aesthetics and art philosophy. Discussion topics include aesthetics issues, requests for information, aesthetics news, and more. You can join this list using the fill-in-the-blank subscription form available on the Aesthetics Online Web site, which also provides access to the Aesthetics-L archives.

### Artcrit

Artcrit is an online discussion group, created in 1990, open to anyone interested in the visual arts. Topics reflect the diversity of contemporary art critical discourse: postmodernism, Marxism, feminism, curatorial practices, funding, or any issue that affects artists, critics, and art viewers. To subscribe to this mailing list, send an e-mail message to the listserver at listserv@yorku.ca and

1. Leave the subject line blank.
2. Type a one-line message reading: Subscribe Artcrit <Your First and Last Name> (e.g., Subscribe Artcrit Pablo Picasso)

Shortly after sending your message, you will receive a confirmation notice from the listserver. Store this message on your computer for future reference as it will tell you the mailing list address that you will use to post messages to the group, as well as how to unsubscribe from the list.

### Book_Arts-L

Book_Arts-L has been online since 1994 and boasts over fifteen hundred subscribers worldwide, among them practicing bookbinders, illustrators, marblers, papermakers, printers, collectors, curators in libraries, educators, and people just interested in the field. Instructions for joining Book_Arts-L can be found on the Book Arts Web site, where you can also browse the list's archives dating back to 1994.

### Clayart

Clayart is an online discussion group sponsored by the American Ceramic Society, that is intended for potters, sculptors, and ceramics enthusiasts. Founded in 1993, this mailing list includes thousands of subscribers and has become known as the "electronic voice of potters worldwide." To subscribe to Clayart, go to the American Ceramic Society Web site, click on "Ceramic Arts" and then "Clayart" where you will find instructions on using the list, a fill-in-the-blank subscription screen, and a searchable archive of previous messages posted to the list dating back to 1996.

---

**Art discussion groups**

**Aesthetics-L**
www.aesthetics-online.org

**Artcrit**
listserv@yorku.ca

**Book_Arts-L**
palimpsest.stanford.edu/byform/mailing-lists/bookarts

**Clayart**
www.ceramics.org

## Web sites and portals for teachers

A number of Web sites and portals have been designed to boost communication and professional development among teachers working in all subject areas. These sites offer a range of online services such as discussion groups, chat boards, courses, workshops, self-guided tutorials, virtual events, guest speakers, newsletters, Web links, and more. Four noteworthy sites worth exploring are the Knowledge Loom, Tapped In, Teachers Network, and TeAch-nology.com.

### The Knowledge Loom

knowledgeloom.org

The Knowledge Loom, developed by the Northeast and Islands Regional Educational Laboratory at Brown University, is a Web-based community of researchers and educators who come together to exchange news, ideas, and information on the best practices in teaching and learning. The site features research summaries, articles, case studies, print references, discussion boards, links to other sites, and more on a variety of themes related to school reform and effective classroom practices. Teachers who register on the site, at no charge, can utilize the Knowledge Loom's interactive features to add their own stories and re-sources, pose questions and get answers from experts, and participate in online events and discussions.

Art educators will find the Teaching for Artistic Behavior (TAB) area of the Knowledge Loom of particular interest. TAB is a nationally recognized, choice-based approach to art education that allows students to experience the work of the artist through teaching that is responsive to their individual needs and interests. For more information on the theory and practice of TAB, visit the Knowledge Loom Web site.

## A member of the Teaching for Artistic Behavior Partnership shares her thoughts . . .

In the Fall of 1998, the United States Department of Education assigned resources to the Northeast and Islands Regional Educational Laboratory at Brown University to develop a "sustainable, customer-driven, distributed repository/ database of information on best practices in teaching and learning." After talking to many educators, we realized that a "repository" was not enough. Our vision was the Knowledge Loom—a comprehensive electronic environment that moves from information delivery to information creation, from data to people, from a learning library to a learning community.

One of the areas featured on the Knowledge Loom is an art teaching concept called Teaching for Artistic Behavior (TAB). This student-centered, choice-based philosophy has proven successful in a number of K–12 classrooms, but falls outside the mainstream of national art education practices. Our goal in putting this curriculum model online is to connect with other teachers across the country who are teaching in this manner. When the Knowledge Loom asked us to create content for visual arts, we were pleased and ready. The content emerged from a graduate course at the Massachusetts College of Art. Students wrote research summaries and collected stories of actual classroom practice. The best practices we identified were refined and clarified in the setting of this course.

The TAB site is interactive, and when teachers visit they can post questions to an "expert," which are answered via e-mail. Visitors to the site can also add their stories and opinions on a panel discussion. We are able to follow up these responses with e-mail.

Our group makes presentations at many regional and national conferences. The TAB/Knowledge Loom site allows us to refer attendees wanting more information. Teachers who are beginning to teach in this student-centered manner use the Knowledge Loom to reassure their supervisors that this concept of teaching has a large research base and a record of success in other schools.

Through the Knowledge Loom, our listserv, and Web log, we have connected with many art educators who have joined our TAB community. We mentor each other through postings and e-mail and feel that the isolation experienced by art teachers is mitigated in this virtual community. We welcome your participation.

Katherine Douglas
Elementary Art Teacher, Central School
East Bridgewater, Massachusetts

## Tapped In 2.0

ti2.sri.com/tappedin

SRI International developed Tapped In, short for Teacher Professional Development Institute, to support the international education community.[1] As mentioned in Chapter 2, Tapped In uses a "campus" metaphor to organize online tools, groups, and activities. Among the many features of this Web-based community environment are:

- A **Reception Area** where members can find a calendar of upcoming events, news items, passageways to other areas of Tapped In, and a helpful staff member or volunteer on duty each day from approximately 8 a.m. to 8 p.m. (PST) to offer newcomers assistance.
- **After School Online (ASO)** where members and guests have the opportunity to interact with speakers and to participate in professional development seminars and workshops. The ASO event calendar provides a monthly schedule of online activities held in this area.
- **Conference Rooms** and a **Lounge** area where members can hold meetings, participate in scheduled events, plan collaborative projects together, or simply chat with one another.
- **Personal offices** where members can meet privately with colleagues, guests, or students.
- **Group rooms** are available for study groups, scheduled meetings, and planning sessions.

In addition to these and other features, Tapped In provides a number of support tools to facilitate communication and collaborative work among its members, including text-based chat, threaded discussion boards, virtual white boards, file sharing, link sharing, sticky notes for posting messages, automatic transcript recorders, and bulletin boards (Figure 5.1).

Through Tapped In, you can plan and conduct online learning projects with colleagues and students in other schools, participate in or lead topical discussions, attend online courses and workshops, mentor other educators, and try out new ideas and tools in a safe and supportive environment. In addition to covering subjects of general interest to teachers, recent discussions have included such art-related topics as "Arts and Literacy," "Integrating Art Across the Curriculum," and "Multimedia in the Art Curriculum." You can also participate with your students in online collaborative projects such as the ongoing Blanket the World with Peace project, which is being sponsored by Tapped In and the Electronic Media Internet Group (EMIG) of the National Art Education Association.

Tapped In membership is free to all educators, education researchers, and preservice education students. Orientation sessions for new members are regularly presented on the site. To become a member, fill out and submit the membership form available on the Tapped In Web site. Visitors can explore the site by clicking on the "Guest Login" button on the Tapped In homepage.

The Me tab gives you quick access to personal information such as your favorite places, links, notes, and files.

The Tapped In tab offers a directory of people, places, and groups in the larger Tapped In community.

The Help tab offers information and tutorials on all topics related to using Tapped In.

The Search tab enables you to quickly find people, places, groups, files, and links at Tapped In.

Shows the room you are currently in.

Click Logout to leave Tapped In.

A pull-down menu that gives you quick access to all your favorite rooms in Tapped In

Menu showing the different areas of the room (e.g. Whiteboard)

Passageways to other places in Tapped In

What you and others say appears in this box.

A list of people currently in the same room

To join a conversation, click in this box, type your message and press Return.

**Figure 5.1** An overview of the Tapped In interface

**A Pennsylvania art teacher shares her thoughts on being a member of the Tapped In community . . .**

Many art teachers feel isolated in their classrooms or lead a nomadic "art on a cart" life where they are unable to put down roots. Not only does Tapped In provide an opportunity for art teachers to collaborate with other art specialists, it also enables them to work with teachers in other disciplines to design cross/interdisciplinary lessons and projects for their students.

As a leader of the "Art and Literacy" monthly discussions on Tapped In, I have been able to interact with science, reading, math, and social studies teachers and enjoy seeing how art and these subjects can complement one another. I know that art teachers have plenty to teach if they just focus on the elements and principles of art. But art teachers also have an opportunity to help students connect with all that is happening in the world around them and to help them learn how to use new tools to communicate their feelings, thoughts, ideas, viewpoints, and opinions.

I believe that in order for art teachers to be able to teach this ability to connect, they must be able to do so themselves. This is where I think the great strength lies in Tapped In—it lets you connect with other educators.

B.J. Berquist
Art Teacher, Loysville Youth Development Center
Loysville, Pennsylvania

## Teachers Network

teachersnetwork.org

Teachers Network is a nationwide, educational nonprofit organization that identifies, supports, and connects innovative teachers who exemplify professionalism and creativity within public school systems. The organization serves thirty national and international affiliates that have adopted one or more of their major program initiatives. More than 40,000 public school teachers have received Teachers Network grants and fellowships in the areas of curriculum, leadership, policy, and new media. The aim of Teachers Network is to support teachers in designing their own professional development, to document and disseminate the work of outstanding classroom teachers, and to help provide teachers with the knowledge and skills they need to become leaders in their classrooms and schools.

You can join the Teachers Network at no cost by completing the online registration form. Doing so gives you full access to the resources available on the site such as a searchable database of teacher-created lessons in all subject areas and several online bulletin boards, where members exchange messages on various topics.

Major program initiatives sponsored by Teachers Network include TeachNet, which provides onsite professional development training and continuing online support focusing on the production and dissemination of Web-based curriculum materials, and New Teachers Online, a related Web site, which offers beginning teachers access to how-to articles, lesson plans, videos, online survival courses, plus online mentoring by experienced teachers and experts who respond to questions sent in via e-mail or posted on the site's bulletin board.

*The Web Portal for Educators!*

**TeAch-nology—The art and science of teaching with technology**

teach-nology.com

Billed as "the Web portal for educators," TeAch-nology's mission is to help the educational community gain easy access to information relevant to the field, and to help teachers use technology to enhance their work with students. Among the many free services and resources that TeAch-nology offers are access to thousands of lesson plans and worksheets; online tutorials on technology in the classroom; links to reviewed Web sites; rubric, worksheet, and webquest generators; educational games; teaching tips; advice from expert teachers; and message boards. Additional tools and services are available to those teachers who sign up for membership, which requires a nominal yearly fee.

## Web logs

Web logs, or blogs for short, are a relatively recent development in online publishing, which allow people to publish a wide variety of content to the Web without having to learn HTML programming. Blogs are essentially online journals or diaries posted to the Web that feature periodic entries arranged chronologically by date, along with links to other blogs and Web sites. They are usually written in a conversational style and tend to reflect the author's personal point of view or opinion regarding a particular topic.

There are literally millions of blogs on the Internet, covering virtually every subject imaginable. Although the majority of blogs are written and maintained by individuals, there are also many group blogs in which multiple users contribute their thoughts and ideas to an ongoing discussion. Group blogs are similar to online discussion boards, in that both foster public discourse and a sense of community.

Most blogs are produced using special software that runs through a Web browser and provides various templates and options to choose from, making it easy to create and update a blog site within minutes. If you are interested in starting up your own blog, a number of companies offer free blogging software and hosting services via the Internet. Two of the most popular are Blogger and LiveJournal.

Blogs are great tools for disseminating information and promoting networking among art educators. They can also be used in the classroom to post assignments, to deliver content, and to connect with parents. For examples, see Kathy Douglas's Teaching for Artistic Behavior Web log on Blogger and the Art Education's Journal on LiveJournal.

**Web log Resources**

**Art Education's Journal**
www.livejournal.com/community/arted

**Blogger**
www.blogger.com

**LiveJournal**
www.livejournal.com

**Teaching for Artistic Behavior Web Log**
tabchoiceteaching.blogspot.com

## Online tutorials

The tutorial has proven to be a very popular format for delivering instructional content over the Internet. Tutorials typically consist of prepackaged lessons or exercises intended to communicate practical information or step-by-step instructions about a particular subject or tool to the learner. They are especially useful for hands-on training and for imparting basic information, but are less effective for presenting complex material where interaction with an instructor would be helpful.

Online tutorials come in many forms, from simple text-based lessons with visual illustrations to those that use multimedia features to present material in a more engaging manner. While most online tutorials are self-paced and freely available to any interested user, some are instructor-led and must be purchased by subscription.

For the busy art teacher, one of the chief advantages of online tutorials is that you can access the material at any time that is convenient for you, move through the lessons at your own pace, and return as needed. However, online tutorials require you to be a self-motivated learner in order to complete them. Furthermore, they seldom offer opportunities to interact with an instructor or with other learners.

An abundance of online tutorials are available today, covering a wide range of topics of interest to art teachers, from learning new art techniques to constructing rubrics, to using software application programs and creating a Web site. Here are some noteworthy examples.

### Adobe Studio

studio.adobe.com/us/tips/main.jsp

This area of the Adobe site offers step-by-step tutorials, in-depth video tutorials, a support knowledge base, fee-based training options, plus downloadable updates and plug-ins for all its major software products, including Acrobat, GoLive, Illustrator, InDesign, Pagemaker, and Photoshop software.

**Figure 5.2** Access Art offers a number of online visual arts workshops.

## Access Art

www.accessart.org.uk

Access Art offers a growing collection of engaging online visual arts workshops for teachers and students of all ages, covering such topics as drawing, sculpture, installation art, photography, color, and visual literacy (Figure 5.2). Each workshop is based on artist-led teaching that has taken place in schools, museums, and galleries. Downloadable teacher notes and other classroom handouts are included.

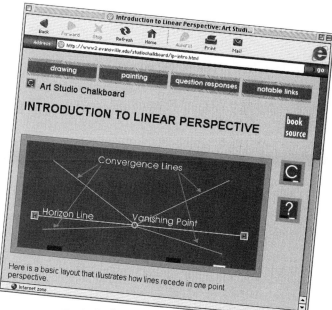

**Figure 5.3** The Art Studio Chalkboard Web site

## Art Studio Chalkboard

www2.evansville.edu/studiochalkboard

Ralph Larmann, an art professor at the University of Evansville, created this site as an instructional resource for artists and art students focusing on the fundamentals of perspective, shading, color, and painting (Figure 5.3). Illustrated lessons and definitions are provided on perspective, drawing grids, chiaroscuro, optical color mixing, stretching canvas, and related topics.

## Color Pencil Challenge

cpchallenge.com

Any teacher or student who uses colored pencils in the art room will likely find this site quite useful. It provides a number of tutorials, referred to as "color pencil challenges," covering a variety of tips and techniques. The site also includes a gallery of color-pencil artwork, a teacher's area that offers printable lessons on color-pencil basics, a discussion forum for registered users, and a collection of links to related Web resources.

## Funderstanding—Engaging Kids

www.funderstanding.com/engaging_kids.cfm

This site includes a collection of short tutorials on learning theories, education history, emotional intelligence, brain research, education reform, and more. Overall, this site offers a good introduction to the roots of our current education system and the many theories that are shaping classroom practices today.

## Make Movies

www.makemovies.co.uk

This site, from British animator Stan Hayward, is an exceptional resource for teachers and students who want to create their own animated movies. The site includes step-by-step, illustrated lessons on everything from the basic principles of flipbook animation, to scriptwriting and character development, to working with computers and other digital equipment in the production process.

## Pottery Tutorial—A Beginner's Guide to the Art of Ceramics

www.jhpottery.com/tutorial/tutorial.html

Ceramicist John Hester presents step-by-step illustrated tutorials that cover different hand-building and wheel-throwing ceramic techniques. The site also includes links to other ceramic resources, artist sites, and suppliers.

## Online courses

The joining of the Internet and education has spawned a myriad of alternatives to traditional forms of teacher inservice training and professional development (Clark, December 2000). Whether you are looking to deepen your subject-matter knowledge, expand your repertoire of teaching techniques, develop your technology skills, or meet your state's certification renewal requirements, you will find a smorgasbord of germane opportunities on the Internet today. In addition to the online course offerings of universities and colleges, a diverse assortment of Web-based courses tailored for working teachers are available through various nonprofit institutions (such as state or regional education agencies and consortiums) and through commercial providers seeking to stake out a market share in the rising field of e-learning.

Broadly speaking, *e-learning* refers to learning or training that involves any type of electronic media. The term is commonly used today to describe learning that occurs over a digital network—most notably, the Internet. There are two types of e-learning: *asynchronous* and *synchronous*. In asynchronous e-learning, students access prepackaged course materials on their own schedules, work at their own pace, and communicate with the instructor or other students through e-mail, discussion boards, file-sharing, listservs, or Web logs. In contrast, synchronous e-learning requires students and the instructor to participate in scheduled class events in "real time" and to interact with one another through audio or videoconferencing tools, chat boards, edMOOs, or two-way satellite broadcasts. Many online courses incorporate both synchronous and asynchronous components. Some may also include occasional face-to-face meetings.

> Just as earlier technologies changed education, so electronic technologies are changing teaching and learning.
> • **Mary Ann Stankiewicz & Elizabeth Garber (2000)**

When searching for an online course to meet your professional needs, it is advisable to have a clear idea of what you're looking for, and employ several strategies and sources in your research. For instance, typing the key phrase "professional development courses" on Google Search produces over 40,000 hits, whereas using the key phrase "online courses for teachers" on AltaVista Search leads to some 400 hits. Browsing through these results, you will discover that some subjects appear to be more popular or perhaps more compatible with e-learning than others. Hundreds of online courses have been designed to assist teachers in integrating technology into their classrooms. Likewise, there are plenty of online courses that cover classroom management strategies and other pedagogical matters. In the field of art, the selection of online courses is rather sparse and concentrated primarily in the areas of art history and art appreciation.

Although there have been several reports on the use of Internet-based technologies in art teacher education programs (Lai, 2002; Stankiewicz & Garber 2000; Krug, 1998; Kiefer-Boyd, 1996), only a few universities and colleges are known to offer Internet-based art education courses at this time.[2] Still, it may not be long before such practice becomes widespread.

If you want to earn college credit for taking an online art education course, try contacting art education programs at universities and colleges within your region to see if they offer any e-learning options that meet your professional needs. If you belong to a mailing list for art educators, post an inquiry to the group to see if there are any members who have taken an online art education course recently or who can recommend an institution supportive of such courses.

As previously mentioned, universities and colleges are no longer the primary sources of professional development for K–12 teachers. A growing number of commercial and nonprofit course providers offer online classes on just about every aspect of teaching, as well as add-on certification endorsement programs in a variety of subject areas. Many providers have agreements with school districts or state boards of education to provide teachers with opportunities to earn Continuing Education Units (CEUs) or Professional Development Points (PDPs) toward recertification upon successful completion of their online courses. Some providers also are able to offer graduate credit for their online courses through affiliations with universities or colleges.

Although such course providers are generally good sources to turn to for professional development, be sure to do your homework on any company or organization before enrolling in one of its online courses—especially if you have to pay a fee to do so. Make certain that you are dealing with a reputable company and that any course credits you earn through its online services will be accepted by your state's credentialing system. The following companies and organizations are intended as examples of the many professional development providers who have a track record for delivering quality online content and instruction.

### ASCD Professional Development Online
pdonline.ascd.org/pd_online/new/index.cfm

The Association for Supervision and Curriculum Development (ASCD) offers a number of online professional development courses for teachers and school administrators. Each course includes interactive Web-based lessons, supplemented with extensive reading material, and access to discussion groups. All ASCD courses require paying a nominal fee at registration and may be taken to earn CEUs or college credit.

### Concept to Classroom Online Workshops

www.thirteen.org/edonline/concept2class

Channel Thirteen/WNET, a public broadcasting station serving the New York area, offers this excellent series of online professional development workshops for teachers in collaboration with Disney Learning Partnership. Each workshop is divided into sections: Explanation, Demonstration, Exploration, and Implementation. Sample workshop topics include Interdisciplinary Learning in Your Classroom, Inquiry-Based Learning, and Cooperative and Collaborative Learning. Completing the free registration process gives you access to several discussion boards, where you can talk with other teachers enrolled in the same workshop.

### Connected University

cu.classroom.com

Classroom Connect's Connected University (CU) is an online professional development community that offers teachers round-the-clock resources; instructor-led and self-paced online courses on a variety of subjects; software tutorials; discussion boards; and more. Each CU course lasts six weeks and involves weekly assignments, class discussions on message boards, and a final project. CU's courses may be taken for CEUs or graduate credit. Access to the CU Web site requires paying a yearly subscription fee.

### Heritage Institute Online

www.hol.edu

Heritage Institute Online (HIO) offers Web-based courses on various subjects such as elementary art teaching, classroom management, and technology. You can even design your own online course by proposing a project that will improve your classroom teaching. HIO courses may be started at any time and registrants have one year to complete their studies. Each course involves self-paced study and e-mail communication with an instructor. Two semester hours of college credit are earned through Antioch University for the successful completion of any HIO course.

### OnlineLearning.net

onlinelearning.net

OnlineLearning.net, a division of Sylvan Learning Systems, is a leading online supplier of professional development courses for teachers. You can select from a wide array of instructor-led and self-paced online courses offered through the University of California, Los Angeles (UCLA) Extension, and the University of San Diego.

### PBS TeacherLine

teacherline.pbs.org/teacherline

The Public Broadcasting Service (PBS) sponsors TeacherLine to help teachers acquire the skills they need to be effective in the classroom. TeacherLine includes a collection of online mini-courses offered by PBS member stations that cover a wide range of topics from integrating technology and the Internet into the curriculum to contemporary theories about teaching and learning. Teachers can use these mini-courses to earn CEUs, PDPs, university graduate credit, or for completion of a certificate program based on national and state technology standards. TeacherLine also offers discussion boards, readings on various topics, live chats with guest speakers, online portfolio tools that teachers can use to document and to plan their professional development, plus links to related Web resources. Registration for TeacherLine is free and gives you access to all of the areas of the site.

### Professional Focus, Inc.

www.virtualed.net

Professional Focus, in cooperation with Fort Hays State University, offers online graduate-level, three-credit-hour courses for recertification and salary advancement. Course topics cover all the major curriculum areas for educators at all levels, including topics in the visual arts. You can enroll in courses at any time and take up to a year to complete your studies. Courses are available in standard "paper-and-pencil" format or online.

## Teacher Education Institute

teachereducation.com

Teacher Education Institute (TEI) offers graduate and professional development courses that address key human factors in education such as inclusion or teaching and learning with groups, as well as technology integration skills and methods. TEI's courses are offered online for either six or thirteen weeks and may be taken for recertification, in-service credit, staff development, or continuing education credit. Graduate courses last thirteen weeks and may be taken either online or in a classroom. A map of the U.S. is provided to show the date and location of classes taught onsite.

## Technology Horizons in Education (T.H.E.) Institute

www.thejournal.com/institute

T.H.E. Institute provides a number of fee-based online courses that are designed to assist teachers in learning how to use different software applications, such as PowerPoint or HyperStudio software, and how to successfully integrate technology into the classroom. All courses are self-paced and moderated by experienced educators.

# Thinking of taking an online course?

In determining whether an online course meets your professional needs and learning style, consider the following questions before enrolling:

**What are the goals of the course?** Examining the course syllabus, objectives, and assignments will help you to determine whether the course meets your learning goals.

**Will you take the course for credit or non-credit study?** Online courses typically offer options for receiving professional development points, continuing education units, graduate credit or, in some cases, completion of a certificate program. Make certain that your state's credentialing system will accept any credits or certificate you earn through a particular online course provider.

**What are the expectations for the course?** The assignments and expectations for an online course will vary depending on whether you're taking it for credit or non-credit study. This will include the amount of time you are expected to commit to the course each week as well as how long you are given to complete course assignments.

**What opportunities for interaction will be available?** Online courses are generally self-paced and involve a lot of independent study work. However, many provide opportunities to receive assistance from an instructor or moderator, as well as to communicate and collaborate with others enrolled in the course.

**What are the technical requirements for the course?** The only technology usually required to take an online course is a reliable Internet connection, an up-to-date Web browser, and e-mail service. Make sure you have access to all the tools necessary to complete course assignments and, more importantly, that you are comfortable using them.

**How will the course be structured?** Some online courses consist of interactive tutorials with weekly individual assignments, whereas others resemble workshops with hands-on group projects. Some are arranged as seminars with assigned weekly readings and online discussions between fellow students and the instructor. Still others combine online instruction with occasional face-to-face meetings in a centralized location.

**Is online learning "right" for you?** To be a successful online student, you need to be comfortable with (1) computers and the Internet; (2) learning on your own; (3) asking questions when you do not understand something; and (4) expressing yourself in writing. While online learning offers the advantages of convenience and flexibility, it is not for everyone. Ultimately, you are in the best position to know whether an online course fits your personal learning style and professional goals.

## Conclusion

The Internet greatly expands teachers' professional development opportunities by allowing them to participate in online learning communities, courses, chats, discussion groups, and self-directed learning modules on their own time and at their own location. The Internet also makes it possible for teachers to connect to other teachers, thereby providing opportunities for sharing ideas, mentoring, collaboration, and informal learning. Teachers who regularly engage in online professional activities acquire valuable Internet skills, which in turn enhance their motivation and capacity to use the technology in the classroom with students.

## Useful Web sites

### Annenberg/CPB

www.learner.org

Annenberg/CPB offers various Professional development opportunities for K–12 teachers free through their satellite channel and Video On Demand.

### Apple Learning Interchange (ALI)

ali.apple.com

Sponsored by Apple Computer, ALI offers a wealth of digital resources for classroom use, ranging from lesson plans, to video field trips, to exemplary teaching practices.

### Education World's Professional Development Center

www.education-world.com/pro_dev

This site offers a huge collection of practical articles written by teachers and other education experts.

# Bringing Web Resources into the Artroom

## CHAPTER 6

Art teachers need to be aware of the available resources and feel comfortable using the Internet as a classroom tool, before they can use the Internet effectively.
• **Donalyn Heise & Neal Grandgenett (1996)**

This chapter serves as a starting point for investigating how art teachers can effectively integrate the Internet into their classroom instruction. It identifies a number of pertinent online resources and suggests strategies for incorporating Web-based content into familiar art-teaching practices.

### So many Web sites, so little time

The Internet offers an ample supply of curriculum-based materials, image databases, informative Web sites, and online tools that can support art instruction in the classroom; so many in fact that you are likely to become overwhelmed sorting through all the resources available to find the ones that are most useful for your own teaching situation. Learning how to use the search tools and strategies described in Chapter 3 is an important first step to making the most efficient use of your time. It would also be helpful to familiarize yourself with Web sites that are especially rich in art-related content that you may want to bookmark in your browser and revisit every so often to check for new material.

To assist you in locating useful online resources for your classroom, this section highlights some of the more fertile places to go to on the Web for articles, images, lesson plans, and other information of special interest to art teachers. Through continued exploration of the Web, you can find many other valuable sites to meet your instructional needs.

## Art lesson plans

As many art teachers have discovered, the Internet is a virtual gold mine of ideas for classroom lessons and projects. Literally thousands of art lesson plans, units of study, and related curriculum materials are available on the Web. Examining lesson plans written by others can be helpful, both in terms of saving you from "reinventing the wheel" and in suggesting new starting points for developing your own lessons and projects. However, as previously cautioned, you should carefully evaluate the quality of each resource you find on the Web. Not all art lessons posted online are accurate or reflect sound art education practices.

Art lesson plans are available online through a number of reputable sources including art museums, arts organizations, university art education departments, government-sponsored Web sites for K–12 education, and commercial companies who supply art-related products to schools. In addition, many art teachers post lesson plans on their school or personal Web sites. Some sites worth exploring for art lesson plans are listed below.

### Advanced Placement—AP Central

apcentral.collegeboard.com

High school art teachers who offer AP courses in studio art and art history will find this site especially useful. It includes comprehensive information on AP courses and exams, as well as tools, resources, and discussion forums to help teachers in guiding their students through AP courses. Free online registration is required to gain full access to the site.

### Art Education and Art Adventures from Sanford and a Lifetime of Color

www.sanford-artedventures.com

This site offers a number of art-intensive lessons as well as general lesson plans for integrating art with other subject areas. In addition, you will find all sorts of interactive and useful online resources designed to support art teaching and learning in the classroom.

### Art:21—Art in the Twenty-first Century

www.pbs.org/art21

This is the companion Web site for the PBS series, Art:21—Art in the Twenty-first Century (Figure 6.1). In addition to exploring the personal experiences, sources of inspiration and creative processes of a diverse range of contemporary artists, the Art:21 Web site includes a growing Online Lesson Library containing teacher-written lesson plans and an online gallery of student art projects. Downloadable Educators' Guides are also available for each season of the series. Art:21 premiered in 2001; successive seasons are broadcast on PBS every two years.

### Ceramics and Pottery

pottery.netfirms.com

This site, created by Georgia art teacher Kerry Marquis, features two illustrated units of study covering hand-building ceramics techniques. It also includes teacher pages, downloadable handouts, a gallery of student work, a glossary of terms, assessment materials, journaling ideas, links to related Web sites, and more. Additional units may be purchased for a nominal fee.

**Figure 6.1** The Art:21 site offers lesson plans for incorporating contemporary art practices and ideas into an educational context.

## Chicana and Chicano Space—A Thematic, Inquiry-Based Art Education Resource

mati.eas.asu.edu:8421/ChicanArte

This site, sponsored by the Hispanic Research Center at Arizona State University, contains inquiry-based interdisciplinary curriculum materials that cover more than twenty-five works by Chicana and Chicano artists along with detailed information about each work. Two instructional units for middle and high school students are provided, along with suggested questioning strategies, exploring the themes evident in the selected art works.

## Haring Kids—Lesson Plan Database

www.haringkids.com/lessons/envs/live/htdocs

The Haring Kids Web site offers teachers and parents an extensive collection of educational resources including explorative lessons for all ages and fields of study. The lessons presented have been gathered from museum education departments, staff members, and visitors to the site. There is also a Keith Haring biography available as well as project ideas, a list of recommended books, links to related sites, and a number of visual aids that can be downloaded for classroom use.

**Figure 6.2** The Incredible Art Department Web site includes hundreds of lesson plans and links to art-related online resources.

## The Incredible Art Department

www.princetonol.com/groups/iad

Ohio art educator Judy Decker maintains this valuable and comprehensive site, originally created by Ken Rohrer, which consists of an exhaustive collection of curriculum resources and links on various topics related to art education (Figure 6.2). Included is a searchable database of lesson plans, contributed by art teachers, covering a wide range of themes and processes typically taught in art classrooms. Other areas of the site offer art assessment tools, tips on classroom management, student art galleries, links to K–12 art departments, art advocacy materials, and more.

## Looking at Portraits: Lessons and Ideas for Discussion

www.getty.edu/education/for_teachers/curricula/portraits

Explore portraiture with your class and discover ways to engage your students in the investigation and creation of portraits with these five lessons offered by the Getty Museum.

## New York Times Learning Network Lesson Plan Archive

www.nytimes.com/learning/teachers/lessons

This archive contains hundreds of free lesson plans for grades 6–12 that have been previously published on the New York Times Learning Network Web site. Over thirty art-related lessons are included.

**Figure 6.3** The UIC Spiral Art Education site features innovative curriculum materials for exploring contemporary art and culture.

## SchoolArts Magazine Online

www.davis-art.com/schoolarts

On this site you can download copies of selected articles from current and past issues of SchoolArts Magazine. Several of the featured articles include lesson plans along with examples of student artwork.

## UIC Spiral Art Education

spiral.aa.uic.edu

This site includes an innovative art curriculum of thought-provoking projects that explore personal, community, and social issues within the context of contemporary artmaking and culture (Figure 6.3). Each project includes a lesson plan, samples of student artwork, information on related artists, plus essays and links concerning the aesthetic and cultural contexts within which the project is based.

## Visual Culture Workshop

www.sva.psu.edu/arted/program/vc_vfdillon

Victoria Franklin-Dillon, a Pennsylvania State University graduate student in art education, created this site containing a compilation of K–12 curriculum ideas and resources on visual culture.[1] Project ideas are organized by grade level and by topic. Also included is a glossary of terms, suggested artists to study, links to related Web sites, and print references.

## Whitechapel Downloads

www.whitechapel.org/content63.html

This site features four innovative art projects involving artistic practices with digital technologies, developed by visiting artists at the Whitechapel Art Gallery in London in the spring of 2000.

## Visual arts directories

Web directories and indexes devoted to the visual arts make searching online for a particular artist or topic in art a relatively easy task. These specialized directories typically consist of categorized listings of annotated hyperlinks to other sites containing pertinent art information or resources, although several also provide search capabilities and their own original content. Some rely on corporate sponsorship to pay for operating costs and acknowledge such support on the site with the use of advertising banners or product endorsements. Academic institutions, museums, public libraries, and individuals with an interest in art host many others.

Visual arts directories are excellent places to begin searching for online material to support your classroom teaching. They are usually maintained by experts in the field of art who verify the reliability and scholarship of the sites referenced in their listings. Keep in mind, however, that art directories (like all Web sites) reflect the values of the authors who created them; and, consequently, their opinions will influence what you read and see on the Web.

In general, it is best not to rely on any one source alone to locate the information you need as an art teacher. Consult several sources when you need to form an opinion on an issue, develop a comprehensive view of your topic, or confirm the accuracy of some art information you already have found. Although not an all-inclusive list, following are some of the better visual arts directories available on the Web today.

### African Americans in the Visual Arts: A Historical Perspective
www.liunet.edu/cwis/cwp/library/aavaahp.htm

This site, maintained by Melvin Sylveste of the B. Davis Schwartz Memorial Library at Long Island University, includes biographical information on numerous African-American artists along with links to museums dedicated to African-American art and culture.

### African Art on the Internet
www-sul.stanford.edu/depts/ssrg/africa/art.html

This listing, which is maintained by Karen Fung of Stanford University Libraries, offers links to sites on topics that range from African fine arts and crafts to culture, museum, and galleries. The listing is part of a larger Web directory titled Africa South of the Sahara.

### Artcyclopedia
www.artcyclopedia.com

Created by John Malyon, an instructional technology professional and entrepreneur, Artcyclopedia is a great reference tool for locating "museum-quality" fine art on the Internet (Figure 6.4). It allows you to easily search the Web for artists by name, artworks by title, and art museums by name or location. You can also browse the site's database of thousands of artists by movement, medium, subject, nationality, name, or gender. Also included is a monthly feature article, art news items, and a list of the thirty most popular artist searches done on the site.

### Art History Resources on the Web
witcombe.sbc.edu/ARTHLinks.html

This site, maintained by Chris Witcombe of Sweet Briar College, contains one of the most comprehensive compilations of links to art history resources available on the Web today. It covers everything from prehistoric art to art of the twenty-first century, in addition to world art, museums and galleries, research resources, and miscellaneous art resources.

### Art in Context
www.artincontext.com

The Art in Context reference library provides public access to information about artists and where to find their work. Curators, dealers, artists, writers, and others from around the world contribute to its growing database. The site includes listings of historical and contemporary artists, museums, galleries, and dealers, current exhibitions, and images.

**Figure 6.4** Artcyclopedia allows you to search the Web for artists, artworks, and art museums.

## AskART.com

www.askart.com

AskART's mission is to create the world's most comprehensive centralized database about American artists. Profile pages on each of the 27,000 artists currently in its database include biographical information, exhibition records, favorite subjects, selected images, and more. The site also provides a glossary of art terms and searchable listings of museums and art dealers. Additional services are available for a subscription fee.

## Hunt For Art History

www.huntfor.com/arthistory

Hunt For Art History is a quick reference guide to Western art history, arranged chronologically from Prehistoric Art to Art of the twentieth century. Selected periods and artists are profiled and linked to other sites on the Web.

## Mother of All Art and Art History Link Pages

www.art-design.umich.edu/mother

Sponsored by the University of Michigan's School of Art and Design, this site contains listings of selected Web sites in such areas as art history departments, research resources, visual collections, online art, online exhibits, fine art schools and departments, and art museums.

## Voice of the Shuttle

vos.ucsb.edu

English professor Alan Liu and a development team at the University of California, Santa Barbara, maintain this superb directory that consists of an extensive compilation of resources covering all disciplines in the humanities. The art and art history pages include links to general art and art history resources, artists and works, museums, image resources, and more.

**Figure 6.5** World Wide Art Resources and absolutearts.com provide an exhaustive compilation of art-related resources.

## Women Artists in History

www.wendy.com/women/artists.html

This site, maintained by Web designers Wendy Russ and Carrie Carolin, consists of a chronological listing of women artists from medieval times to the present. A number of the citations include links to other sites where you can find information on the artist.

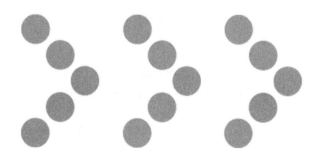

## World Wide Arts Resources/absolutearts.com

wwar.com

Billed as "the largest Internet arts gateway," World Wide Arts Resources and its sister site absolutearts .com offer an exhaustive compilation of online resources covering a variety of art-related topics such as art history, art schools, museums, children's art resources, exhibitions, galleries, as well as individual artists, both past and present (Figure 6.5). Perhaps the most valuable feature for art teachers is the Art History index of famous masters, which provides access to imagery and in-depth information for over 22,000 artists. The site also offers portfolios for contemporary artists and galleries to organize, display, and market their current art online. Altogether, this mega-site is loaded with art resources and is worth taking the time to explore.

# Art and arts organizations

The Internet has become a major means of communication and promotion for nonprofit arts agencies, associations, and foundations around the world. Establishing a presence on the Web has enabled these groups to increase their exposure and to provide online support for their members' activities. The following organizations offer various types of Web-based content that art teachers will find useful, including articles, arts advocacy materials, curriculum-based resources, funding sources, news items, digital images, and more.

## Americans for the Arts

www.artsusa.org

Americans for the Arts, the nation's largest arts advocacy organization, is dedicated to representing and serving local communities and creating opportunities for every American to participate in and appreciate all forms of the arts. Its site provides access to an abundance of resources and publications for advocating and supporting arts education in the schools.

## ArtsEdge

www.artsedge.kennedy-center.org

Sponsored by the John F. Kennedy Center for the Performing Arts and the MarcoPolo Consortium, ArtsEdge's mission is to use technology to support the place of arts education as a core subject in the K–12 curriculum. The site contains advocacy materials, arts-integrated lesson plans, student-oriented interactive activities, professional development resources, examples of best practices in arts education, links to related online resources, and more.

## Arts Education Partnership

aep-arts.org

The Arts Education Partnership is a national coalition of arts, education, business, philanthropic, and government organizations that promotes the essential role of the arts in the learning and development of every child and in the improvement of America's schools. Its site includes a directory of participating organizations, funding information, Partnership Task Force initiatives and reports, advocacy resources, and links to other arts education sites.

## Community Arts Network (CAN)

www.communityarts.net

The Community Arts Network (CAN) promotes information exchange, research, and critical dialogue within the field of community-based arts. Their Web site includes an ever-expanding library and archive of articles and essays on community art, a discussion board, plus an extensive collection of links to related resources on the Web.

## Creative Time

www.creativetime.org

Creative Time is a New York-based nonprofit organization that commissions and presents adventurous public arts projects from all disciplines. Its site features illustrated highlights of numerous past and present projects.

## International Sculpture Center (ISC)

www.sculpture.org

The ISC is a member-supported, nonprofit organization whose mission is to advance the creation and understanding of sculpture and its unique, vital contribution to society. Its site includes feature articles from *Sculpture* magazine, a portfolio of works by contemporary sculptors, information on historical sculptors, and educational resources for teaching sculpture in the classroom.

**Figure 6.6** The National Art Education Association is the world's largest professional organization devoted to art education.

## Media Awareness Network (MNet)

www.media-awareness.ca

MNet is a Canadian non-profit organization that has been pioneering the development of media literacy programs since its incorporation in 1996. Their award-winning Web site contains an outstanding collection of educational resources related to the role of media in our lives.

## National Art Education Association (NAEA)

www.naea-reston.org

The National Art Education Association promotes art education through professional development, service, advancement of knowledge, and leadership. Its site includes membership information, advocacy and policy materials, a listing of professional publications, convention information, and links to affiliated groups (Figure 6.6).

## National Endowment for the Arts (NEA)

www.arts.endow.gov

The National Endowment for the Arts Web site includes a collection of essays covering artists and arts agencies that have received federal grants and NEA awards over the years. In addition to information on the AIDS Quilt, self-taught artists, and the Visual Artists Rights Act, the site also includes an online gallery of work by American artists, artist interviews, and more.

## VSA arts

www.vsarts.org

VSA arts, formerly known as Very Special Arts, is an international nonprofit organization dedicated to promoting the creative power in people with disabilities. Its site offers an extensive collection of educational resources as well as a number of online galleries containing work by artists with disabilities.

## Online art journals and newspapers

A wide variety of art-related literature is available on the Web today. Some of these online publications are digests of monthly journals available in print, whereas others exist only on the Internet. For busy art teachers, these sites offer a convenient way to keep abreast of what is going on in the world of art. They include everything from critical reviews of current art exhibitions to featured articles, interviews with contemporary artists, and important news items from the art world. You will find on these sites a wealth of pertinent material that can inform your teaching and possibly kindle classroom discussions on various cultural issues. Although online art publications vary in quality, the six sites listed here will give you consistently good information—and they are all available at no change.

### Absolutearts.com

www.absolutearts.com

Absolutearts.com's Arts News provides the online arts community with international arts news items on a daily basis. Browsing the site's archives gives you access to hundreds of quality arts news stories and exhibition reviews dating back to 1999.

### Art Daily

www.artdaily.com

Billed as "the first art newspaper on the Net," Art Daily presents featured stories covering art-related news and events internationally as well as exhibition reviews, interesting anecdotes about notable artists, an online art history quiz, links, and more.

### Art Deadlines List

artdeadlineslist.com

Art Deadlines List is a monthly newsletter that provides current information about juried exhibitions and competitions, calls for entries/proposals/papers, jobs, internships, scholarships, residencies, and more. A premium edition is available for an annual fee.

### Artnet Magazine

www.artnet.com/Magazine/Frontpage.asp

Among the many services available on artnet.com is the art world's leading online magazine, where you will find articles written by well-known critics, news items, plus reviews of art exhibitions and books.

### The Art Newspaper

www.theartnewspaper.com

The Art Newspaper is an all-inclusive source of art news worldwide. It offers daily interviews with featured artists, news that affects the art world, information on the art market, annotated links to museums and galleries worldwide, and more.

### Arts Journal

www.artsjournal.com

Arts Journal is a weekday digest of more than 180 English-language newspapers, magazines, and publications featuring writing about arts and culture. A premium edition is available for an annual fee.

107

## Art museums

Of special interest to art teachers are the countless art museums worldwide with established Web sites that offer immediate online access to selected works in their collections, art historical information, curriculum materials, and more. Museum sites are especially valuable for locating relevant art reference materials for classroom use. The content they provide is generally more reliable and authentic than you might find elsewhere on the Web. Moreover, because museums attempt to appeal to a wide public audience, the material on their sites is often accessible to people of all ages and backgrounds.

Art museums vary greatly in the way they present their collections on the Web. Some aim for wide coverage, including image banks with a high percentage of their collections along with brief accompanying text. Others focus on displaying highlights of their permanent collections and special exhibitions arranged during the year. Some go further by offering virtual tours of the museum or special exhibitions accompanied by audio narratives by a museum curator or staff member. Still others offer in-depth analyses of selected works in their collections accompanied by detailed information on the subject matter depicted in the work, facts concerning the painting and artist, plus zoom-in capabilities that allow you to study details in the work.

Some museums provide search capabilities on their sites that allow you to retrieve items of interest by subject, artist name, media, place, or date. Others organize their online collections in categories according to media or by curatorial departments to help you focus your browsing. The most rewarding art museum sites offer online visitors something more than they might get from an exhibition brochure or a visit to the museum itself. They recognize the unique potential of the Web as an interactive educational medium and the variety of learning styles and understandings that visitors bring to the online viewing experience. Following are seven exemplary art museum sites.

### The Art Institute of Chicago Museum

www.artic.edu/aic

The Art Institute of Chicago Museum's Web site includes a number of important works from its collection such as *American Gothic* by Grant Wood, *Nighthawks* by Edward Hopper, and *A Sunday on La Grande Jatte* by Georges Seurat (Figure 6.7). It also allows you to explore the museum's galleries using virtual reality technology as if you were there. In addition, the Art Access area of the site examines selected objects from the museum's collection in detail and offers a variety of educational resources for classroom or home use. Several elements of this site require Apple's Quicktime plug-in.

### The J. Paul Getty Museum

www.getty.edu

The J. Paul Getty Museum's Web site provides an assortment of options for exploring the Getty's collections and exhibitions. You can search or browse selected works by artist's last name, collection type, subject, or theme. In addition, the Video Gallery offers streaming videos on a number of art-related topics, though you'll need the RealPlayer plug-in installed on your computer in order to watch these. One of the assets of this site is the high-quality digitized images of works of art it provides along with easy-to-read accompanying text, which places each work in historical and cultural context.

### Kyoto National Museum of Japan

www.kyohaku.go.jp

On this museum site, you can browse the most comprehensive collection of East Asian Art images available on the Internet. In addition to detailed introductions to over a hundred selected masterworks, the site offers a searchable database containing more than 10,000 digitized images of over 5,000 objects or sets of objects from the museum's collection.

**Figure 6.7** The Art Institute of Chicago Museum site offers a variety of ways to browse their collections.

## Metropolitan Museum of Art

www.metmuseum.org

This site allows you to browse or search through some 3,500 images of works of art and objects from the Met's permanent collection, which spans more than 5,000 years of world culture. You can also view current and future special exhibitions or access various educational resources designed for classroom use. An additional feature called My Met Gallery allows registered visitors to save selected works for later viewing.

## National Gallery of Art (Washington, D.C.)

www.nga.gov

The National Gallery of Art's Web site is exceptionally rich in art content and images. In addition to providing general information about its collections, current exhibitions, and services, the site offers a number of online tours; in-depth analyses that focus on selected artists, themes, and selected works of art; an extensive collection of classroom materials and educator resources; plus a special NGA Kids area that features online activities for young viewers.

### Smithsonian American Art Museum (SAAM)

www.americanart.si.edu

The SAAM Web site allows you to easily browse or search the museum's collection of 40,000 art objects, over 18,000 of which are illustrated online. Other features of the site include over thirty virtual exhibitions, several online teachers' guides, interactive Flash presentations focusing on the work of specific artists, and an online reference service called "Ask Joan of Art," where you can submit questions about American art to research specialists at the museum.

### State Hermitage Museum

www.hermitagemuseum.org

The Hermitage Museum in St. Petersburg, Russia, has created an impressive online presence with this Web site, thanks to sponsorship from the IBM corporation. The site offers a number of special features including an exceptional digital collection that displays much of the museum's collection of art and artifacts as well as several virtual exhibitions and a virtual gallery of 3-D images that allow you to view specific artifacts from all sides.

### Museum Directories

Many more art museums have Web sites with valuable information for teachers and students. Consult the following directories to find other art museums online.

**Art Museum Network**
www.amn.org

**MuseumSpot**
www.museumspot.com

**Virtual Library Museums Pages**
icom.museum/vlmp

## Art museum educational resources

Many art museums address the instructional needs of teachers by providing online curricular materials for classroom use. Some have even developed special online education centers that offer teacher guides, lesson plans, self-guided tours, museum-hunt games, reference services, online learning tools, downloadable activity sheets for students, and more. Following are some noteworthy examples of the types of online educational resources you can find on art museum sites.

### ArtsConnectEd

www.artsconnected.org

As an online, educational gateway to the Walker Art Center and The Minneapolis Institute of Arts, ArtsConnectEd is an extremely useful and fertile Web site with a wide array of full-color digital images of works of art, audio and video clips, more than eighty online lesson plans and curriculum units, interactive activities, textual information, and more (Figure 6.8). The site consists of five major areas including the Art Gallery, For Your Classroom, Library and Archives, the Playground, and Search All. Each area provides tools for searching and sorting through the abundance of educational resources available. One of the more valuable educational tools on the site is the Art Collector, which allows visitors to create personal collections of works of art with accompanying text for later viewing (see page 127).

**Figure 6.8** ArtsConnectEd provides a wealth of art educational resources and tools for classroom use.

## Arts Curriculum Online

www.guggenheim.org/artscurriculum

This area of the Solomon R. Guggenheim Museum's Web site provides teachers with downloadable curriculum materials that support the use of the museum's exhibitions and collections both during school visits and in the classroom. Focusing on modern and contemporary art, each resource unit includes an introductory essay, a biography of the featured artist, information on specific works of art, printable color images of these selected works, discussion questions, follow-up activities, and a listing of related resources.

## Cleopatra: A Multimedia Guide to Art of the Ancient World

www.artic.edu/cleo

This multimedia program examines eighteen artifacts from the Art Institute of Chicago Museum's distinguished Roman, Greek, and Egyptian collections, and includes maps, an illustrated timeline, video clips, close-up views of the objects, a glossary of terms, links to related sites, and lesson plans in five subject areas for grades 4–12. In order to access all the media used in this site you must have the QuickTime plug-in installed on your computer.

### e.school

www.sfmoma.org/eschool

Sponsored by the San Francisco Museum of Modern Art, this site is an excellent resource for teachers, students, and art enthusiasts of all ages who are interested in contemporary art. It offers online exhibitions, curriculum materials, a teacher's lounge where you can share your thoughts and ideas, and a gallery of student artwork.

### Learning@Whitney

www.whitney.org/learning

Sponsored by the Whitney Museum of American Art to support K–12 educators, this site includes a gallery of selected works from the museum's collection of twentieth- and twenty-first-century American art, interdisciplinary lesson plans that examine some of the key themes and concepts in the featured work, plus a list of related print and online resources for further study.

### Looking and Learning Lesson Plans

www.albrightknox.org/ArtStart/lessonplans.html

The Albright-Knox Art Gallery offers an excellent collection of lesson plans on their Web site that explore various works of art in their permanent collection. The lessons include digital reproductions of the selected artworks, discussion ideas, suggested activities, worksheets, and information for teachers.

### Making Sense of Modern Art

www.sfmoma.org/msoma

This multimedia guide to modern and contemporary art focuses on key works in the San Francisco Museum of Modern Art's permanent collection. The program allows you to "zoom in" and examine details of individual artworks, view excerpts from archival videos and films, and listen to commentary by artists, art historians, critics, and collectors. You will need the Flash and QuickTime plug-ins installed on your computer to view the program.

### MCA Collection Online—Teacher Resource Book

www.mcachicago.org

Teachers can use this resource book (found in the Teacher Resource area of the site) either as pre-visit preparation for a field trip to Chicago's Museum of Contemporary Art (MCA) or as an independent curriculum reference on contemporary art and culture. The guide focuses on the work of twenty-two contemporary artists and includes a short biography on each artist, in-depth information about their work, discussion questions, recommended classroom activities, and related resources.

### More Than Math

www.morethanmath.org

More Than Math is designed to show teachers how to integrate the visual arts into a third through fifth grade mathematics curriculum using selected works of art from the collection of the Asheville Art Museum in Asheville, North Carolina. The site features eight activities that explore concepts shared by mathematics and the visual arts, including pattern, symmetry, proportion, perspective, balance, and geometric form. Other areas of the site include instructions for using the activities in the classroom, a gallery of artwork, and artist biographies.

### NGA Classroom for Teachers and Students

www.nga.gov/education/classroom

This site contains a variety of thematic lesson plans based on selected artists and works of art from the National Gallery of Art's collection. It also includes a Resource Finder that can be used by teachers to access the extensive collection of lessons and resources that are available on the NGA site by curriculum area, topic, or artist. For students, four interactive game-like activities are available dealing with mythology, medallions, mobiles, and cake decoration.

**Figure 6.9** Odyssey Online takes students on a journey through the ancient cultures of the Near East, Egypt, Greece, and Rome.

## Odyssey Online

www.carlos.emory.edu/ODYSSEY

Odyssey Online offers elementary and middle school students the opportunity for in-depth study of the ancient cultures of the Near East, Egypt, Greece, and Rome (Figure 6.9). This engaging online learning resource uses artifacts from three museums: the Michael C. Carlos Museum of Emory University, the Memorial Art Gallery of the University of Rochester, and the Dallas Museum of Art. Available teacher resources cover how to teach with museum objects, how to use Odyssey Online and the Internet in the classroom, plus how to link Odyssey's learning modules to national and state standards.

## Red Studio

redstudio.moma.org

Developed by the Museum of Modern Art (MoMA) in collaboration with local high school students in New York City, the Red Studio explores issues and questions raised by teens about modern art and contemporary working artists. The site includes artist interviews by teens, activities and contests inspired by current Red Studio features and guest artists, artistic e-cards that can be sent over the Internet, online polls, and links to related online resources for those wanting to learn more about art.

### Street to Studio: The Art of Jean-Michel Basquiat

www.basquiatonline.org

Educational Web Adventures collaborated with the staff at the Brooklyn Museum and its partner museums to produce this interactive Web site about the artist Jean-Michel Basquiat. Designed primarily to engage teenagers in exploring Basquiat's art, the site includes a biography of his life, a gallery of his works, a digital painting tool, and an online discussion forum .

### Tate Learning

www.tate.org.uk/learning

Part of TateOnline, Tate Learning consists of a variety of ideas and resources for learning and teaching about modern and contemporary art using the collections and exhibitions of the Tate Galleries of Britain. The site consists of four areas: Learn Online, which offers interactive online courses and links to the Tate archives; Tate Kids, which includes online art activities for children; Learn in the Galleries, which lists upcoming events and programs planned for the four Tate Galleries; and the Staff Room, which includes teacher's notes, lessons, and resources available for downloading in PDF format.

### World Myths and Legends in Art

www.artsmia.org/world-myths

This Web site, also designed by Educational Web Adventures, provides a comprehensive look at how mythology has inspired artists around the world using twenty-six works of art from the permanent collection of The Minneapolis Institute of Arts. Students can explore the works presented on the site by theme or culture, or they can choose two works to analyze in depth and then write a printable essay comparing their selections. Each work can be studied independently and enlarged for closer inspection. The site also contains a wealth of accompanying information, a glossary of terms, a teacher's guide, and a downloadable curriculum in PDF format.

## Virtual art museums

A number of purely virtual art museums exist on the Web that are not associated with any physical display facilities; nor do they have actual holdings of their own. Yet they share with their "real world" counterparts a common mission of education, exhibition, and cultural preservation.

The collections of virtual art museums typically consist of digitized versions of works of art or other cultural objects obtained from various sources—such as different art museums around the world or private collectors—and organized chronologically or thematically for easy browsing. While some virtual art museums function with institutional or corporate support, individuals with a special interest or expertise in art manage others.

Virtual art museums vary greatly in terms of the quality of their content and usefulness in the classroom. The better ones enable visitors to locate specific works of interest quickly and to explore additional layers of contextual information through hyperlinks. Following are seven examples.

### CGFA–A Virtual Art Museum

cgfa.sunsite.dk

This virtual museum, created by Carol Gerten-Jackson, consists of digitized color reproductions of artwork by hundreds of artists from the medieval age to the early twentieth century. The site offers biographical information for many of the artists represented. You may search the site by artist's name, nationality, or period.

### Diego Rivera Web Museum

www.diegorivera.com

This virtual museum explores the life and work of Diego Rivera, perhaps the greatest Mexican painter of the twentieth century. You can view thirty of Rivera's paintings in the Gallery section or see photographs of over twenty of his murals located throughout Mexico and abroad. The site also contains several video/audio clips featuring works by Rivera and his wife, Frida Kahlo, plus magazine articles written by Rivera and Web links.

### Greenmuseum.org

www.greenmuseum.org

The Green Museum is a nonprofit, online museum of environmental art dedicated to advancing creative efforts to improve our relationship with the natural world. Its Web site includes articles on featured artists, news items, links, and more.

### Virtual Museum of Canada (VMC)

www.virtualmuseum.ca

Sponsored by the Canadian Heritage Information Network, the VMC draws from the collections of hundreds of cross-country museums to "celebrate the stories and treasures that have come to define Canada over the centuries." The site features online thematic exhibits, an image gallery of thousands of images, a teacher center with links to learning resources, and a customizable user interface called My Personal Museum that allows visitors to create personalized virtual exhibits from the images and presentations of the VMC.

**Figure 6.10** The Virtual Museum of Japanese Arts is devoted to traditional Japanese arts and culture.

### Virtual Museum of Contemporary African Art (VMCAA)

www.vmcaa.nl/vm

The Dutch Africaserver Foundation sponsors this site that focuses on contemporary African art. The VMCAA consists of three major areas: an e-zine that includes critical art reviews and articles; virtual projects specifically created for the Web; and a large database of links to Web sites on contemporary African Art as well as documentation on contemporary African artists based in the Netherlands.

### Virtual Museum of Japanese Arts

web-japan.org/museum/menu.html

Japan's Ministry of Foreign Affairs sponsors this three-dimensional virtual museum (Figure 6.10) that is devoted to traditional Japanese arts and culture. The site features six galleries of exhibits in the fine arts, crafts, performing arts, pastime arts, martial arts, and other areas (such as cuisine, dolls, Ninja, and festivals). Each gallery includes numerous examples along with extensive historical information and supplementary materials.

### WebMuseum, Paris

www.ibiblio.org/wm

Created by Nicolas Pioch in 1994 and expanded by other contributors, the WebMuseum is the most frequently visited virtual art museum on the Web. The site includes a collection of over one hundred works by Paul Cézanne as well as an alphabetical listing of over two hundred notable artists along with links to selected works and informed commentary on each artist.

## Digital archives

Like virtual art museums, online digital archives exist to preserve historical and cultural materials for educational and scholarly use. These online repositories generally consist of large collections of raw, uncontextualized audio, visual, and text materials stored in various digital formats. Most allow you to access their databases by using a keyword search method or by browsing a topical directory. While many can be used free of charge, others are only available via paid online subscriptions.

Museums, libraries, universities, and governmental agencies manage the majority of digital archives that are currently available online. Several of these sites are devoted exclusively to the visual arts and concentrate on digitizing, preserving, and displaying works done in traditional art media. Quite a few others contain visual materials on such art-related topics as documentary photography, mass media, print advertising, and the built environment.

Although all of these sites share a common aim of enabling individuals to access important digitized materials for nonprofit use, teachers need to be mindful of copyright and "fair use" issues before freely using images or other materials from these sources. We will examine the subject of copyright as it pertains to use of digital materials in the classroom at the end of this chapter. For now, spend some time browsing one or more of the following digital archives and discover what they have to offer.

### AdFlip
www.adflip.com

Adflip.com is billed as the "world's largest archive of classic print ads." You can search the database of ads dating back to the 1940s by category, by decade, or by year. This is a great resource if you need print ads in the classroom. To gain full access to the site requires a paid online subscription.

**Figure 6.11** The Learning Page on the American Memory Web site

## American Memory

memory.loc.gov

Built and maintained by the U.S. Library of Congress, American Memory is a gateway to a wealth of primary source materials relating to the history and culture of the United States (Figure 6.11). The site includes more than seven million digital items from more than one hundred historical collections covering a broad range of subjects and themes. You can search for specific items in the collections or browse through the Collection Finder, which sorts all the collections according to broad topics, format, time, and place. The Learning Page contains lesson plans plus tips on how to use the collections in the classroom.

## Archives of American Art (AAA)

archivesofamericanart.si.edu

The AAA in Washington, D.C. houses the largest collection of documents—totaling roughly 14 million items—on the history of the visual arts in the United States. Although this site covers only a small portion of the AAA collection, it is a great place to explore and learn about the history of American art. The types of materials you can find here include digital reproductions of artists letters and diaries, sketches and sketchbooks, photographs, exhibition catalogs, artist scrapbooks, and transcripts of interviews. Various search tools and online exhibitions are available to assist users in locating pertinent material on the site.

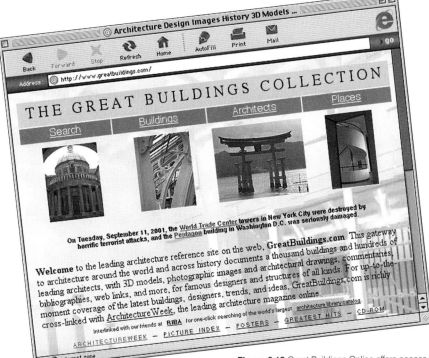

**Figure 6.12** Great Buildings Online offers access to over eight hundred digital images of architectural sites around the world.

### Art Crimes: The Writing on the Wall

www.graffiti.org

Susan Farrell manages this extensive and growing collection of graffiti art from over one hundred cities around the world. Many of the works shown no longer exist in real space.

### Charles W. Cushman Photograph Collection

webapp1.dlib.indiana.edu/cushman/index.jsp

This digital archive, sponsored by the Indiana Digital Library Program, contains approximately 14,500 color slide images of everyday life in the middle of the twentieth century, taken by amateur photographer Charles Weever Cushman. Cushman's images document a wide range of American and international subjects, from city storefronts and industrial landscapes to candid portraits and botanical studies.

### Chicano Art Digital Image Collection

cemaweb.library.ucsb.edu/digitalArchives.html

This collection, sponsored by the California Ethnic and Multicultural Archives, contains over five hundred images of works of art by Mexican-American artists. Among the works shown are paintings, murals, sculptures, installations, performance art, and more.

### Great Buildings Online

www.greatbuildings.com

Billed as the "leading architecture site on the Web," Great Buildings Online offers instant access to the world of architecture, past and present (Figure 6.12). The site includes over eight hundred images of buildings around the world, biographies on hundreds of architects, online 3-D models of buildings, photographic images, architectural drawings, and more.

### The ImageBase

www.thinker.org/fam/about/imagebase

The ImageBase offers searchable access to over 82,000 images of artworks and cultural objects from the collections of the Fine Arts Museums of San Francisco. The images in this database include works from the Americas, Africa, Oceania, and Europe as well as ancient artifacts and sculpture. The site utilizes zoom technology that enables visitors to view images in detail. You can also use the unique Virtual Gallery feature to curate your own exhibition of images from the database for later viewing by students or friends.

### LACMA Collections Online

collectionsonline.lacma.org

This site currently contains over 46,000 records and digital images of artworks in the permanent collections of the Los Angeles County Museum of Art. Included are representative artworks from numerous countries in Africa, Asia, Europe, and the Americas. By using the simple or advanced search feature, you can locate artworks on a multitude of historical, scientific, literary, and cultural topics. You can also browse several featured collections on American art, costumes and textiles, photography, artist portraits, and more.

### The Picture Collection Online

digital.nypl.org/mmpco

The New York Public Library sponsors this image resource site that contains over 30,000 images from books, magazines and newspapers as well as original photographs, prints, and postcards, mostly created before 1923.

### Picturing the Century: One Hundred Years of Photography from the National Archives

www.archives.gov/exhibit_hall

This online database, sponsored by the National Archives in Washington, D.C., contains historically significant photographs from both well-known and amateur photographers.

### September 11 Digital Archive

911digitalarchive.org

The September 11 Digital Archive was created to "collect, preserve, and present the history of the September 11, 2001, attacks". It contains more than 135,000 items in a variety of media formats, enabling visitors to examine a wide spectrum of opinions and perspectives regarding the events of 9/11.

**Figure 6.13** A page from the World Art Treasures Web site

### World Art Treasures

www.bergerfoundation.ch

The Jacques-Edouard Berger Foundation in Switzerland developed this site (Figure 6.13) to encourage the discovery and appreciation of art. It includes an extensive collection of digital images covering a wide range of artworks and artifacts from various world cultures.

## Individual artists

A considerable number of Web sites focus exclusively on the work of individual artists. These sites vary in purpose and in how they make use of the Web as a medium of communication and expression.

Some contemporary artists use the Web as an art medium in itself to create dynamic, interactive works that invite viewer participation. For many other artists working in traditional art media, the Web serves as a means of displaying their work to potential clientele. One of the best places to find information on contemporary artists is through an art gallery Web site that represents and sells the artist's work. You can often locate these gallery associations through the art directories previously mentioned such as Artcyclopedia, Art in Context, or World Wide Arts Resources.

If you're looking for information on a well-known artist (past or present) along with images of his or her work, chances are you will find several Web sites worth exploring. These sites originate from a variety of sources including art museums, foundations, admirers, or the artists themselves. Following is a sampling of Web sites dedicated to artists who are typically covered in school art curricula.

### Romare Bearden Foundation

www.beardenfoundation.org

This official site, sponsored by the artist's estate, offers a wide range of resources and information on the art and life of Romare Bearden. Selected works by the artist, arranged by medium, are available for online viewing only.

### Calder Foundation

www.calder.org

This official site features an extensive collection of works by Alexander Calder, organized by periods and medium. It includes a biography and an archive of photographs showing the artist with his work and in his studio.

**Figure 6.14** Campfire Stories with George Catlin presents and interprets hundreds of the artist's works.

### Campfire Stories with George Catlin—An Encounter of Two Cultures

catlinclassroom.si.edu

This award-winning Web site presents hundreds of George Catlin's artworks from the Smithsonian American Art Museum's permanent collection, along with a variety of historical and contemporary voices and resources that provide a context for understanding Catlin's art and his nineteenth-century encounters with Native Americans (Figure 6.14). The site is especially attentive to the needs of teachers with extensive lesson plans that make connections to other subject areas and national standards.

### Marc Chagall

www.chagallpaintings.org

Created and managed by a Chagall admirer, this site features a gallery of ten works of art by Chagall along with the author's commentary and a biography of the artist's life.

### Carmen Lomas Garza

www.carmenlomasgarza.com

This is the official Web site for Carmen Lomas Garza, a Chicana narrative artist and writer who creates images about the culture and everyday lives of Mexican-Americans based on her memories and experiences growing up in South Texas. The site includes an artist statement, a brief biography, a list of her children's books, a gallery of selected works, and more.

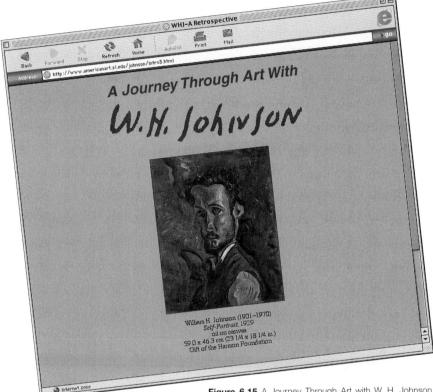

A Journey Through Art With

## W. H. Johnson

William H. Johnson (1901–1970)
*Self-Portrait,* 1929
oil on canvas
59.0 x 46.3 cm (23 1/4 x 18 1/4 in.)
Gift of the Harmon Foundation

**Figure 6.15** A Journey Through Art with W. H. Johnson includes selected works by the artist along with suggested classroom activities.

### Journey Through Art with W. H. Johnson

americanart.si.edu/education/johnson/index.html

This site, created by the Smithsonian American Art Museum, provides an illustrated account of the life, work, and travels of one of America's most important African-American painters, William Johnson (Figure 6.15). Selected works by the artist are organized by theme, and accompanying classroom activities help students to explore the art. A teacher's guide is also available.

### Roy Lichtenstein Foundation

www.lichtensteinfoundation.org

Sponsored by the estate of Roy Lichtenstein, this site seeks to foster a broader understanding of the Pop Art style seen in the work of this twentieth-century American artist and his contemporaries. The site includes a listing of current and upcoming exhibitions featuring Lichtenstein's work; a chronology of his life, work, and significant related events; images of his public sculptures, murals, and paintings in museums and galleries around the world; and written reviews of his work.

### Claes Oldenburg and Coosje van Bruggen

www.oldenburgvanbruggen.com

This official site includes biographies on the husband-wife team of Claes Oldenburg and Coosje van Bruggen, an illustrated chronology of their large-scale projects, and links to related sites.

### Faith Ringgold

www.faithringgold.com

This official site includes a large collection of digital images of work by Faith Ringgold, the African-American artist and writer who is best known for her painted story quilts. It contains a biography of the artist, a list of her popular children's books, answers to frequently asked questions, and more.

### Sandy Skoglund

www.sandyskoglund.com

This official Web site includes digital images of Sandy Skoglund's past and recent work, photographs of the artist working on her installations, a biography, a calendar of her exhibitions and activities, and a link to a curriculum resource on the artist's work stored on the J. P. Getty Museum's Web site.

### The Vincent van Gogh Gallery

www.vangoghgallery.com

Teachers and students interested in learning about van Gogh will find an abundance of information and images on this site. It contains an extensive collection of works by the artist, copies of his letters, photographs of the artist and family members, and more.

### Going Back to Iowa: The World of Grant Wood

xroads.virginia.edu/~MA98/haven/wood/home.html

The University of Virginia's American Studies Program hosts this well-researched site created by Janet Haven that provides a comprehensive review of the work of one of America's best-known artists, Grant Wood. The site explores various themes evident in the artist's body of work and places it in the context of Depression-era America.

**Figure 6.16** Going Back to Iowa is an excellent resource for learning about Grant Wood's contribution to American art and culture.

## Putting the Web to work for you

While the Web offers a cornucopia of interesting and informative sites on a wide variety of art-related topics, the real question is how can we harness these resources and bring them into the classroom. Before exploring student-centered approaches to Internet use, let's examine how this new technology can enhance what art teachers typically do as part of their daily instructional activities. If you are the least bit leery about introducing the Web into your art program, one of the following six strategies may serve as a good starting point.

### Download supportive curriculum materials

The easiest way to use the Web for teaching purposes is to download pertinent online resources and make hard copies of them for classroom use. Simply select "print" on your browser to produce a copy of any current Web page. You can then photocopy these printouts or turn them into overhead transparencies to illustrate important art concepts, processes, styles, or other historical information for your students.

### Bookmark useful Web sites

Another simple way to make use of Web resources to support your teaching is to bookmark sites in your browser that you want to show during a lesson. You can organize these sites in topical folders on your browser for easy reference. Taking this practice one step further, several free, easy-to-use Web-based services allow you to save and organize your bookmarks online. Many teachers use BackFlip for this purpose, while others use iKeepBookmarks or Yahoo! Bookmarks.

Each of these sites requires free online registration in order to utilize their services. One of the advantages of placing your bookmarks online is that you can access them anytime, from any computer connected to the Internet. For instance, you can create a list of links related to a lesson you will be presenting in the classroom on a Monday and upload them to the Web

from your home computer the night before. Similarly, students working on an Internet-connected computer in the classroom or at home can access your bookmarks by simply clicking on the address of the Web sites in their browsers.

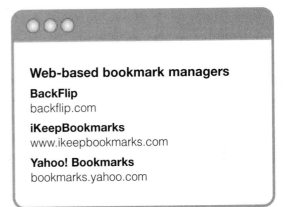

**Web-based bookmark managers**

**BackFlip**
backflip.com

**iKeepBookmarks**
www.ikeepbookmarks.com

**Yahoo! Bookmarks**
bookmarks.yahoo.com

### Create a hotlist

An alternative to bookmarking sites involves creating a Web page containing links to pertinent sites organized by themes or unit topics (often called a hotlist or curriculum resource page) and then storing it on your school or department's Web site. Students can then use this page as a springboard to visit the selected sites from their classroom or home computers. Many of the art departments featured in the next chapter include curriculum resource pages on their Web sites.

### Take your class on a virtual field trip

With a video projector connected to your classroom computer, you can take your students on virtual field trips to places that they may not otherwise ever get to see. For instance, you can take your class on a virtual tour of the Louvre Museum in Paris and challenge students to find the Mona Lisa or the Venus de Milo. You can also explore 7,000 years of Egyptian art, culture, and history with your students on the Eternal Egypt Web site.

If you are presenting a lesson on Alexander Calder, you can guide your students through the 1998 retrospective exhibition of Calder's work at the National Gallery of Art in Washington, D.C. Likewise, if your students are studying cave art in class, you can take them on a virtual tour of the Chauvet-Pont-d'Arc Cave in France that includes over four hundred paintings and engravings dating to the Paleolithic era.

The literally thousands of such virtual tours available through the Web make it possible for you and your students to explore art museums, art exhibitions, sculpture gardens, and public art sites without ever leaving the classroom. Just as you would with an actual field trip, it is important to preview any site you plan to visit with students to make certain the content of the site is compatible with your curriculum goals and there are no surprises lurking around any corners.

If you cannot find an existing virtual field trip to meet your instructional needs, consider creating one yourself with TourMaker software from Tramline. You can download a thirty-day free trial version of the program (available for PC computers only) from the company's Web site and see how other teachers have used it to create their own virtual field trips.

## Curate your own virtual art exhibition

Several art museums offer visitors to their Web sites opportunities to become virtual curators by creating their own personalized exhibitions of artworks chosen from their online collections. One of the best examples of this capability is the Art Collector tool available on ArtsConnectEd, which you can use to create individual sets of images, add your own text and then publish them on the Internet.[2] When you publish a collection, ArtsConnectEd assigns it a unique Web address (or URL) that you can call up from your browser, include as a link on your own Web page, or share with others via e-mail. You can revise, update, or even "unpublish" your collections at any time.

A little ingenuity can turn Art Collector into a powerful teaching tool. For instance, you can use Art Collector to create slide shows for your students that illustrate important concepts or themes in art. You can assemble pairs of images that enable students to analyze and compare different artists' approaches to the same subject matter or media. Or, you can create a "treasure hunt" by selecting details of images with the "zoom" feature, printing them out, and then challenging students to find them in a collection. These ideas only scratch the surface of using Art Collector in the classroom. In the next chapter, we will consider its role as a research tool in the hands of students.

### Virtual field trips

**Alexander Calder Virtual Tour**
www.nga.gov/exhibitions/caldwel.htm

**Chauvet-Pont-d'Arc Cave**
www.culture.gouv.fr/culture/arcnat/chauvet/en

**Eternal Egypt**
www.eternalegypt.org

**Louvre Museum**
www.louvre.fr/louvrea.htm

**TourMaker**
Tramline
www.field-trips.org

## Try This: Create a personal art collection with ArtsConnectEd

**Directions:** Using the Art Collector tool available on ArtsConnectEd, create a personal collection of ten images based on a theme of your choice. When you are finished, publish your collection on the Internet.

**Step One:** Go to the ArtsConnectEd Web site (www.artsconnected.org) and click on the Art Gallery icon.

**Step Two:** On the right-hand side of the screen, click on the Art Collector icon.

**Step Three:** On the left-hand side of the screen, type in your name, a username or email address, a password, and confirm your password. Write down your username and password in a safe place for future reference. Click on "Sign up."

**Step Four:** On the next screen, type in a title for your collection and click on "start a new collection."

start a new collection

**Step Five:** Search the ArtsConnectEd database by entering a keyword(s) in the search box at the top of the screen and click on "go."

self portraits | go

**Step Six:** Select any image from your keyword search that you wish to use in your collection by clicking on "add to my collection."

add to my collection

**Step Seven:** The editor page provides several options for formatting your collection, including adding a close-up of the current image or a text page to accompany it.

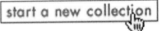

**Step Eight:** You can continue your search for images by clicking on "back to last search" or by starting a new keyword search.

back to last search

**Step Nine:** Click on "present" in the top toolbar to view a slide show of your collection. When you are ready to share your collection with others, click on "publish."

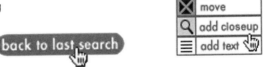

**Step Ten:** Click on "logout" to leave Art Collector.

**Import online materials into your computer presentations**

The days of slide projectors and carousels in art classrooms are numbered. With presentation software tools such as Apple's Appleworks, Microsoft's Power-Point, or Roger Wagner's HyperStudio, you can now easily produce dynamic, computer-based slide shows containing animation, audio and video clips, plus text and images that you import from the Web or that you generate yourself. These multimedia elements will capture your students' attention in the classroom and spice up your presentations at schoolboard meetings, parent open houses, in-service workshops, and professional conferences.

### Capturing Web images

To capture an image from the Web and import it into a PowerPoint presentation, follow the steps below:

1. Place your cursor over the image.

2. Right-click on the image if you are on a Windows-based computer, or click and hold the mouse button down if you are on a Macintosh computer.

3. Depending on the type of browser you are using, select either "Save Image As" or "Download Image to Disk" from the pop-up menu that appears (Figure 6.17).

4. A dialogue box will appear that will have a file name and an extension indicating the file type (typically .jpg or .gif). You can rename the file, but the file type extension should remain the same. Select a folder where you want to store the image on your hard drive and then click on "Save."

5. Open your presentation in PowerPoint.

6. Select the slide that will contain the image you downloaded from the Web.

7. From the Insert menu, select "Picture" and "From a File."

8. Locate the folder where the image is stored; select the image and then click on "Insert."

9. The image should appear on your slide. You can resize or move the image if necessary.

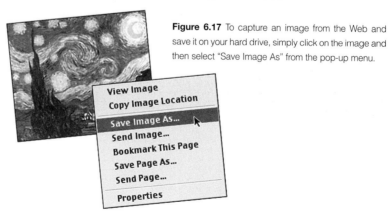

**Figure 6.17** To capture an image from the Web and save it on your hard drive, simply click on the image and then select "Save Image As" from the pop-up menu.

## A matter of copyright

Although it is extremely easy to grab images from the Web and incorporate them into your teaching materials, it is important to abide by copyright restrictions placed on the use of digital resources. Most art museums provide "conditions of use" or "user agreement" statements indicating that all the images and text stored on their Web sites are for educational and noncommercial use only. The same is true of many other Web sites offering original content that might interest art teachers.

It only takes a few moments to read the statements that are usually accessible through a Web site's homepage. They typically spell out in detail what is allowable in regards to use of the materials available on their Web sites. For instance, most art museums permit teachers (and students) to download images and text from their Web sites for educational use in the classroom as long as proper credit is given. However, they usually prohibit reproducing or distributing any image or text from their sites on a CD-ROM, DVD, print publication, or Web site without expressed written permission—especially if such use is for personal gain.

It is good practice to always cite the source of any image you obtain from the Web and to ask for permission from the Web site owner to use the image if it is not clear whether you have license to do so. When making such a request (via email), include your name and the name of your school along with an explanation indicating what you would like to use the image for, and how long you intend to use it. If the owner grants permission to use the image, you will most likely have to post a copyright notice along with it.

## Conclusion

Knowing what types of art-related resources are available on the Web is important, but more important is how teachers go about weaving these digital resources into their classrooms. Teachers need to be able to select educationally valuable Web sites and develop strategies for effectively integrating Web-based tools and resources into their instructional activities. All of this should be done with an eye toward addressing the learning outcomes of their curriculum and the particular needs of their students.

# Promoting Your Art Program on a Global Scale

## CHAPTER 7

### Why create a Web site for your art program?

There is a big difference between getting on the Internet and being on the Internet.

• **V. A. Shiva (1996)**

Art teachers know how important it is to publicize their programs through local media channels. They recognize that such publicity can develop positive attitudes in students and foster public interest in the art program. With access to the Internet, they can now promote their programs on a global scale by posting curriculum materials, learning resources, information on special local art events, and student artwork on the World Wide Web.

This chapter describes a four-step model for creating an art department Web site. Along the way, it presents tips on designing a Web site, useful software tools to choose from, and a dozen existing art department Web sites that can serve as models in planning your own site.

Besides supporting your advocacy efforts, creating a Web site for your art program offers numerous other benefits. An art department Web site can be

- a tool for fostering motivation and pride in students by publishing their artwork online for viewing by a worldwide audience;
- a point of contact with parents and community members who have an interest in what is happening in your classroom;
- a vehicle for guiding your students to suitable online art resources that will enhance the learning that takes place in the classroom;
- a digital archive of student work for purposes of instruction and assessment;
- a means of sharing your teaching philosophy and art curriculum with other art teachers around the world.

## How can I create a Web site?

Publishing on the Web involves a four-step process. You need to: (1) gather and develop the content you want to offer on your site; (2) convert your content to HTML code; (3) find a host to store your Web pages on the Internet; and (4) copy the files you create from your computer to the computer that will act as your Web host.

### Developing your Web content

The first step in creating a Web site is to decide what to include on it. For ideas, take a look at what other art teachers have done to create a Web presence for their programs. (A list of art department Web sites is provided near the end of this chapter.) As you visit these sites, make an assessment of the design and visual aspects of each site as well as the content included on it. It goes without saying that an art department Web site should reflect good Web design as well as be rich in content (Figure 7.2).

**Tip**

Before you begin developing your department's Web site, read your school district's guidelines or policies regarding publishing on the Web, especially with reference to placing photographs, artwork, and names of students on Web sites.

**Figure 7.2** The homepage for the Spring Branch Independent School District's program in Houston provides a visual overview of the site's contents.

# Promoting Your Art Program on a Global Scale

## CHAPTER 7

There is a big difference between getting on the Internet and being on the Internet.
• **V. A. Shiva (1996)**

Art teachers know how important it is to publicize their programs through local media channels. They recognize that such publicity can develop positive attitudes in students and foster public interest in the art program. With access to the Internet, they can now promote their programs on a global scale by posting curriculum materials, learning resources, information on special local art events, and student artwork on the World Wide Web.

This chapter describes a four-step model for creating an art department Web site. Along the way, it presents tips on designing a Web site, useful software tools to choose from, and a dozen existing art department Web sites that can serve as models in planning your own site.

### Why create a Web site for your art program?

Besides supporting your advocacy efforts, creating a Web site for your art program offers numerous other benefits. An art department Web site can be

- a tool for fostering motivation and pride in students by publishing their artwork online for viewing by a worldwide audience;
- a point of contact with parents and community members who have an interest in what is happening in your classroom;
- a vehicle for guiding your students to suitable online art resources that will enhance the learning that takes place in the classroom;
- a digital archive of student work for purposes of instruction and assessment;
- a means of sharing your teaching philosophy and art curriculum with other art teachers around the world.

## An art teacher shares his thoughts on the benefits of a departmental Web site . . .

An art department Web site can be a very versatile teaching tool, especially if it can be fashioned to suit the daily needs and classroom practices of teachers in the department.

I am fortunate to be able to project our Web site in the classroom and so I use it for everything from classroom presentations on various topics in art and art history to showing samples of student work, class handouts, lesson plans, activity previews, assignment sheets, worksheets, schedules, and reference links. As a department head, I also use our Web site during area meetings with my colleagues to discuss scheduling, curriculum scope and sequence, or to simply point out promising online resources.

Teachers new to our department have used our Web site to get acquainted with the scope and sequence of the curriculum they are about to teach, and team members are using it to coordinate their teaching with departmental colleagues. Seeing our curriculum literally "at a glance" is leading to new insights and discussions among our team members, and this promises to stimulate some fresh initiatives in curriculum development. Our designated substitute also uses our Web site to keep current with the program and to better prepare her lessons and understanding of what we teach throughout the year.

After only one school year of being online, our Web site has proven to be well worth the time and effort our department has invested in developing it. You can visit the Harvard-Westlake Middle School Visual Arts Department Web site (Figure 7.1) at: http://hw.com/academics/msvisualarts.

Andrew LauGel
Visual Arts Department Head
Harvard-Westlake Middle School
Los Angeles, California

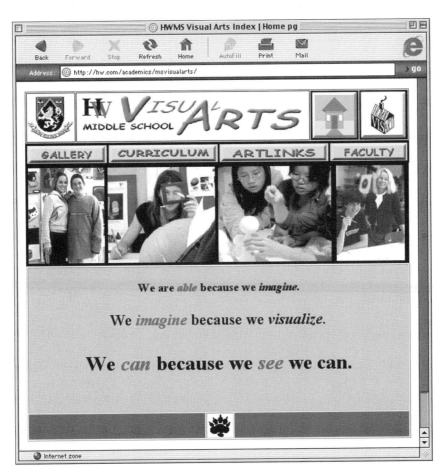

**Figure 7.1** The homepage of the Harvard-Westlake Middle School Visual Arts Department Web site

## How can I create a Web site?

Publishing on the Web involves a four-step process. You need to: (1) gather and develop the content you want to offer on your site; (2) convert your content to HTML code; (3) find a host to store your Web pages on the Internet; and (4) copy the files you create from your computer to the computer that will act as your Web host.

### Developing your Web content

The first step in creating a Web site is to decide what to include on it. For ideas, take a look at what other art teachers have done to create a Web presence for their programs. (A list of art department Web sites is provided near the end of this chapter.) As you visit these sites, make an assessment of the design and visual aspects of each site as well as the content included on it. It goes without saying that an art department Web site should reflect good Web design as well as be rich in content (Figure 7.2).

### Tip

Before you begin developing your department's Web site, read your school district's guidelines or policies regarding publishing on the Web, especially with reference to placing photographs, artwork, and names of students on Web sites.

**Figure 7.2** The homepage for the Spring Branch Independent School District's program in Houston provides a visual overview of the site's contents.

In addition to looking at other art department Web sites, you should identify your target audience and what you expect them to find and do while on your site. If you want parents, community members, and other art teachers as well as students to visit your site, the content you include on it should reflect the needs and interests of this broad audience.

> The more you focus your site on its goals and the more precisely defined your target audience is, the more efficiently and effectively you can present the information.
> • **Robin Williams and John Tollett (1998)**

Once you have completed your initial research, you are ready to make a list of potential content items and then to prioritize them in some way. Decide what should be made available immediately and what can be added later. The following list suggests content items that you might consider including on your art department Web site:

- a statement of your teaching philosophy and goals
- an overview of the art curriculum
- course descriptions
- links to state or national visual arts standards
- sample art units or lesson plans
- an online student art gallery
- your classroom rules
- information for parents
- information on upcoming special events (like a spring art show)
- links to online resources associated with units of study in your classroom
- links to student-oriented Web sites on artists and art history.

Some items might already be available as electronic documents on your computer, whereas others may need to be created from scratch or converted to digital form using a scanner. For convenience, it is a good idea to store all of this material as text and image files initially in the same folder on your computer's hard drive or on removable media like a Zip disk. Further dividing these files into subfolders labeled according to their content or use on the site will facilitate the Web design process. For example, place all image files of student artwork in a subfolder labeled "artwork" or "gallery," files associated with your lessons and curriculum in a subfolder labeled "curriculum," and so on. Creating a sitemap or storyboard can further help to establish the organization of your site and how visitors will navigate through it (Figure 7.3).

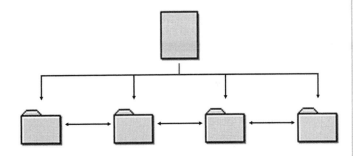

**Figure 7.3** Creating a sitemap of your Web site can help to establish its organizational scheme.

As you assemble items for your Web site, it is important to bear in mind the matter of copyright of any material derived from sources such as textbooks or artwork made by anyone other than yourself. Do not assume that because you are creating a Web site for educational purposes that copyright laws do not apply. For the most part, you need to obtain permission to post any material on your Web site that was created by another individual—including students in your classes (see figure 7.7, page 141). One of the few exceptions here would be items that are in the public domain.[1]

## A primer on selecting and preparing images for the Web

Images and graphics can make or break a Web site. On the one hand, they can convey essential content, draw a visitor's attention and greatly enhance the aesthetic appearance of a site. Then again, they can also divert the viewer from the main content of a page, severely impede a site's performance, and, in effect, cause potential visitors to turn away.

Making wise choices about what images and graphical elements to include in your site is an important part of the Web design process. It is extremely easy and tempting to avail yourself of the abundance of clip art, animated graphics, and stock photographs freely available on the Internet. Even so, you should avoid adding superfluous visual components to your site that become merely distractions on a Web page and needlessly increase its download time. If an image or graphic doesn't serve a useful purpose on your site, seriously consider not using it.

It is equally important to make certain that the images you add to your site download quickly and display properly on different computer screens. Web users are an impatient lot; they will not wait around for slow-loading images to appear on their screens. Also annoying is coming across pages with missing images not prepared properly for display on the Web. In order to prevent such download problems from occurring, you need to keep your file sizes as small as possible without compromising image quality and to save your images in the proper file format.

All of this is especially relevant if you decide to design a Web site for your art program. Chances are you will want to include graphics, photographs, and numerous pictures of student artwork within its pages. In order to produce such an image-intensive site with some efficiency, you need a good image-editing program to use in performing the associated tasks. There are a number of such programs available on the market.

Adobe Photoshop software is by far the most powerful and most popular image-editing program. It is widely thought of as the industry standard for manipulating digital images because of its many sophisticated features. If you are looking for something less complex or less expensive, Adobe Photoshop Elements software is a bare-bones version of its "big brother" for a fraction of its price. Other popular image-editing programs used in art classrooms today include ArcSoft PhotoStudio, Corel PHOTO-PAINT, Macromedia Fireworks, and Jasc Paint Shop Pro. Each of these programs is available at a reasonable price for both Macintosh and Windows computers.

The three factors that are most important to consider when preparing images for the Web are screen resolution, image size, and image file formats. In the following pages, I will examine each of these factors using screen shots from Adobe Photoshop Elements software to illustrate key points.

## Screen resolution

One of the first things to consider when preparing images or graphics for the Web is that most computer monitors have resolutions that vary from 72 to 96 pixels per inch (ppi) as opposed to printers that typically output documents at 300 dots per inch (dpi) or much higher. Consequently, it is generally recommended that you save any image files destined for your Web site at 72 ppi to match the lowest monitor resolution that they are likely to be viewed on. You can easily convert any existing digital images with a higher resolution to 72 ppi using the Image Size controls available with Adobe Photoshop Elements software (Figure 7.4). The lower resolution will reduce the file size of your images without compromising their display quality on the average monitor.

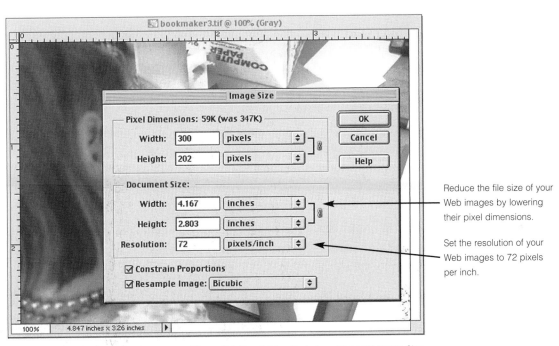

Reduce the file size of your Web images by lowering their pixel dimensions.

Set the resolution of your Web images to 72 pixels per inch.

**Figure 7.4** Use Adobe Photoshop Elements' Image Size controls to resize your images and to change their resolution to 72 pixels per inch.

## Image size

Reducing the physical dimensions (height and width) of your images is another way to keep file sizes down and to increase the overall friendliness of your Web pages. Images that you scan or take with a digital camera are often too large to insert into a Web page. You can usually reduce the size of an image by 40 to 50 percent without losing any significant details or sharpness. In addition, you can crop an image more tightly to strengthen its composition and to remove unnecessary details (Figure 7.5).

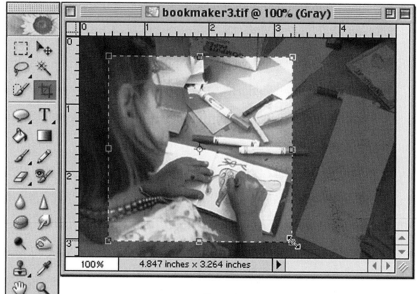

**Figure 7.5** Use Adobe Photoshop Elements' Crop tool to select the portion of the photograph or graphic that you want to use and to cut away the rest.

If you plan to include an image gallery of photographs or student artwork on your Web site, it is always better to provide small previews, called thumbnails, that visitors can click on to view full-sized versions of the same images displayed on separate pages. Choose a sensible size for all your large images (300 x 200 pixels) and their matching thumbnail images (100 x 75 pixels). Then use your image-editing program to resize each set of images before saving them in an appropriate file format.

**Image File Formats**

The two most common image file formats used on the Web today are GIF and JPEG. Each format has its strengths and is best suited for a particular type of image:

- The GIF (Graphic Interchange Format) format is limited to a palette of 256 colors and is appropriate for line art, illustrations, logos, icons, graphical text, navigational buttons, and other graphics created with a small number of flat colors. One benefit of using the GIF format is that you can select a color in your image to be transparent so the background color of a Web page will show through part of the image. You can also use the GIF format to create simple animations.
- The JPEG (Joint Photographic Experts Group) format can contain up to 16.7 million colors and is appropriate for photographs, watercolors, pastel or charcoal drawings, and other images that have subtle gradations of tones. When image quality is paramount, it is best to use the JPEG format.

Each of these formats employs a different compression method to reduce the file size of an image so that it will download quickly from the Web to a user's computer. In addition, there are steps that you can take with each format to further reduce the size of an image file before saving it.

The GIF format uses a lossless compression technique that results in crisp edges and sharp details. You can further reduce the size of a GIF file by choosing fewer than the standard 256 colors used to render it. This technique works especially well with graphics like logos and navigational buttons that do not use more than a handful of colors in the first place.

Conversely, the JPEG format uses a lossy compression technique that selectively discards data causing image details and edges to appear slightly blurred. With Adobe Photoshop Elements software, you can choose different levels of compression (low, medium, and high) when saving JPEG files (Figure 7.6). The more you compress a JPEG file, the smaller the file size, but the lower the image quality. To determine which level is best for a particular image, you simply have to experiment with different settings until you achieve an optimal balance of image quality and file size.

**Figure 7.6** Use Adobe Photoshop Elements' Save for the Web feature to select the level of compression for a JPEG file before saving it to your hard drive or disk.

Keep in mind that when saving images for the Web in one of these formats you need to include the appropriate extension on the filename. GIF files should always end with the .gif extension (e.g., image1.gif) whereas JPEG files should always end with the three-letter .jpg extension (e.g., image2.jpg). Otherwise, your graphics will not load properly on a Web page.

This primer has introduced many of the key issues involved when working with images on the Web. In the end, experience will be your best guide in learning how to prepare your images and graphics for the Web properly.

## Sample Permission Form for
## Publishing Student Work on the World Wide Web

Date: _____

Name of Student: _____

Age of Student: _____ Grade Level: _____

Title or Type of Artwork: _____

Sponsoring Teacher: _____

School: _____

Location of Web site: http://_____

Your daughter or son's artwork, writing or other school project is being considered for publication on the school's Art Department Web site. If published, the work will be identified using your child's first name only, his or her grade level, the title of the work and the art media used to create it. No other personal information will appear with the work.

By signing this form, you affirm that you are the parent or the legal guardian of the above-named student and that you grant permission for <name of school> to publish your child's work on the World Wide Web under the conditions described above. Failure to return this signed form indicates that you do not want your child's work to be published.

Parent/Legal Guardian's Name (print): _____    Date: _____

Signature: _____

Address: _____ Telephone Number: _____

If you have any questions regarding this matter, please contact <name of teacher> at <school's telephone number>.

I, the student, also give my permission for publishing my work on the World Wide Web.

Student's Name (print): _____    Date: _____

Signature: _____

This form will be kept on file in the Art Department office.

**Figure 7.7** Sample Parental Permission Form: You must obtain written parental permission for any student under the age of eighteen whose work you plan to publish on the Web.

## Converting your content to HTML code

Once you have gathered together the material you intend to publish on your Web site, the next step is to convert it to HTML code. To do so, you have to learn how to write the HTML code yourself or use Web-authoring software that writes the code for you.

As discussed in Chapter 3, HTML consists of special commands (called tags) that determine the layout and behavior of Web pages. The thought of having to spend hours learning HTML and creating Web pages from scratch is intimidating to many teachers. While it does take time to completely master HTML, it is not a difficult language to learn. Once you have grasped the basics of HTML, you can start making simple Web pages almost immediately. As you learn more about HTML, you will be able to spice up your Web pages with more interesting layouts and other enhancements (such as interactive and multimedia features).

Writing your own tags gives you complete control over the look and behavior of your Web pages, and you do not need to purchase special software to program in HTML. Any word processing program will do.

If learning to program in HTML is not for you, several alternatives are available (Table 7.1). There are a number of Web-authoring software programs on the market that allow you to build Web sites without ever seeing any HTML code. These programs are often referred to as WYSIWYG (pronounced "whizzi-wig" or "What You See Is What You Get") Web editors. They let you create a Web page by simply pasting text and dropping images where you want them on the page. To make adjustments in the page, you simply highlight an item and then select from the options available in pull-down menus. While you are doing all this, the software is busy working behind the scene, generating the necessary HTML code.

| Software and Source | Description |
|---|---|
| **BBEdit HTML Editor**<br>Bare Bones Software<br>www.barebones.com | This HTML Text Editor is available for Macintosh computers and requires a basic knowledge of HTML |
| **CoffeeCup HTML Editor**<br>CoffeeCup<br>www.coffeecup.com | This HTML Text Editor is available for Windows computers only and requires a basic knowledge of HTML. |
| **Dreamweaver Web-authoring software**<br>Macromedia<br>www.macromedia.com | This WYSIWYG Web editor is available for Windows and Macintosh computers. |
| **FrontPage Web-authoring software**<br>Microsoft<br>www.microsoft.com | This WYSIWYG Web editor is available for Windows and Macintosh computers. |
| **GoLive Web-authoring software**<br>Adobe<br>www.adobe.com | This WYSIWYG Web editor is available for Windows and Macintosh computers. |
| **Netscape Composer**<br>Netscape Communications<br>home.netscape.com | This free WYSIWYG Web editor is available for Windows and Macintosh computers with Netscape Navigator. |

**Table 7.1** Web-authoring tools

**Figure 7.8** Netscape Composer is an easy-to-use Web-authoring software program that allows you to drag-and-drop images and paste text onto your Web pages.

While these programs do take some time to learn how to use, Web-authoring software relieves you from having to spend hours learning HTML and writing long pages of code. Moreover, the Web design process is more intuitive than when programming directly in HTML.

Adobe GoLive, Microsoft FrontPage and Macromedia Dreamweaver are some of the most popular Web-authoring software programs being used today. If you are interested in learning how to use one of these programs, there are numerous "how to" books and online tutorials that will help you to get started. Also, ask around your school to see if any colleagues or students have created Web pages with one of these programs and are willing to offer you assistance. Having someone available to answer your technical questions can greatly reduce your learning curve.

Another possibility is to use Netscape Composer, which is a free WYSIWYG Web editor (Figure 7.8) that comes bundled with Netscape Navigator. It allows you to create and edit simple Web pages and then upload (or publish) them to a host computer on the Internet.

In addition to Web-authoring programs, there are several inexpensive shareware programs, like Coffee-Cup HTML Editor for Windows computers and BB-Edit HTML Editor for Macintosh computers, that can be downloaded from the Internet for a nominal fee. These programs typically come with a number of templates and time-saving wizards that will help you get your Web pages online quickly. While they perform many of the tasks required to create a Web page, you need to have a basic knowledge of HTML to get the most out of these programs.

# Six principles of good Web design

Designing a Web site requires an eye for visual design, consideration for your audience, some knowledge of the technical aspects of the Web, and, of course, worthwhile content to offer. As you set out to design your art department's Web site, keep the following six principles in mind.

### 1. Consistency

Make it easy for visitors to understand the structure of your site by keeping the design uniform throughout its pages. Using the same layout, fonts, color palettes, and navigational scheme on every page will make your site visually consistent and user-friendly. An easy way to achieve this consistency is to create, save, and test a page template to begin with and then use it to produce all the pages on the site.

### 2. Convenience

Make it easy for visitors to find their way around your site. Place a masthead or title at the top of every page that identifies the site and include consistent navigational links to the main pages of the site such as the homepage. Consider providing a site map or index page that offers an overview of the site and links to every page.

### 3. Readability

Make it easy for visitors to read your pages and to find information. Choose a text color that is easy to read against your chosen background color, such as a dark text on a light background. Avoid placing text against a patterned background, which makes it difficult to read. Break the text into meaningful chunks to make it more readable. Give titles, subtitles, and content text a different visual treatment to establish their hierarchy on a page. Make judicious use of "white space" between sections of text and between text and images to give your pages an uncluttered look. Avoid making your visitors scroll in two directions to view the contents of a page.

### 4. Speed

Make it easy for visitors to download your pages. If your pages take longer than 20 seconds or so to download with a 56K modem, you will likely lose visitors to your site. Reduce the download time of your site by keeping the number of images (especially large ones) on each page to a minimum. Consider using thumbnail images as links to larger images that appear on their own pop-up pages. Recycle graphics (such as banners, buttons, and icons) throughout your site to decrease the download time for each page. This in turn will make the site more visually consistent. Most important, refrain from gratuitous use of graphics (especially animated ones) that add nothing more than "eye candy" on your pages.

### 5. Accessibility

Make your site accessible to a broad audience. Your pages may look great on your computer; but someone visiting your site using a different browser, computer, or monitor may see something quite different or

may not see the pages at all.  While it is impossible to accommodate everyone who might visit your site, there are things you can do that will make your pages compatible with various hardware and software configurations. For instance, use a standard font (such as Arial or Times Roman) for the text on your pages rather than a specialty font (like Broadway or Perpetua) that most visitors are unlikely to have available on their computers. Be considerate of those who access your site using a standard dial-up connection by keeping your page sizes as small as possible. The size of a Web page includes the size of the HTML code, plus the size of each image file, and any additional elements (like musical files) added to the page. For example, if you include four images that are 10K each to a HTML page that is also 10K in size, your overall Web page is 50K in size. Ideally, you should keep your Web page sizes to less than 40K.

Also, bear in mind that the screen resolution of your visitors' monitors will vary and that this will influence how your pages are seen (Figure 7.9). Conventional wisdom currently suggests that you should design your Web pages for monitors set at 800 x 600 pixels—the most common screen resolution among Web users worldwide. However, most computer monitors sold today are set at 1024 x 768 pixels or higher. Consequently, the industry standard is likely to shift to a higher resolution in the near future.

1024 x 768 pixels

**Figure 7.9** The same Web page as seen on three different screen resolutions

800 x 600 pixels

640 x 480 pixels

## 6. Testing

Before launching your site, test all of its pages with as many different computers and monitors as possible as well as with different versions of Internet Explorer and Netscape Navigator. Although you may not be able to fix all the irregularities that occur with different systems, finding out how your pages look to others—especially to your target audience—will enable you to troubleshoot the problems visitors may encounter on your site before you go live.

If you are looking for the quickest and easiest way to create a Web page, there are a number of places to go on the Web that allow you create and publish Web pages at no charge. You do not need to know anything about HTML to use these services. You simply type the information you want on your page into one of the templates provided, choose from various formatting options, and with the click of a button you have your own Web page.

The chief advantage of using one of these Web-hosting sites is, of course, that the service is free. They also make the process of creating a Web page quick and easy to accomplish. However, there are trade-offs with these free-service sites. While some Web hosting services offer tools for creating sophisticated Web pages, the templates and choices typically offered for basic page layouts are rather limited. Also, you have to put up with advertising banners being displayed on your Web page, which in effect permit the Web hosting service to be offered to you at no cost.

Some of the sites that offer free Web-hosting services to teachers include TeAch-nology, TeacherWebsite, and Scholastic's Class Homepage Builder. Each of these sites takes you step by step through the process of creating Web pages and posting them on their Web servers. There is also an easy-to-use online template called the Homepage Maker on Teachers.net that you can use to make your own Web page, which is sent as an attachment to your e-mail address. You can then post it on your school's Web server.

Many school districts offer workshops and technical assistance to help their teachers get on the Web. In some schools, a person is assigned as "Webmaster" to handle all of the responsibilities of posting and managing Web pages for teachers. While this type of support service releases teachers from having to deal with the technical aspects of Web site management, it often requires patience and negotiation with the school's Webmaster in order to get updates or changes to a Web site done in a timely manner.

**Free Web hosting services**

**Scholastic's Class Homepage Builder**
teacher.scholastic.com/homepagebuilder

**TeAch-nology**
www.teach-nology.com

**Teachers.net Homepage Maker**
www.teachers.net/sampler

**TeacherWebsite.com**
www.teacherwebsite.com

## Reflections of a wired art teacher . . .

I have met several art teachers who are intimidated by the idea of creating a Web site because of their lack of technology expertise. But you do not necessarily have to know how the technology works to create a Web site. There is a number of Web-authoring software programs available today that allow you to design and publish Web pages quickly and easily. The challenge lies in overcoming our fears in trying something new. A positive attitude toward technology can easily overcome the lack of technology skills.

A teacher needs a computer with Internet access, a digital camera or scanner, photo-editing software and Web-authoring software, and most important plenty of time to create a Web site and to maintain it. I have learned from experience to set up my Web site so that it appears to always have new material, without the time commitment I once made to it. My site features recent school events, links to newly created Web pages, and announcements on the main pages of the site. The majority of my site is composed of informative pages that rarely change, which I add to when I have the opportunity.

Be sure to obtain written permission from students and from their parents if you intend to publish student artwork or photographs of students in your classroom on your Web site. Also be aware of other legal issues that may affect what you can and cannot publish online. Cite the source of any materials you use on your Web site that were written or created by someone else, and teach your students to do the same when they are doing online research or designing their own Web sites. You can visit my Web site (Figure 7.10) at: http://harrell.srhs.net.

Michelle Hardison Harrell
Southeast Raleigh High School
Raleigh, North Carolina

Michelle offers web design workshops for art teachers and can be contacted via e-mail at mharrell@wcpss.net for more information.

**Figure 7.10** The homepage of Michelle Hardison Harrell's Web site

## Find an Internet host to store your Web pages

Once you have created one or more Web pages and are ready to show them in public, you need to transfer (upload) them to a Web server on the Internet. While most teachers post Web pages on their school's Web server, there are other alternatives.

If you use one of the free Web-hosting services mentioned on page 146, you can post your pages on their server at no charge. Or if you have your own Internet Service Provider at home, chances are you will be given Web space for hosting a site as part of the service.

Check your Yellow Pages for local ISP companies that provide Web site hosting services. Most charge a nominal monthly or annual fee for hosting a Web site. Before you choose one of these companies, inquire about their technical support services, how much space they give you for your Web site, their security features, and whether they offer any additional services like a chat room or a bulletin board that you can install on your Web site.

## Upload your pages to a Web server

In order for others to see your Web pages on the Internet, you have to transfer (upload) them to your Web host's server. One way to accomplish this task is by using an FTP program such as Fetch (Figure 7.11) for Macintosh Computers or WS_FTP for Windows computers.

Another option is to use Web-authoring software with publishing features that enable you to upload your pages to a Web server. Whichever way you may choose, ask your ISP (or school's Webmaster) about the best way to upload your files to their server and the Internet address you need to accomplish this task. While uploading files to the Web is easy to do, it may be helpful to ask someone who has done it before to assist you the first time you do it.

**FTP Software**

**Fetch** (for Macintosh computers)
Fetch Softworks
www.fetchsoftworks.com

**WS_FTP** (for Windows computers)
Ipswitch
www.ipswitch.com

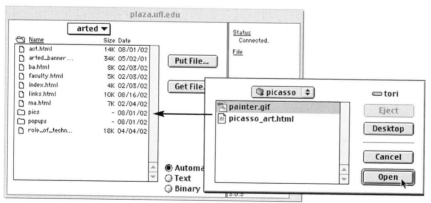

**Figure 7.11** With the FTP program Fetch, you select the file(s) you want to upload to your Web host in the window on the right. Once the file is transferred, it will show up in the window on the left.

## If you build it, will they come?

Once you have uploaded your pages to the Web, there are still a few things to do. First, you need to test each page to make sure that all of the links work and that any images you included on a page show up properly. Open your browser, enter the Web address (or URL) of your site's homepage into the location bar, and press the Return or Enter key. If you do not know the URL of your homepage, ask the school's Webmaster or your ISP for assistance. If you find broken links or missing images, you will need to reexamine the pages in your Web-authoring software program, fix the problem, and then upload the corrected files again. Also, do not forget to proofread your pages and correct typos and any grammatical or spelling errors.

Next, you need to let others know that you are on the Web! If you belong to an art education mailing list, use it to announce the launch of your Web site and invite other teachers to visit your site and to offer feedback. Also, include the URL of your Web site on all e-mail messages and printed materials you send out from your desk.

Lastly, continue to improve and update your site. A Web site is never finished. From time to time, it is important to update your site with new content and to check any links to external sites to make sure they are still active.

**An art teacher shares her experience in developing a Web-based student art gallery for her school . . .**

I love sharing the creative and beautiful artwork of my students with other people. As a twenty-four-year veteran of teaching art, I have used traditional photography over the years to record countless images of my students' work. I placed these images in scrapbooks and slide shows that I frequently shared with parents, colleagues, administrators, and students. These scrapbooks and trays of photos were archived evidence of our art program in action. However, it was quite costly and time-consuming to keep having these photos developed professionally, not to mention the cost of plastic sleeves and notebooks and the space they consumed. I discovered that developing an online student art gallery offered a much more creative, efficient, and cost-effective way to share the work of my talented students with a vastly larger audience.

The first tasks I faced in creating our Web gallery were to learn how to use a digital camera and Adobe Photoshop, the popular digital-imaging software program. Our school's Technology Department was highly supportive of my early shaky ventures into the digital world. While taking a three-day workshop on Adobe Photoshop software greatly helped my progress and self-confidence, the way I really learned to use this program was by just getting into it and playing with the seemingly endless possibilities it offered. It did not take long for me to learn how to scan my photos, enhance them if needed, save them on disk, and so on.

Once comfortable with the digital camera and Adobe Photoshop, I began working with Macromedia Dreamweaver Web-authoring software to create our online gallery. While I had no idea initially how to create the actual Web pages, I did know what I wanted our online gallery to look like. Learning how to use the Web design tools available in Dreamweaver software was more challenging than learning to use Adobe Photoshop software. I really depended upon my school's technology team for assistance, and a three-day workshop on using Dreamweaver software was very helpful.

With the basic design of our online gallery completed, it is now just a matter of updating the pages several times a year to keep it fresh and current. Since our school's overall Web site has grown so large over the years, we are currently using an external Web designer to manage the site. To update our online gallery, I simply take digital photos of student work and then send them to the Web management team to do the rest. I no longer have to do the work of adding and deleting images on the site myself.

I have been amazed by the great things that have happened for our students as a result of our online gallery. A textbook author and illustrator recently saw our site and solicited six of our students' artworks

for inclusion in her book. We have also been featured in a number of prominent art education Web sites. The time it took to learn how to use the technology, design the site, and maintain it has benefited our students, our program, and my record keeping in countless ways. Now, whenever I want to share anything with students, parents, administrators, or fellow art educators on the Internet, all I have to do is refer them to our online gallery.

To visit our online gallery (Figure 7.12), go to: http://www.sjs.org, then click on "Arts" and "An Arts Story."

Linda Woods
Art Teacher
St. John's Lower School
Houston, Texas

**Figure 7.12** The Web site for St. John's Lower School in Houston consists of multiple online galleries of student artwork.

## Try This: Take a look at these art department Web sites

**Directions:** Visit three of the art department sites listed below. Compare and contrast the sites you visit to evaluate overall visual design and layout, content, navigational features, and how student artwork is presented.

### Elementary and middle school

### Art Is Fun

www.artisfun.net

    Jacqui Derby created this site that features class information, links to online art resources, and a gallery of artwork by her students at Alta Vista Middle School in Carlsbad, New Mexico.

### Aurora Middle School Art Department

Aurora, Nebraska

www.esu9.org/~swegenas/midart

Sarah Wegenast created this site that includes several exhibitions of student artwork, information about the school's art curriculum, and links to online art resources.

### Harvard-Westlake Middle School Visual Arts

Los Angeles, California

hw.com/academics/msvisualarts

This site includes an overview of the school's art curriculum, illustrated descriptions of art courses and projects, a gallery of student artwork, and a collection of links to online curriculum resources.

### St. John's Lower School Art Gallery

Houston, Texas

www.sjs.org/arts/story

This site includes an overview of the school's art curriculum, an art calendar, and galleries of student artwork.

## High school

### Horton High School Art Department

Greenwich, NS, Canada

www.horton.ednet.ns.ca/staff/syme

This site, created by Paul Syme, is jam-packed with curriculum materials, student artwork, and projects done in traditional and newer media, links to online art resources, and more.

### Mrs. Harrell's Online Artroom

Southeast Raleigh High School

Raleigh, North Carolina

harrell.srhs.net

Michelle Hardison Harrell created this site that includes course descriptions and assignments, information for parents and other art teachers, photo galleries, plus links to other art teachers' Web sites and art resources.

### Monte Vista High School Art

Monte Vista, Colorado

monte.k12.co.us/high/hsdepts/art

Dan Garcia created this site that features galleries of artwork by current and former students, plus links to online art resources.

### North Pole High School Art Department

North Pole, Alaska

www.northstar.k12.ak.us/schools/nph/depts/fineart/art

This site, created by Tyrell Robinson, includes art course descriptions, information about special events, and galleries of student artwork from past years.

### South Gwinnett High School Art Department

Snellville, Georgia

www.sghsart.com

This site, created by Dianne Bush, includes an overview of the school's art curriculum, art course materials, a gallery of student artwork, and links to online art resources.

## District-level sites

### Millard Art Collection

Omaha, Nebraska

www.esu3.org/districts/millard/millART/millART.html

This site, designed by the millART WWW Development Team, features galleries of student artwork, an overview of the district's K–12 art curriculum, a searchable database of art lessons for local art teachers, plus links to art museum sites and other curriculum resources.

### Roanoke County Schools Art Department

Roanoke, Virginia

www.rcs.k12.va.us/art

On this site, created by Lazzelle Parker, you will find information about the district's K–12 art program, including a teaching philosophy and goals statement, online curriculum guides, exhibitions of student artwork, virtual tours of art classrooms and local shows, a yearly calendar, the Visual Arts Standards of Learning for Virginia Public Schools, and a comprehensive list of links to online resources.

### Spring Branch Independent School District Art Department

Houston, Texas

www.springbranchisd.com/instruc/art/artindex.html

This site provides a wealth of information on the district's art programs including philosophy statements, course descriptions, a calendar of important dates, descriptions of special events, exhibitions of student artwork, and a link to the Texas Essential Knowledge and Skills (TEKS) Standards for Fine Arts.

## Conclusion

A Web site for your department can be a great resource for facilitating student learning, reaching out to parents, and promoting your art program in the community and beyond. While building a Web site from scratch is a tedious and time-comsuming task, fortunately there are now many excellent Web-authoring tools that take away some of the more menial aspects of Web page creation. These tools enable teachers to focus on the content and look of their Web pages without having to worry about the details of the underlying HTML code.

## Useful Web sites

### FrontPage 2000 in the Classroom

www.actden.com/fp2000/java

This is a twelve-unit tutorial designed for K–12 teachers who want to use FrontPage 2000 Web-authoring software to design a Web site or to teach their students how to make their own Web sites.

### Getting Started with HTML

www.w3.org/MarkUp/Guide

Dave Raggett provides a basic introduction to creating Web pages in HTML with links to tutorials covering more advanced HTML techniques.

### Golive Basics

www.golivebasics.com

This site offers a number of tutorials on using Adobe Golive Web-authoring software to create a Web site, along with links to related online resources.

### Macromedia Dreamweaver Support Center

www.macromedia.com/support/dreamweaver

Here will you find a number of tutorials on developing a Web site with Macromedia Dreamweaver MX Web-authoring software.

### WebTeacher Tutorial: Homepage Construction

www.webteacher.org

This is a comprehensive sixteen-part tutorial on creating Web pages in HTML.

### Web Style Guide

www.webstyleguide.com

This well-organized site is a comprehensive guide to understanding the fundamentals of Web design, based on Patrick Lynch and Sarah Horton's book by the same title.

# Guiding Student Art Research on the Internet

## CHAPTER 8

Not only must you acquire the skill of finding things, you must also acquire the ability to use these things in your life.
• **Paul Gilster (1997)**

This chapter introduces guidelines and practical strategies for effectively combining Internet resources and technologies with opportunities for students to conduct online research into art and visual culture. Later chapters examine additional topics essential to broadening students' research skills through Internet-based activities involving collaborative work and on-line publishing.

## Why should your students do art research on the Internet?

The use of the Internet as a tool for conducting remote research opens up new avenues for supporting student learning in the art classroom. In addition to allowing communication with art experts through e-mail, use of the Web offers instant access to a wealth of art information and resources that were not previously available in schools.

As we saw in Chapter 6, these resources come from all over the world and arrive at your desktop in many forms, including digital image archives, online art journals and newspapers, online museum collections and educational materials, virtual art galleries, and more. With an Internet-connected computer, students can tap into these global resources in combination with local research tools and traditional printed materials like the school library and textbooks when doing research projects in their art classes.

Besides increased accessibility to historical materials, the Web also provides an abundance of up-to-date information on current exhibitions, and issues and trends in contemporary art and culture. Until recently, elementary and secondary art programs have largely ignored the work of new and emerging artists, due, in part, to the dire lack of relevant educational resources. With the spread of the Internet in schools, teachers and students can now see and study the latest art being made today through the Web sites of contemporary art museums, commercial galleries, alternative exhibition spaces, and individual artists.

The Web is an ideal medium for pursuing classroom investigations into the issues, questions, and themes that contemporary artists explore in their work. These authentic inquiries can be integrated into students' art educational experiences and serve as points of departure for their own creative pursuits.

Another benefit of having students conduct online research is that they take a more active role in their own learning and are motivated to use their critical-thinking skills. A project-oriented curriculum involving online research requires students to locate, interpret, evaluate, organize, synthesize, and present the information they find—transforming it into knowledge in the process. Teachers play an integral part in fostering the development of these skills by scaffolding the inquiry process and by guiding students through huge quantities of information, making sure they are obtaining accurate information and staying on task (McKenzie, 1999; Dodge, 1998).

## Getting started

In order for students to effectively use the Internet as a research tool, we must set them up for success. To begin with, this means ensuring that all students are able to perform basic computer skills such as word processing; creating, opening, and saving documents; and using a Web browser. Before engaging your students in online research, it's a good idea to determine what they already know and are able to do with computers. While most students today are adept at using computers and the Internet, it may be necessary to review basic procedures with students who have limited computer experience.

Another thing to consider is how your students will actually use the Internet to conduct their research projects. Older students typically are able to conduct more complex research projects and effectively search the Web on their own for information. With younger students, it is wise to limit the number of Web sites they can visit by creating a hotlist that offers direct links to pre-selected resources.

Lastly, you'll need to schedule time for everyone in class to use the Internet. Depending on how many Internet-connected computers are available, you may need to rotate computer access among your students. Teachers in a one-computer classroom often create a "round robin" schedule so that students take turns working individually or in pairs on the computer as the rest of the class works on other activities. The first student to complete work on the computer helps the next student get started, and so on. In addition to the benefit of having students teaching students, this approach also allows the teacher and students to become comfortable with using the computer while continuing with the rest of the curriculum.

## Questions, worksheets, and virtual treasure hunts

Any art learning experience is more successful when accompanied by structured activities that foster critical inquiry leading to tangible, creative outcomes. Achieving this result requires planning, and many potential models exist that art teachers can draw upon for ideas. This section examines some of the most popular pedagogical strategies used by teachers to engage students in Internet-based research, and recommends a number of "best practices" for integrating this type of online learning activity into an art curriculum. Regardless of whether you have one Internet-connected computer in your classroom or many, these strategies are adaptable to a myriad of different situations.

One of the easiest ways to involve students in Internet-based research is by using instructive or informative Web sites to reinforce or supplement traditional curricular activities. If you are teaching a lesson on printmaking, for example, the Museum of Modern Art's Web site has an animated feature called "What Is a Print?" where students can learn how etchings, lithographs, screen prints, and woodcuts are made while watching interactive demonstrations of each art form. If you are teaching a lesson on the art of portraiture, students could visit the Smithsonian Institution's "Eye Contact—Modern American Portrait Drawings from the National Portrait Gallery." While there, they might compare different approaches to portraiture or search for clues in the drawings that reveal the character of the sitters. Likewise, to augment a lesson on landscape art, students could visit the Virtual Museum of Canada's online "Panoramas" exhibition and examine different ways that artists in North America have interpreted the subject of the landscape.

Whatever your lesson objectives, there are a number of pertinent Web sites that students can explore to enhance their learning in art. Many of the Web sites referenced in Chapter 6 and some of the tutorials discussed in Chapter 5 are appropriate for student use. ArtLex, created by art educator Michael Delahunt, is a helpful site where high school students can look up definitions of terms used to discuss art and visual culture. Another site called "Eyes on Art 2," by Web-based educational designer Tom March, includes a series of interactive tutorials intended to engage students in learning how to look at art. There are also sites where students can learn about the life and art of Romare Bearden, study the prints of Katsushika Hokusai, read letters written by Vincent van Gogh (Figure 8.1), and more. The challenge is not so much in locating good Web resources to supplement your curriculum as it is in determining how to make the best use of them in the classroom.

**Figure 8.1** Students can read letters exchanged between Vincent and Theo van Gogh on this site sponsored by WebExhibits.org.

## Useful online art resources for student research projects

Here is a sampling of Web sites that are suitable for use by students when conducting online research in art.

### ArtLex—A Dictionary of Visual Art

www.artlex.com

This site contains definitions of more than thirty-five hundred art-related terms along with thousands of images, pronunciation notes, and quotations.

### The Art of Romare Bearden

www.nga.gov/feature/bearden

This site, from the National Gallery of Art, examines the personal interests, techniques, and subjects evident in the work of Romare Bearden.

### Eye Contact—Modern American Portrait Drawings from the National Portrait Gallery

www.npg.si.edu/cexh/eye

This site consists of an interactive exhibition of portrait drawings dating from the 1880s that, viewed together, reflect the ways in which the art of portraiture has changed over the years.

### Eyes on Art 2

www.kn.pacbell.com/wired/art2

This site offers a series of interactive tutorials designed to engage students in learning how to look at art.

### Katsushika Hokusai

www.csse.monash.edu.au/~jwb/ukiyoe/hokusai.html

This site, created by Professor Jim Breen, includes selected works by the Japanese artist and printmaker Katsushika Hokusai and a brief biography of his life.

### Panoramas—The North American Landscape in Art

www.virtualmuseum.ca/Exhibitions/Landscapes

This site, from the Virtual Museum of Canada, offers an in-depth look at different ways that artists in North America have interpreted the theme of the landscape.

### van Gogh's Letters—Unabridged and Annotated

webexhibits.org/vangogh

This site, from WebExhibits.org, provides a searchable database and topical directory of nearly all the letters exchanged between Vincent van Gogh and his brother, Theo (Figure 8.1).

### What Is a Print?

www.moma.org/whatisaprint

This feature on the Museum of Modern Art's Web site, offers examples and interactive demonstrations of the four major print forms: etching, lithography, screen printing, and woodcuts.

## Essential questions

Effective use of the Internet for student inquiry depends a great deal on framing a good research task or question that challenges students to locate, gather, and synthesize information in authentic, meaningful, and original ways. Asking students to find out all they can about a particular artist and then write a report too often results in them rehashing someone else's research or, worse yet, "cut-and-paste" plagiarism. Internet-based assignments, instead, should encourage students "to think, explore and make meaning for themselves" (McKenzie, 1998, p.31). Such a pedagogical approach is consistent with constructivist views of learning (Jonassen et al.,1999; Perkins, 1992).

The growing consensus in the educational community is that all learning activities (Internet-based and otherwise) should focus on exploring essential questions.[1] Simply put, essential questions challenge us to think about things that matter. They point to the significant ideas, issues, and controversies of a discipline. Essential questions are typically open-ended with no obvious, correct answer. They are so compelling and enduring that people have raised them many times and in many different ways over the years. Most important, essential questions are the questions we want students to continue to ponder long after they have left our classrooms.

Questions and questioning may be the most powerful technologies of all.
• **Jamie McKenzie (2000)**

Some essential questions that seem germane to the study of art and visual culture include:

- Why do people make art?
- What do people say about art?
- Who decides what art is or is not?
- Why are some things considered to be art and other things are not?
- How does art connect us to each other?
- What is the role of the artist in society?
- How can art make a community better?
- How can art help us to see things differently?
- How do images shape our perceptions of the world and ourselves?
- How do images, objects, and events convey cultural values, beliefs, and roles?

Essential questions are sometimes too broad or abstract for students, so you may need to generate further, more pointed questions to guide their research activities. For example, the essential question "Why do people make art?" might lead to students investigating questions like "Why do contemporary artists do what they do?" or "How does art function in African cultures?" The overarching question "How do images shape our perceptions of the world and ourselves?" could frame a whole unit or curriculum, whereas individual student inquiries might focus on related questions such as "How does advertising affect our personal behaviors, beliefs, and desires?" or "To what extent can you trust a photograph?"

## Worksheets

Teachers often create worksheets to help guide students in exploring Web sites. The example shown below in Figure 8.2 illustrates how open-ended questions can be more effective in fostering deeper thinking than simple fact-finding, and can lead students to delve into a Web site in a meaningful manner.

Holding a class discussion once everyone has completed their worksheets provides an opportunity for sharing individual responses, comparing different perspectives, and making connections to larger questions and issues. These discussions can serve as springboards for students' critical-thinking skills and their own creative pursuits in the classroom.

---

## The Role of art in public places

Name: _____  Class Period: _____  Date: _____

**Essential questions:** Why do people make art? How does art connect us to each other? What is the role of the artist in society?

**Directions:** Go to the *Adams Avenue: A Work In Progress* site at: http://gothere.com/AdamsAve/Banners. This site describes a 1998 public art project in San Diego, California, in which eleven artists created 120 banners celebrating community revitalization in the Adams Avenue commercial district. Click on the title under each banner to see more banners and to read each artist's statement. Once you have examined all the banners on the site, respond to the following questions as best you can.

1. How do these banners promote community identity?

2. Which artist's banners impress you as being striking, beautiful, or provocative? What makes these particular banners so unique?

3. What issues does an artist have to consider when creating work for a public place?

4. What possible benefits would come from placing public art in a city's business district?

5. Who should choose the art for a city's public spaces? What standards should they use to select the work?

6. Why do you suppose some people approve of governments spending large amounts of money on public art and others do not

---

**Figure 8.2** Sample research worksheet

## KWL charts

Many teachers have found KWL charts to be an effective tool in scaffolding the inquiry process, both on and off the Internet. A KWL chart is a graphic organizer that students use to record what they know, want to know, and have learned about a particular topic (Ogle, 1986). To create a KWL chart, have each student fold a piece of paper into three sections and write "What I Know," "What I Want to Know," and "What I Learned" at the top of the columns (Figure 8.3). With small groups or a whole class, you might use markers and large roll paper taped to a wall or a whiteboard to create a large KWL chart that everyone contributes to and uses for research purposes.

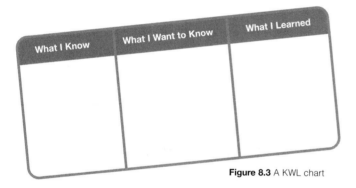

**Figure 8.3** A KWL chart

In the first column, ask students to write down everything they know about the topic of study, say, *American Gothic* by Grant Wood. In the second column, have the students jot down questions indicating what they want to know about the topic. For example, students might be curious about the identity of the two people portrayed in the painting and why the artist depicted them the way he did.

Students often need coaching on asking and refining questions that can open up a topic to authentic inquiry. Questions that start with "who," "what," "when," "where," "why," or "how" generally lend themselves to worthwhile investigations. For example, questions like "What is the artist trying to show or say through this work?" "Where did the idea come from for this painting?" "Why did the artist paint the picture in this way?" and "How did the artist make this work?" all point to significant content and issues involving the interpretation and study of works of art. The important thing here is not to simply dictate the questions; rather it is to help students formulate their own investigative questions based upon their prior knowledge and inquisitiveness about the topic of study.

Once students have settled on their questions, the next step is to send them online to search for answers. Depending on the age of the students, the amount of classroom time available, and the complexity of the subject matter, a single Web site or several sites might serve as sources of information (Figure 8.4). In some cases, you might choose to have students search for their own sites using a kid-friendly search engine or directory. For most situations, though, students' online investigations should be restricted to sites that you have pre-selected for their use. Regardless of the approach taken, remind the students that their purpose is to search for answers to their questions and to either confirm or disprove what they thought they knew about the topic of study.

As students work online, they should take notes about what they learn in the third column on their KWL charts. In addition to recording answers to their questions, students should be encouraged to jot down any interesting facts uncovered in their research that they feel others should know. Students can then use their completed KWL charts to reflect upon and summarize what they have learned in a written report or other form of presentation. Teachers can use the completed KWL charts to assess students' understandings at each stage of the research process as well as the suitability of the Web resources used for the assignment.

### *American Gothic* online

Here are three sites where students can find information on Grant Wood's *American Gothic*.

**Art Access—Grant Wood**

www.artic.edu/artaccess/AA_Modern/pages/MOD_5.shtml

The Art Institute of Chicago offers a brief historical account of Grant Wood's most famous painting, which hangs in the museum.

**Present at the Creation: American Gothic**

www.npr.org/programs/morning/features/patc/americangothic

Melissa Gray, of National Public Radio's *Morning Edition*, tells the story behind Grant Wood's masterpiece.

**Sister Wendy's American Collection—American Gothic**

www.pbs.org/wgbh/sisterwendy/works/ame.html

Art aficionado Sister Wendy describes some common speculations raised by *American Gothic*.

**Figure 8.4** A few Web sites where students can learn about Grant Wood's *American Gothic*

**Tip**

Before students use a search engine, have them brainstorm ten to fifteen keywords and phrases about the topic they are studying to help guide their research.

### Virtual treasure hunts

Virtual treasure hunts are another popular method of helping students practice their Internet research skills while they learn about a particular topic of study. A virtual treasure hunt consists of a number of questions or clues with corresponding links to different Web sites or pages where students can go to find the answers. Students may work individually or collaboratively to complete a hunt.

Teachers often use virtual treasure hunts as enrichment activities, to extend upon a lesson or to reinforce prior learning. Hunts are also beneficial as introductory activities, to help students develop a basic framework of knowledge on a topic that they will explore further in class (Figure 8.5). The best treasure hunts reach beyond the pursuit of unrelated trivia to having students gather, analyze, and synthesize information into a broader understanding of a given topic (March, 2001).

To design a virtual treasure hunt you need to first, identify the particular curricular topic and skills you want to target; and, second, locate Web sites or pages that contain information fundamental to understanding the given topic. After identifying and creating a list of these sites, you need to develop a list of questions or clues to include in the hunt. Try to vary the difficulty of these items, with the final one requiring synthesis. To finish up, use a word processing program or Web-authoring software to combine all of these elements into a Web page, create links to the Web sites students will visit, and then post it on your departmental or personal Web site.

## Try This: Design your own virtual treasure hunt

1. Identify a curricular topic or content objectives you want to target through a treasure hunt.
2. Identify the thinking skills (e.g., finding, describing, comparing, interpreting, classifying, selecting, rating, justifying) you want to target through the hunt.
3. Locate Web sites that will support your objectives. Be sure to preview all sites you select for your hunt. Cut and paste the title and URL of each site you decide to use into a text document.
4. Develop five to ten questions or clues to incorporate into the hunt. The more varied the items, the better. Some should be easy to find answers to, while others should require more thought and effort.
5. Create your hunt using word processing or Web-authoring software. Save this file to your hard drive or a disk.
6. Ask someone to look over your hunt, checking for clarity, accuracy, and age appropriateness. If possible, pilot your hunt with a small group of students. Revise if necessary.
7. Print out a final copy of your hunt for use in the classroom and, if possible upload it to a Web site with the URLs linked to their corresponding sites.
8. Your hunt is now ready for student use.

## The power of ads treasure hunt

How does advertising affect the way we think about others and ourselves? What techniques and tools do advertisers use to persuade us to buy their products and services? Let's try to find answers to these and other important questions about advertising by searching the Internet.

**Directions:** Visit the Web sites listed below to find the information you need to formulate answers to the following questions. Complete as many of the items as you can.

1. Photographers typically take hundreds of pictures of a model during a shoot, just so that they can get one best shot for a magazine cover. Once the best photo is chosen, what happens to it?

2. Imagine that you are going to design an advertisement to go in your local newspaper. What three things should you do to gain a viewer's attention?
   a.
   b.
   c.

3. Describe one strategy that advertisers use to get you to buy their products.

4. Describe one way that advertisers make food appear more appetizing in a magazine ad or television commercial than it does in real life.

5. How do the images of men and women seen in advertisements compare to those we see everyday in real life? What affect do these images have on our views of others and ourselves?

### Web Resources

The following sites hold the answers to the above questions:
- www.zillions.org/Features/Foodadtricks/Food_ad001.html
- www.pbskids.org/dontbuyit
- www.mediascope.org/pubs/ibriefs/bia.htm
- www.naa.org/display/retailheadlines/v1no4/pg2.html
- www.media-awareness.ca
- www.saintmarys.edu/~medi0639/femalestereotypes.html

### Extensions

To complete the Power of Ads hunt, try to apply what you have learned by finding three examples of advertising tactics in magazine or newspaper ads. Cut each advertisement out and label it on the back with a description of how it manipulates consumers. Then, select one of these ads and turn it into a "counter-ad," by changing the text or pasting new materials onto it to create a more truthful or constructive message.

**Figure 8.5** A sample treasure hunt for middle school students

## Tools for developing Web-based curricular activities

Quite a few Web sites offer free tools to help educators create customized online activities for their students, and serve as hosts for the resources developed. Filamentality and TrackStar are two of the most popular. These sites are especially useful for teachers who have access to the Internet in their classrooms, but have neither the time nor the expertise to create their own Web pages. What is crucial to using these sites is the teacher's ability to develop online inquiry-based activities that promote exploration and strengthen students' critical thinking skills.

**Figure 8.6** Filamentality enables teachers to turn Web resources into learning activities.

### Filamentality
www.kn.pacbell.com/wired/fil/index.html

Filamentality is an interactive Web site, created and maintained by the SBC Knowledge Network Explorer design team and hosted by SBC, which guides teachers through the development process of turning Web resources into learning activities for students (Figure 8.6). It provides fill-in-the-blank templates for creating five different online activities, including hotlists, multimedia scrapbooks, subject samplers, treasure hunts, and WebQuests.

Filamentality provides easy-to-follow instructions and clear examples on using the various templates to develop activities. Before using one of these templates yourself, it helps to know what Web sites you would like your students to access and what you want them to learn or do on these sites. Once you are ready to go, the whole process should take less than a half hour. In addition to being able to save your activities on the SBC server, you can also search the site for activities created by other teachers.

### TrackStar
trackstar.4teachers.org/trackstar

TrackStar is hosted by the High Plains Regional Technology Consortium (HPR*TEC) for facilitating the integration of online resources into the classroom. With TrackStar, teachers can organize and annotate Web sites for use in lessons. The resulting list of resources, called a track, remains visible as students work through the questions or learning tasks developed by the teacher for each site.

If you are planning a lesson on photomontage, for example, you might create a track of links to Web sites of artists who use this technique in their work. To accomplish this, you need to: (1) collect the Web sites you want students to access and develop learning tasks or questions for each site; (2) register for a personal account by typing in your e-mail address and a password; (3) select "Make a New Track"; (4) enter all your sites and accompanying annotations; and (5) select "Submit Track." Instantly, TrackStar turns your lesson into a Web page, assigns it an identification number, and posts it online.

Like Filamentality, TracksStar contains a searchable database of Web-based learning activities that other teachers have created. If you find a track that relates to a lesson you are doing with students, TrackStar allows you to customize that track to fit your particular classroom needs. When doing so, TrackStar rewrites the credit line for the track to include both you and the original author.

## Digital archives in the classroom

Some art teachers have found innovative ways to stimulate student learning through the use of digital archives in the classroom. As discussed in Chapter 6, digital archives are Web-based collections containing a variety of primary source materials organized around a common theme or topic. While many of these sites provide little more than cataloging data for the items in their collections, a few, like the American Memory Project and ArtsConnectEd, offer extensive supporting materials, lesson plans, and online tools that teachers and students can use to interact with the materials on the site.

The presence of these collections on the Web can afford teachers and students many unique opportunities to work with an extraordinary array of authentic materials for classroom research purposes. However, in order to leverage the potential of these resources to support student learning, teachers must organize their use in ways that are meaningful for students and that address worthwhile curriculum goals at the same time (Hofer, 2004). Research projects that involve students in constructing their own knowledge through searching, finding, analyzing, evaluating, and using images and other source materials in digital archives offer the greatest potential. Following are two examples from art classrooms that illustrate this goal.

### View from the school: Then and now

www.floridamemory.com/OnlineClassroom/Then_Now

During the 2002 school year, Florida art teacher Polly Werner conducted a pilot project with her third grade class at Dr. N. H. Jones Elementary School in Ocala in collaboration with the Florida State Archives.

In the Then and Now project, Ms. Werner's students researched the history of their community by examining old photographs from the Florida Photographic Collection, the local historical society, and their own family photos. The students then revisited the locations or themes of the historic photographs and re-photographed them as they appear today.

You can view the then-and-now photographs and read short artist statements by Werner's students at the Florida State Archives' Online Classroom Web site. A lesson plan and project directions are also available.

## An Art teacher shares his thoughts on using ArtsConnectEd in his classroom . . .

As a high school art instructor, I use the computer and the ArtsConnectEd Web site in all of my classes. ArtsConnectEd is the online teaching/learning environment of the Minneapolis Institute of Art and the Walker Art Center. The site offers virtually limitless art resources to students, which they can use in the classroom for personal exploration, discovery, and research.

ArtsConnectEd employs a wide variety of online tools and strategies for students to interact with, making the information that they are gathering and interfacing with much more personal to them. Among these tools is Art Collector, which offers the ability to create personal collections of artwork from both of the museums' digitized collections as well as other online sources. These collections may include not only images of artwork, but also text, sound, and video.

I have my students use Art Collector to complete research projects on artists who are recognized for the various media we study in class. These projects involve creating personal collections featuring biographical information about the particular artist selected in addition to images of works by that artist and accompanying text relating to the work shown.

I have also had some of my other classes create online journals using ArtsConnectEd tools. These journals are created with the idea of studying a range of art history as it effects particular artistic disciplines. Timelines, historical data, styles, artists, other historical figures of note, and personal reflections are included in these journals.

Another way I use ArtsConnectEd in my classes is by having students write critiques of works of art displayed on the site, focusing on their sensory, formal, expressive, and technical qualities. Here the magnification function available on ArtsConnectEd proves to be immensely valuable as it allows students to more closely examine the works being studied. Being able to more clearly identify the elements and principles of art is easy to do using ArtsConnectEd, as students can focus on specific areas of a work of art as well as compare and contrast them with others to make their points.

A whole host of other integrated learning opportunities are possible using these online tools. But of greatest importance is the emphasis that this technology in the classroom places on student-directed learning, giving them extraordinary capabilities to explore works of art, ideas, and the times that have shaped them on their own. This type of learning helps to increase not only the students' ability to more easily employ technology in their daily lives, but also helps to foster a whole new experience in critical and creative thinking as well.

The ArtsConnectEd Web site can be found at http://www.artsconnected.org. Visit my art department Web site at http://www.anoka.k12.mn.us/ahsnitzberg.

Kevan Nitzberg
Anoka High School
Anoka, Minnesota

## Beyond treasure hunts: Teaching information literacy

Thus far, we have discussed ways to augment traditional art curricula using pertinent Web resources, worksheets, and online activities like treasure hunts. These strategies have their place in the art classroom, but they only scratch the surface. If you want to help your students make the most of the Internet as a research tool, you need to engage them more deeply in the inquiry process and make it possible for them to build "more meaningful personal interpretations and representations of the world" (Jonassen et al., 1999, p. 13). Achieving this goal requires applying a systematic approach to information gathering and, more specifically, to student use of the Internet as a research tool.

The most popular approach to organizing student research activities in the classroom is the Big6 Information Problem-Solving Process, although other approaches like Jamie McKenzie's (2000) Research Cycle are also widely used in classrooms. While each of these models has its own distinguishing features, they share a common goal—to help students learn how to effectively gather, evaluate, and use information from a variety of resources for specific needs and tasks.

Collectively these skills fall under the umbrella of information literacy, which Terry Crane, a Vice President at America Online (AOL), defines as "the process of turning information into meaning, understanding, and new ideas."[2] Information literacy is not a new concept in education. Yet it is now widely recognized as a core set of competencies that are essential to living in our complex and information-saturated world.

The pervasiveness of information technologies in contemporary society underscores the need for educators to integrate information literacy skills across existing curricula. The best way to teach these skills is by embedding them into classroom research projects in which students explore important issues and problems relevant to a field of study, ask significant questions, and seek answers on their own using different types of information resources.

The Big6 is a proven model for integrating these skills and practices within the context of classroom instruction. It is adaptable to a myriad of information problem-solving situations, in and outside of school. As you read the description of the Big6 below, bear in mind that its benefits depend on a number of factors, including the objectives of the lesson, the nature of the research problem or questions posed, the amount of time devoted to the activity, as well as the knowledge and skills students bring to the research task.

### The Big6

www.big6.com

The Big6, created by Mike Eisenberg and Bob Berkowitz, is a skills-based framework for solving any type of information-related problem. Since its inception in the late 1980s, use of the Big6 model has spread to thousands of K–12 schools, colleges, and universities, as well as corporate and adult-training programs all over the world. The phenomenal popularity of Big6 is due, in large part, to its broad applicability in promoting information and technology skills within subject area curriculum and other meaningful contexts (Eisenberg & Berkowitz, 1996). It is a simple yet powerful approach to information problem solving, easily integrated into classroom lessons and research projects, especially those involving use of the Internet.

The Big6 model consists of six stages: task definition, information seeking strategies, location and access, use of information, synthesis, and evaluation (Figure 8.7). Under each of these stages are two substages, commonly referred to as "the little twelve."

## The Big6 skills

The Big6 is a process model of how people of all ages solve an information problem.

**1. Task Definition**

1.1 Define the information problem

1.2 Identify the information needed

**2. Information-Seeking Strategies**

2.1 Determine all possible sources

2.2 Select the best sources

**3. Location and Access**

3.1 Locate sources (intellectually and physically)

3.2 Find information within sources

**4. Use of Information**

4.1 Engage (e.g., read, hear, view, touch)

4.2 Extract relevant information

**5. Synthesis**

5.1 Organize from multiple sources

5.2 Present the information

**6. Evaluation**

6.1 Judge the result (effectiveness)

6.2 Judge the process (efficiency)

**Figure 8.7** The Big6 Skills

While it may be convenient to present the Big6 stages to students in a sequential manner, Eisenberg and Berkowitz (2003) warn that the research process doesn't always proceed in a linear fashion: "Sometimes we jump from Task Definition—figuring out the scope of a project—to Synthesis—creating an outline of what the result might look like. Then, we might loop back and determine the resources we wish to use (Information Seeking Strategies) and so on" (p.31).

Whether students work through the stages sequentially or move back and forth, the important thing is that they successfully address each Big6 stage during the information problem-solving process.

Teachers can help students to become effective and efficient users of information by

- using Big6 vocabulary when discussing assignments and tasks;
- talking students through the Big6 process for particular projects;
- asking key questions that focus students' attention on specific Big6 actions they need to accomplish (Figure 8.8); and
- applying the Big6 model when designing lessons and projects that focus on subject area content.[3]

The broad adoption of the Big6 model in diverse educational settings has spawned a cornucopia of "how to" descriptions, testimonials, research reports and other helpful resources on the Web that teachers can turn to for guidance and advice on implementing the Big6 in their classrooms. The best place to start looking for information and assistance is the official Big6 Web site, which includes sample lesson plans, articles, practical tips, a list of print publications, information on professional development workshops and events, the Big6 Newsletter, discussion forums, a special kids' section, links to schools that use the Big6, and more.

## Big6 sample questions

Asking certain types of questions can focus students' attention on specific Big6 actions they need to accomplish when doing a project or task.

1. **Task Definition**
   - What are you trying to accomplish?
   - What information do you need to do this?
   - What will your project look like when you've finished it?

2. **Information-Seeking Strategies**
   - Where can you find the information you need?
   - Which sources of information are the best ones to use?
   - What keywords and phrases describe this information?

3. **Location & Access**
   - Where will you find these sources?
   - Where is the information you need within these sources?
   - Do you know how to use these sources?

4. **Use of Information**
   - How will you record the information you find?
   - How will you decide what information to use?
   - How will you credit your sources?

5. **Synthesis**
   - What project will you create to show what you have learned?
   - How will you organize all the information you find?
   - How much time will you need to finish your project?

6. **Evaluation**
   - How well did you accomplish what you set out to do?
   - What would you do differently, if you did this project again?

**Figure 8.8** Sample questions for fostering Big6 actions in students

# A Big6 art project: Homage to an artist

Before closing this chapter, let's examine how the Big6 model might be used to structure a research project in art.

**Suggested Grade Level:** Middle or High School

**Overview:** Where do artists get ideas? Artists sometimes borrow ideas from other artists and then mix those ideas with their own to create something new. In this project, you will apply the Big6 Information Problem Solving Approach to research the life and work of a notable artist from the past or present. You will then create a new work of art that combines something you learn from studying your chosen artist's work with your own ideas and interests.

## 1. Task Definition

What are you supposed to do?

To complete this project, you need to: (a) select an artist from the following list that you would like to learn more about; (b) research your chosen artist using the Internet and other local sources, paying special attention to the subjects, style, and influences in the artist's work; (c) create an original work of art that, in some way, draws upon the artist's work for inspiration; and (d) write a one-page "artist statement" that summarizes how your work reflects what you have learned by studying this artist's work.

| | | | |
|---|---|---|---|
| Giuseppe Arcimboldo | Guerrilla Girls | Barbara Kruger | Pablo Picasso |
| Jean-Michel Basquiat | Keith Haring | Jacob Lawrence | Faith Ringgold |
| Romare Bearden | David Hockney | Roy Lichtenstein | Diego Rivera |
| Joseph Cornell | Katsushika Hokusai | René Magritte | Cindy Sherman |
| Marc Chagall | Jasper Johns | Henri Matisse | Sandy Skoglund |
| Salvador Dalí | Frida Kahlo | Edvard Munch | Vincent van Gogh |
| Carmen Lomas Garza | Käthe Kollwitz | Georgia O'Keeffe | Andy Warhol |

What information do you need for this project?

In researching your chosen artist, try to answer as many of the following questions as you can:

1. What is this artist's background? What do you find most interesting about this artist's life?
2. What are some major influences on this artist's work?
3. What medium(s) does this artist work in? What medium do you prefer?
4. What are this artist's favorite subjects? What is your favorite subject(s) in art?
5. What are the central themes or concerns expressed in this artist's work?
6. What style(s) does this artist work in?
7. What do you find most interesting and unique about this artist's work?

In addition to gathering pertinent information on your artist, download and print out images of three of the artist's works for further study.

## 2. Information-Seeking Strategies

Where can you find the information needed for this project?

Make a list of all the possible sources where you might find information on your chosen artist, including Web sites, art history books, art magazines, art exhibition catalogs, art CD-ROMs, your local art museum, and so on.

What sources of information are the best ones to use?

The following Web sites are good starting points for researching your artist online:

Artcyclopedia (www.artcyclopedia.com)

Art Institute of Chicago  (www.artic.edu/artaccess)

AskArt (www.askart.com)

Fact Monster (www.factmonster.com)

Global Gallery (www.globalgallery.com)

Famous Painter (www.famouspainter.com)

National Gallery of Art (www.nga.gov)

National Museum of Women in the Arts (www.nmwa.org)

Web Museum (www.ibiblio.org/wm)

Yahooligans! (yahooligans.yahoo.com)

Here are a few good art history books that focus on the lives and work of famous artists:

*100 Artists Who Shaped World History*, by Barbara Krystal, 1997.

*Getting to Know the World's Greatest Artists*, by Mike Venezia, 1999.

*Lives of the Artists*, by Kathleen Krull, 1995.

## 3. Location and Access

Where can your find these resources?

Use your classroom or home computer to search the Web sites listed for information on your chosen artist. Check with your teacher about other potentially good resources (such as art history books, art magazines, or CD-ROMs) that are available in the classroom or school's library.

Do you know how to use these resources?

Use the table of contents or index to locate needed information within books and other print resources. When using the Web sites listed to do your research, type your artist's first and last name into the search tool window available on the site's homepage to locate any relevant information or images. Some of these sites also have index pages that list all of the artists covered on the site in alphabetical order.

Collaboration is not a new idea in education, yet its use as a learning strategy has seen a resurgence of interest in American schools. To encompass the diversity of work being done in the field today, Smith and MacGregor (1992) suggest that "collaborative learning" be viewed as an umbrella term for a broad range of pedagogical approaches—both old and new—that involve students, or students and teachers, working together in joint intellectual efforts. Some of these approaches include cooperative learning, debates, group work, learning communities, project-based learning, study circles, and teamwork.

It is the give and take of talk that makes collaboration possible.
• **Jerome Bruner (1996)**

## Why promote collaboration in the art classroom?

Art educators have historically shown little interest in collaboration as a classroom learning strategy. For a greater part of the past century, modernist theories of art persuaded us to value individualism and self-expression in our classrooms over pedagogical models that foster more collaborative and socially responsive learning environments (Ament, 1998). We still tend to think of art as *the* subject in school that offers students the greatest opportunity to express their individuality. As Gude (2000) writes, "Few art programs at the elementary and secondary level regularly include the study of the modern and contemporary history of collaborative practices in art making."

While individualism continues to play a prominent role in our thinking about art, at least in North American schools, collaboration is gaining wider acceptance in contemporary discussions of art education. A number of art educators have challenged the exclusivity of art as a solitary pursuit, while calling for more collaborative approaches to the study of art and art making in and outside of the classroom.[1] This interest has run parallel to a similar trend within the Western art world, which has witnessed the erosion of conventional notions of artistic authorship by growing numbers of artists who have joined in partnerships and collectives to realize creative works that would be otherwise impossible to execute on their own (Cotter, 2003; Green, 2001; Gablik, 1995; Zorpette, 1994).

Besides responding to the increase of collaborative methods in contemporary art and art education practices, there are other reasons why elevating the role of collaboration in the study and making of art in schools makes good sense. We know from the work of Bruner (1996), Vygotsky (1978), and other social constructivists that students construct knowledge through meaningful interactions with others, usually adults and more capable peers. Moreover, a large body of research shows that learning situations in which students work together leads to positive gains in the areas of academic achievement, self-esteem, motivation, learner autonomy, conflict resolution, higher-order thinking skills, and interpersonal skills (Johnson & Johnson, 1999; Hamm & Adams, 1992; Slavin, 1988).

Providing opportunities for student collaboration in the art classroom does not mean abandoning individual expression, only that we need to make room for the social aspects of learning by offering activities that require students to work together to achieve shared artistic and educational goals. Doing so creates a richer, more diverse classroom environment within which students actively learn from each other as well as on their own.

2. **Information-Seeking Strategies**

Where can you find the information needed for this project?

Make a list of all the possible sources where you might find information on your chosen artist, including Web sites, art history books, art magazines, art exhibition catalogs, art CD-ROMs, your local art museum, and so on.

What sources of information are the best ones to use?

The following Web sites are good starting points for researching your artist online:

Artcyclopedia (www.artcyclopedia.com)

Art Institute of Chicago (www.artic.edu/artaccess)

AskArt (www.askart.com)

Fact Monster (www.factmonster.com)

Global Gallery (www.globalgallery.com)

Famous Painter (www.famouspainter.com)

National Gallery of Art (www.nga.gov)

National Museum of Women in the Arts (www.nmwa.org)

Web Museum (www.ibiblio.org/wm)

Yahooligans! (yahooligans.yahoo.com)

Here are a few good art history books that focus on the lives and work of famous artists:

*100 Artists Who Shaped World History*, by Barbara Krystal, 1997.

*Getting to Know the World's Greatest Artists*, by Mike Venezia, 1999.

*Lives of the Artists*, by Kathleen Krull, 1995.

3. **Location and Access**

Where can your find these resources?

Use your classroom or home computer to search the Web sites listed for information on your chosen artist. Check with your teacher about other potentially good resources (such as art history books, art magazines, or CD-ROMs) that are available in the classroom or school's library.

Do you know how to use these resources?

Use the table of contents or index to locate needed information within books and other print resources. When using the Web sites listed to do your research, type your artist's first and last name into the search tool window available on the site's homepage to locate any relevant information or images. Some of these sites also have index pages that list all of the artists covered on the site in alphabetical order.

### 4. Use of Information

How will you record the information you find?

Once you find a valuable source of information on your artist, you can begin taking notes. Using note cards is a good way to do this. To help you organize your notes and remember where you found useful information later on, write down a keyword or question on the top of each note card and the title of the source you use and its location for each note. For example:

---

**What are the central themes in Warhol's work?**

Warhol both celebrated and poked fun at American middle-class values by erasing the distinction between popular and high culture. (Fact Monster)

Warhol was fascinated by consumer culture, the media, and fame. (National Gallery of Art)

Warhol often used repetition in his work. (National Gallery of Art)

Warhol said "In the future, everyone will be famous for fifteen minutes." (*Lives of the Artists*, p. 92)

---

How will you decide what information to use?

Chances are that you will learn a lot more about your chosen artist than you need to complete this project. What you need to focus on are those things that interest you the most such as the artist's style, subject matter, or themes.

### 5. Synthesis

What project will you create to show what you have learned?

The artwork you create should incorporate ideas from your chosen artist's work as well as your own ideas, interests, and concerns (Figure 8.9). Think of this project as a collaboration between you and the artist you studied. Although the work you create may take on some of the characteristics of your collaborator's work, you should not get lost in the mix. Challenge yourself to do something different than you might normally do on your own. For example, you may choose to recreate or update a scene in your chosen artist's work, but use different characters or media to create your work.

The materials you use for this project will depend on the work of the artist you studied as well as the materials that are available in the classroom. If the artist paints in bold colors, for example, you might use oil pastels to create your own work. If the artist is a photographer, you might use a digital camera to create your work and then enhance the picture using image-editing software. Choose a medium you are comfortable with and that won't require learning new skills in order to create a finished piece.

**Figures 8.9, 8.10** Student artwork inspired by the study of Andy Warhol. University of Florida Art Foundations Program.

Once you have completed your artwork, use a word-processing program to write a one-page "artist statement." This statement should discuss what your work is about and how it reflects what you learned by studying your chosen artist's work. This statement will be displayed next to your work for the final critique in class. Be prepared to share what you learned about your chosen artist and the resulting work you created by making a five-minute presentation to the rest of the class.

How much time will you need to finish your project?

You will have five weeks to complete this project in class. If you need additional time, please talk with your teacher about arranging a time to work on your project outside of class.

6. **Evaluation**

How well did you accomplish what you set out to do?

To receive a grade for this project, you must submit: (1) a finished work of art; (2) an artist statement; (3) the note cards you used to gather information on your artist; and (4) printouts of three works by the artist studied. Use the following rubric to assess your success in this project (Table 8.1).

| Criteria | Novice | Accomplished | Exemplary |
|---|---|---|---|
| **Artist research** | Student is able to gather relevant information from a few sources. Student needs to work on note-taking skills and correctly citing sources. | Student is able to gather and organize relevant information from several sources, but needs to work on paraphrasing or correctly citing sources. | Student is able to effectively gather, organize, and summarize relevant information from a variety of correctly cited sources. |
| **Work of art** | Student has made an effort to use ideas from the work by the artist studied. However, the resulting work of art is lacking in originality or is poorly executed. | Student has combined ideas drawn from work of the artist studied with his/her own ideas, but needs to work on technique or control of the medium. | Student has effectively combined ideas drawn from the work of the artist studied with his/her own ideas to create an original and technically competent work. |
| **Artist statement** | Student describes what s/he learned from studying the artist's work, but does not make a clear connection to the work of art produced. | Student describes what s/he learned from studying the artist's work and how these ideas are reflected in the work of art produced. | Student describes what s/he learned from studying works by the artist and how s/he personalized these ideas in the work of art produced. |

**Table 8.1** Artist homage project rubric

## Conclusion

It is easy to overstate the value of the Internet as a research tool in the art classroom. The Internet in general, and the World Wide Web specifically, offers immediate access to a wealth of historical and cultural information. Yet despite the enormous amount of valuable information available, the Internet is far from perfect. Since the Internet is not peer-reviewed, some of the information found there is controversial, offensive, or simply not credible. Moreover, searching for pertinent information on the Internet can be a daunting task, especially for students who lack the content knowledge or decoding skills necessary for interpreting and verifying the quality of information they find online.

While recognizing the limitations of this medium, there are several things we can do as teachers to maximize the potential of the Internet for student research in our classrooms. Chief among these is ensuring that students have a clearly defined, curriculum-specific purpose before they go online to search for information. Classroom research activities that revolve around essential questions and that use of a variety of resources offer the best opportunities for creating rich learning experiences in which students construct their own understandings of the topic or issue at hand.

Selecting resources appropriate to the research task is another essential element of structuring students' learning experiences involving the Internet. Students need to understand the advantages and limitations of using the Internet as a research tool, so a balance needs to be struck between the use of online resources, print-based resources, and real-world experiences that involve students in gathering information themselves from primary sources in their local communities.

Lastly, we need to empower students with the confidence and skills to use information critically and creatively in their lives. Students today should not only be able to create and effectively communicate their own messages with new technology tools, they should also be able to effectively gather, analyze, interpret, and evaluate messages they receive from our information-rich, technology-mediated environment. Gaining such information literacy skills requires education.

## Useful Web sites

### Cyberbee
www.cyberbee.com

This site offers teachers a wealth of information on integrating the Internet into the classroom, including many resources pertaining to organizing student online research activities.

### Landmark's Citation Machine
www.landmark-project.com/citation_machine

The Citation Machine, created by David Warlick, is an interactive Web tool designed to assist teachers and students in producing reference citations for crediting information from other people.

### Module Maker
questioning.org/module/module.html

This site, developed by education technology expert James McKenzie, guides teachers through the process of creating their own online research modules based on the Research Cycle, a seven-step framework for structuring and guiding meaningful student research projects.

### Web Inquiry Projects
edweb.sdsu.edu/wip

Web Inquiry Projects (WIPs) are inquiry-based learning activities that involve locating, interpreting, and using online data and information. They are like WebQuests, only more intensive. Find out more about WIPs on this site, hosted by the Educational Technology Department at San Diego State University.

# The Art of Online Collaboration

## CHAPTER 9

A collaborative approach does have a needed place in art education, and it should not be limited to the occasional group mural.

• **Sally Hagaman (1990)**

While there are many ways to use the Internet to facilitate student learning in the art classroom, the most promising applications may involve students taking part in online curriculum-based activities that foster dialogue and collaboration within the classroom and across cultural contexts. Through these group interactions, students encounter multiple perspectives and gain a greater sense of interdependence—both of which are vital in constructing their own knowledge of the social world and their place within it.

The following pages will explore, first, the concept of collaboration and why it is important to promote in today's art classrooms, and second, ways that students can use the Internet as a collaborative tool to exchange ideas and work with others in pursuit of shared artistic and educational goals.

## What is collaboration?

Over the past decade, considerable attention has been given to the topic of collaboration in academic, corporate, and cultural circles. A number of authors have written about collaboration and have defined the term in various ways. For example, Hathorn and Ingram (2002) propose that collaboration can describe "almost any situation in which groups of two or more individuals work together to learn or to solve a problem" (p. 33). John-Steiner (2000) defines collaboration as "the interdependence of thinkers in the co-construction of knowledge" (p. 3). Peters and Armstrong (1998) suggest that collaboration occurs when "people labor together in order to construct something that did not exist before the collaboration, something that does not and cannot fully exist in the lives of individual collaborators" (p. 75), whereas Schrage (1995) refers to collaboration as "an act of shared creation and/or shared discovery" (p. 4).

Although these definitions differ somewhat, collectively they enable us to characterize a collaborative situation as one in which participants work together to achieve a common goal or purpose; engage in reciprocal talk, exchanging ideas and information; value each member as an equal partner; share responsibility for completing tasks and making decisions; and jointly construct something of greater depth or larger scale than could be accomplished through the efforts of a single individual.

Collaboration is not a new idea in education, yet its use as a learning strategy has seen a resurgence of interest in American schools. To encompass the diversity of work being done in the field today, Smith and MacGregor (1992) suggest that "collaborative learning" be viewed as an umbrella term for a broad range of pedagogical approaches—both old and new—that involve students, or students and teachers, working together in joint intellectual efforts. Some of these approaches include cooperative learning, debates, group work, learning communities, project-based learning, study circles, and teamwork.

It is the give and take of talk that makes collaboration possible.

• **Jerome Bruner (1996)**

## Why promote collaboration in the art classroom?

Art educators have historically shown little interest in collaboration as a classroom learning strategy. For a greater part of the past century, modernist theories of art persuaded us to value individualism and self-expression in our classrooms over pedagogical models that foster more collaborative and socially responsive learning environments (Ament, 1998). We still tend to think of art as *the* subject in school that offers students the greatest opportunity to express their individuality. As Gude (2000) writes, "Few art programs at the elementary and secondary level regularly include the study of the modern and contemporary history of collaborative practices in art making."

While individualism continues to play a prominent role in our thinking about art, at least in North American schools, collaboration is gaining wider acceptance in contemporary discussions of art education. A number of art educators have challenged the exclusivity of art as a solitary pursuit, while calling for more collaborative approaches to the study of art and art making in and outside of the classroom.[1] This interest has run parallel to a similar trend within the Western art world, which has witnessed the erosion of conventional notions of artistic authorship by growing numbers of artists who have joined in partnerships and collectives to realize creative works that would be otherwise impossible to execute on their own (Cotter, 2003; Green, 2001; Gablik, 1995; Zorpette, 1994).

Besides responding to the increase of collaborative methods in contemporary art and art education practices, there are other reasons why elevating the role of collaboration in the study and making of art in schools makes good sense. We know from the work of Bruner (1996), Vygotsky (1978), and other social constructivists that students construct knowledge through meaningful interactions with others, usually adults and more capable peers. Moreover, a large body of research shows that learning situations in which students work together leads to positive gains in the areas of academic achievement, self-esteem, motivation, learner autonomy, conflict resolution, higher-order thinking skills, and interpersonal skills (Johnson & Johnson, 1999; Hamm & Adams, 1992; Slavin, 1988).

Providing opportunities for student collaboration in the art classroom does not mean abandoning individual expression, only that we need to make room for the social aspects of learning by offering activities that require students to work together to achieve shared artistic and educational goals. Doing so creates a richer, more diverse classroom environment within which students actively learn from each other as well as on their own.

Art education must provide means to present a more holistic approach to education, presenting models of the artist-collaborator rather than the artist as solitary maverick or hero.

- **Melody Milbrandt (1998)**

## Collaboration and the Internet

The Internet is an ideal medium for promoting collaboration within the art classroom and beyond. Apart from supporting group research projects in the classroom, the Internet affords students the ability to interact and work with their peers and experts around the world. This capacity opens the door to a myriad of possibilities for helping students build new connections between people, places, and ideas.

If you are interested in trying out an online collaborative project in your classroom, there is no need to reinvent the wheel. Other educators have already done much good work in this area and, in the process, have developed many successful strategies and practices for promoting student collaboration—both on and off the Internet. It is up to you to determine which strategies will yield the best results in your classroom, based on an assessment of your students' needs, technological capabilities, time constraints, and curriculum goals.

### Collaborative art and the Web

Collaborative artmaking is thriving on the Web. Many artists use the Web to seek out other artists who will participate in collaborative projects together. Among the numerous sites that have been set up to unite artists in joint creative endeavors are Nervousness and SITO.

### Nervousness

www.nervousness.org

Nervousness promotes and facilitates the exchange of various forms of "Land Mail Art Objects" (such as artist books, traveling journals, matchbox shrines, artist trading cards, and art postcards) through the postal service, also known as snail mail. A number of online forums are available on the site for interested artists to start a new exchange or sign up for a current one.

### SITO

www.sito.org

SITO has been initiating and hosting collaborative art projects on the Web since 1993. In one of its earliest collaborative projects, based on the popular Surrealist parlor game of the 1920s and 30s known as the "Exquisite Corpse," participants contributed separate panels to a figure-like image without knowing what other participants had done. More recent SITO projects have involved participating artists in contributing separate panels to comic-book sagas, individual frames of animated movies, and portions of larger group-constructed images.

## Types of online projects

Online curriculum-based projects can take many different forms, from students using e-mail to exchange ideas and experiences with their peers in other schools to groups of students from different countries working on social-action projects and companion Web sites together. Although online curriculum-based projects may differ in design, focus, and commitment, they all have certain features in common:

- They are authentic, inquiry-based activities in which students are expected to make use of the Internet in some way to attain certain learning outcomes.
- They typically require students to engage in collaborative work or research to achieve the desired outcomes.
- They usually focus on a specific theme or essential question, occur during a set time, and result in a product or presentation of some kind.
- Many involve communicating, sharing, and working in partnership with students and teachers from different geographical locations, backgrounds, and cultures.

In her book, *Virtual Architecture: Designing and Directing Curriculum-Based Telecomputing*, Judi Harris (1998) suggests that curriculum-based projects involving online collaboration or research using remote resources focus on at least one of three primary learning processes: interpersonal exchange; information collection, and analysis; or problem solving. She further divides these three broad categories into eighteen different "activity structures" that teachers can use to design curriculum-based projects in which online resources and tools are used in educationally worthwhile ways. Table 9.1 provides an overview of these processes and structures.

Harris reminds us that these categories are not mutually exclusive and that some of the more successful educational undertakings incorporate aspects of all three. She also emphasizes that teachers must decide whether the use of Internet tools and resources in a particular learning situation is worth it. In making this determination, Harris recommends that teachers consider two questions:

1. Will this use of the Internet enable students to do something they could not do before?
2. Will this use of the Internet enable students to do something they could do before, but better?

If the answer to both of these questions is no, then there is no reason to use Internet tools and resources in this particular way. If students can achieve the desired outcomes just as well or better with traditional tools and approaches, it is not worth the time and effort to use the new tools.

**To learn more about Judi Harris's activity structures visit**

**Virtual Architecture
WEB HOME**
virtual-architecture.wm.edu

| Learning Process | Description | Activity Structures | Supportive Tools |
|---|---|---|---|
| **Interpersonal exchange** | Activities that involve individuals talking electronically with other individuals, with groups, or groups talking with other groups | Keypals, peer feedback, global classrooms, question and answer sessions, telementoring, and electronic guest appearances | E-mail, instant messaging, Web chat, listserv, mailing list, and videoconferencing tools |
| **Information collection and analysis** | Activities that involve collecting, sharing, compiling, and then comparing different types of information | Database creation, information exchanges, pooled data analysis, electronic fieldtrips, and electronic publishing | E-mail, Web browser, Web-authoring tools, videoconferencing tools, digital camera, and scanner |
| **Problem solving** | Activities that promote critical thinking, collaboration, and project-based learning | Information searches, parallel problem-solving activities, sequential creations, social action projects, and simulations | E-mail, Web browser, Web-authoring tools, Web chat, videoconferencing tools, digital camera, scanner |

**Table 9.1** Types of online curriculum-based projects

## Getting started

Judi Harris's model provides a comprehensive guide to the options available to teachers who are interested in pursuing student-centered, curriculum-based projects on the Internet. Still, with so many choices, you may be wondering, "Where do I get started?"

### Arrange a student art exchange

The most natural way for art teachers to make immediate use of the Internet as a medium for collaborative learning is by arranging student art exchanges with other schools around the globe. Work completed with traditional art materials may be sent via postal mail or scanned and transmitted electronically over the Internet. Work done with the aid of a computer may also be sent over the Internet. Such exchanges typically involve students in each location creatively responding to a common theme and then sharing the resulting work with the other school(s) involved in the project. Combining this activity with an e-mail exchange offers the potential for students of different countries to interact and gain insights into the cultures, interests, and life experiences of their peers in other schools.

Students can use e-mail to exchange personal views, experiences, and information with their peers around the world. This activity may take some time to set up, but it is well worth the effort. It involves electronically linking individual students or groups of students of similar age across geographic boundaries for the purposes of sharing ideas, experiences, and information. Online projects built around interpersonal exchanges can range from having individual students swap personal messages with their distant partners to having two or more classrooms in different locations study a selected topic together and then meet online to exchange views and share information. Additional possibilities are available if you have videoconferencing capabilities in the classroom.

The following examples illustrate some of the ways that teachers have used the Internet to initiate, manage, and promote student art exchanges and dialogue between schools. While most of them represent past projects, they may serve as models for future projects you plan for your students.

### Art Across America

In this ambitious project, Wisconsin art teacher Mary Bolyard worked with her eighth-grade class to arrange a national exhibition of student artwork at her middle school in conjunction with Youth Art Month. Bolyard initially posted a call for submissions on an art teachers' mailing list. Teachers from 35 schools in 30 states and Iceland responded, resulting in an exhibition titled "Art Across America" of 70 pieces of student work. A smaller traveling version of the exhibition toured all participating schools over a two-year period (Bolyard, 2001).

### Electronic Postcards

Second grade students in Fort Worth, Texas and in Los Angeles studied David Bates's painting *Grassy Lake* and then used the software program KidPix to create electronic postcards about where they lived. The e-cards were then exchanged between the two schools over the Internet.[2]

### The First Peoples' Project
www.iearn.org.au/fp

The First Peoples' Project enables indigenous students from around the world to work together on collaborative projects involving writing exchanges, art exchanges, and discussions about issues relating to their lives. The project's Web site displays samples of students' artwork and writing from past exchanges, which were based on the themes of "Myself, My Family, My Culture," "Traditional Stories," "Honoring the Elders," and "Traditional Foods."

**Figure 9.1** The My Place Asia Australia homepage

## My Place Asia Australia

www.curriculum.edu.au/accessasia/myplace

This site features student artwork from an educational exchange between Australian schools and their counterparts in China, Japan, Korea, India, Indonesia, and Vietnam (Figure 9.1). Students in the participating schools created artwork reflecting their ideas, feelings, and beliefs about places of significance in their lives and wrote an accompanying short story. The artworks and the translated stories were mounted and laminated to form a series of traveling exhibitions shown in participating schools and other community venues. A teacher's guide is available on the site.

## A Tale of Four Cities

www.photonet.org.uk/programme/projects/fourcities/intro.html

This site documents an international e-mail and photo exchange between children in London, Nairobi, Cape Town, and Dhaka. Working with artists, photographers, and youth leaders, over two hundred children used photography and creative writing to explore, document, and share their lives and experiences growing up in these four very different world cities.

## The Horton Art and Cultural Exchange Gallery

www.horton.ednet.ns.ca/staff/syme/hago2004

The art education department at Horton High School in Greenwich, N.S., Canada recently implemented an exciting new curriculum-based project involving an online gallery of student artwork and videoconferencing with artists, teachers, and students from around the world.

Paul Syme, Chair of the department, shares his thoughts on initiating this project, its goals, and its potential benefits for his students:

Although we have had a virtual gallery of student work up on the Web for some time, it now includes work from our Art 10, Design 11, and Art 12 classes done in a range of conventional and new media. Further, with a grant from SchoolArt Canada, we are now able to perform live-video exchanges over the Internet using Apple Computer's iChat AV videoconferencing system (Figure 9.2).

The aim of this online project is twofold: (1) to share the art and design work of our students with a worldwide audience; and (2) to invite artists and students from around the world to critique our students' work. When possible, we also aim to have our students experience and respond to the work of our conferencing partners.

We hope that by forging real-world exchanges of student artwork with people from outside of the school and local community, students may reconsider how they value their own work. Such exchanges should also lead students to see that others value what they think and do. We anxiously wait to see what impact this project may have on student learning and performance at our school.

Paul Syme
Chair of Art Education
Horton High School
Greenwich, N.S., Canada

**Figure 9.2** A screen-shot of a video conference between art students from Horton High School in Greenwich, Nova Scotia and KTA de Merodelei Turnhout in Antwerp, Belgium

# Finding online partners

The easiest way to initiate a classroom exchange is by recruiting other teachers through an online discussion group or mailing list. Once you know who the participants will be, you can handle logistical issues and other matters related to the exchange through e-mail. Keep in mind that school schedules vary considerably and that the expectations of the teacher on the other end may be quite different than your own. It is a good idea to work these differences out beforehand, in order to ensure that everyone is on the same page and that the exchange takes place as planned.

There are also a number of organizations that sponsor Web sites where you can find teachers and schools willing to participate in a joint classroom e-mail project or student art exchange. Most of these sites require you to first register for a personal account in order to join a project or to post your own project. Some require paying a nominal fee for their services and others are available to educators at no charge. Following are some worth checking out.

## Art Junction
www.artjunction.org

Art Junction promotes collaborative art making, student art exchanges, debates, joint research projects, and other communicative activities between art classrooms that are meant to foster meaningful art learning and cultural understanding.

## Creative Connections Project
www.ccph.com

The Creative Connections Project, sponsored by The New York Foundation for the Arts, links classrooms from around the world through e-mail, art and music exchanges, and study partnerships. Teachers may choose from different levels of participation, each of which requires paying a fee.

## ePALS
www.epals.com

ePALS is the world's largest online classroom community, with over 4.5 million students and teachers from 191 countries involved in working on cross-cultural and interactive projects together. Free registration is required to take full advantage of the numerous re-sources, tools, and services available on this site.

## iEARN
www.iearn.org

The International Education and Resource Network, or iEARN, is a non-profit organization made up of almost 4,000 schools in over 90 countries that encourages teachers and young people (K–12) to work together online to solve social problems and to improve the quality of life on earth. Teachers or their schools must join iEARN (for an annual fee) in order to take full advantage of the services and resources available on the site.

## Intercultural E-mail Classroom Connections (IECC)
www.iecc.org

Sponsored by Teaching.com, IECC is a free online service dedicated to helping educators at all levels to arrange intercultural e-mail exchanges between schools. Their site offers several mailing lists, links to online resources, and survey forms for use in exchanges.

## KIDPROJ
www.kidlink.org/KIDPROJ

As part of the KIDLINK network, KIDPROJ offers students through secondary school opportunities to join various global projects. Teachers and youth group leaders can plan activities and projects for their students by joining the KIDPROJ-COORD mailing list. You can read about current and ongoing projects as well as browse an archive of past projects.

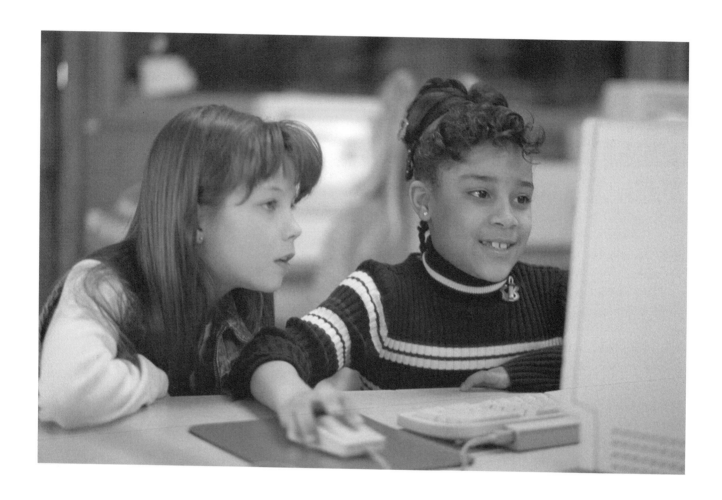

## Supporting collaborative inquiry on the Internet

The old adage "two heads are better than one" applies to the Internet as well. While there are times when students may need to conduct research on the Internet independently, it is generally more efficient and effective when done collaboratively by groups of students committed to the same learning goals. From a practical standpoint, having students work together in pairs or small groups on the computer is especially advantageous in classrooms with limited Internet access. Pedagogically speaking, collaborative inquiry requires students to recognize and to utilize the insights and skills of each member of the group.

Students must discuss the work with each other and think deeply about it themselves in order to effectively function as a team or group. In the deliberative process, collective and individual knowledge intermingle and new understandings emerge.

Many of the research strategies presented in Chapter 8 could easily apply to either independent or group work. In the following pages, we will examine two additional approaches to structuring student activities on the Internet that are particularly supportive of teamwork and collaborative inquiry: Project-Based Learning and WebQuests. Both methods are widely used by educators, at all levels and across all disciplines, to effectively integrate the Internet into their classrooms.

## Project-based learning

Project-based learning has a long history in the field of education. Its roots can be traced back to the philosophy of John Dewey (1916) and one of his protégés, William Kilpatrick (1918), who developed the "project method" as a way of connecting student interests and learning with real-life problems they encounter outside of school. Recently, project-based learning has become an enormously popular pedagogical strategy used in many disciplines and across grade levels—often in combination with various technology tools and online resources.

The concept of project work is certainly not new to art teachers, who frequently give their students open-ended assignments that offer some degree of choice and that extend over time. However, project-based learning requires a decidedly different way of thinking about project work that many art teachers will find unfamiliar. Chen and Armstrong (2002) write:

> In project-based learning, students investigate rich and challenging issues and topics, often in the context of real-world problems, integrating subjects such as science, mathematics, history, and the arts. Students typically work in teams, using technology to access current information and, in some cases, consult with experts. They coordinate time and work schedules, develop real work projects such as multimedia reports, and present them to their teachers and the larger community, often in a culminating presentation (p. 3).

For students to fully benefit from project-based learning, a project must be well designed and of interest to the students. An essential component of a well-designed project is a compelling question or problem, developed by the students or the teacher, which serves to organize and drive the activities involved in the project. Another vital element is the creation of shareable artifacts or products that address the initial driving question or problem. It is through the production of these artifacts that students construct and represent their understandings, and engage in dialogue with their peers (Blumenfeld et al., 1991).

### Student ownership of projects

A project is more likely to sustain student interest when it offers some degree of novelty, an authentic and challenging task, opportunities to work with others, significant choices, and a sense of closure through the creation of some artifact or product (Blumenfeld et al., 1991). Motivation is highest when students assume ownership of the project and play an active role in determining its outcomes. Teachers can foster this level of engagement by making sure that the project is not overly defined or prescriptive so that students are able to shape some of its aspects on their own. The sample project described on the next page fits these parameters.

Ideas for projects can come from many sources including an important curriculum idea or standard, a teacher's or visiting artist's special interest or expertise, the concerns and interests of students, local problems facing members of the community, issues of global importance, or a desire to enhance the quality of life in the community (see page 202). Whether the teacher introduces the idea or it springs from the students themselves, the important thing is to allow the students to take the lead in making critical choices and decisions regarding how they will find answers or resolve the problem posed.

## Try This: A social action project for high school students

**Introduction:** Many artists make valuable contributions in promoting public awareness of important issues and in working to effect positive change within their communities. How can art help us to see things differently? How can art make a community better?

**Project Statement:** Research an issue or problem within your community and then create a work that will, through its message, focus public attention on your chosen topic and suggest a possible solution.

**Process:**

1. As a group, generate a list of issues and problems facing your community.
2. Review the list and mark the issues that seem the most important ones to you personally.
3. Discuss all issues chosen by the group. Select one issue that seems most compelling to everyone and list everything the group knows and wants to know about the topic.
4. Research your issue using local and online resources. What are the various "sides" of the issue? Who is interested in it? What is at stake if the issue goes unresolved? What are people writing and saying about it? If necessary, interview local community members. Collect a variety of information (e.g., images, video footage, and textual material) that might prove useful in your work.
5. Discuss your findings among your group. Generate possible options toward a creative solution and decide how your group might respond to the issue.
6. Select your best idea and put it into action (for instance, create a video, a zine, a mural, a Web site, or a multimedia presentation).
7. Present your work in a public setting and online through your school's Web site.

**Project Requirements:** Your work must be presentable in public and online, suggest a possible solution, involve all members of your group in its production, and be accompanied by a written narrative describing how you feel it contributes to the community.

**Associated Tasks and Time Table:** Generate a list of tasks associated with your project along with projected completion dates for each task. Nine weeks of class will be devoted to this project.

**Participant Roles:** List each member of your group along with their assigned role(s). List any additional individuals or community members that you might call upon for assistance with your project.

**Assessment:** How well does your work meet the project requirements? What do you like most about your work? What would you change about your project if you had more time or could do it over again? What did you learn about your issue while doing this project? What were the benefits and drawbacks of working as a group on this project?

**Extension:** Research artists who address important social, cultural, or environmental issues in their work (e.g., The Guerilla Girls, Lynne Hull, Barbara Kruger, Suzanne Lacy, Buster Simpson, Susan Leibovitz Steinman, Mierle Laderman Ukeles, Krzysztof Wodiczko, and others). Share your findings with the class.

## Social Action Projects

Social action projects involve students in addressing a real social or environmental issue, by working to understand the problem and contribute constructively to its solution. Here are five sites that offer opportunities for students to get involved.

### Earth Day Groceries Project

www.earthdaybags.org

The Earth Day Groceries Project is a cost-free environmental awareness project that teams up youth and grocers to spread the message of Earth Day. To participate, teachers borrow paper grocery bags from a local grocery store. Students decorate the bags with environmental messages and then return them to the grocery store, where they are distributed to customers on Earth Day. Teachers are encouraged to post reports and images of their students' decorated bags on the project's site.

### Earth Works—Putting Art to Work for the Sake of the Earth

www.artjunction.org/projects/earthworks

Earth Works is an interdisciplinary project that invites teachers and students to work together to study their local environment and then use the power of art to show how we can better coexist with the natural world. Teachers can submit visual and written documentation of their students' accomplishments for display on the project's site.

### Empty Bowls Project

www.emptybowls.net

In this project, participants create ceramic bowls and then serve a simple meal of soup and bread. Guests choose a bowl to use that day and to keep as a reminder that there are always empty bowls in the world. In exchange for a meal and the bowl, the guest gives a suggested minimum donation of ten dollars. The meal sponsors and/or guests choose a hunger-fighting organization to receive the money collected.

### Global Art Project for Peace

www.global-art.org

The mission of the Global Art Project (GAP) is to spread world peace by promoting tolerance and nonviolence through art. Participants of all ages and from all around the world create works of art expressing their vision of global unity. Following local displays of each participant's work in their community, the Global Art Project organizes an international exchange by matching participants group-to-group and individual-to-individual. The exchange occurs April 23–30 biennially, resulting in thousands of messages of peace and unity encircling the globe at one time.

### KidCast for Peace

creativity.net/kidcast2.html

Each year on Earth Day, students of all ages come together during this virtual event to share their art live and direct people to their pre-built "KidCast For Peace" Web sites, VRML worlds, chat rooms, Interactive Music spaces, and so on. Depending on the time zone, children at each participating site respond to comments and questions from locally gathered and cyber-audiences. The project uses CU-SeeMe videoconferencing software to enable real-time interaction between participating sites.

## Technology's role in project-based learning

Technology can provide a significant boost to student interest in doing a project as well as support their learning in numerous ways (Blumenfeld et al., 1991). The Internet enables students to access various information resources and experts from around the world. Multimedia tools and resources allow students to experience information through multiple modes of presentation and to exhibit their understanding of a subject in many ways. The availability of digital cameras, scanners, word-processing software, and other electronic media can aid in carrying out the work in a project and in the production of the final products. Lastly, publishing on the Web offers students unprecedented opportunities to share their learning projects with an audience of millions and to obtain real-world feedback in return.

## Project-based learning in the classroom

Implementing project-based learning in the classroom requires creating the learning conditions necessary for students to be able to effectively work together in groups. This means, in part, ensuring that adequate space, time, tools, and materials are available for each group to complete their work. It also means providing instruction and guidance in such interpersonal matters as managing group dynamics and negotiation since many students are inexperienced in working together in small groups.

Grant (2002) makes the point that conducting the type of in-depth investigations called for in project-based learning requires more class time; so, less time will be available for teaching other content in the curriculum. Additionally, putting project-based learning into practice often leads to a dramatic change in roles and responsibilities from what traditionally occurs in classrooms. Students assume more control over their learning and teachers become facilitators of learning rather than repositories of knowledge.

These challenges may dissuade some teachers from trying out project-based learning in their classrooms.

However, those that have been successful re-port that project-based learning greatly enhanced the quality of their students' learning. This anecdotal evidence is part of a growing body of academic research that shows bringing real-life context and technology to the curriculum through a project-based approach to learning leads to improvements in student engagement, collaboration skills, and academic achievement (George Lucas Educational Foundation, 2001).

In its simplest form, project-based learning involves a group of learners taking on an issue close to their hearts, developing a response, and presenting the results to a wider audience. Projects might last from only a few days to several months.
- **Heide Spruck Wrigley (1998)**

Many schools provide their teachers with inservice training on integrating project-based learning with technology as part of whole-school reform. There are also a number of useful Web sites with information on project-based learning, where you can go to learn more on your own (see page 197). If you decide to give project-based learning a try in your classroom, I suggest starting with a WebQuest.

WebQuests, which I will discuss shortly, resemble project-based learning in that both start with a compelling question or task, allow students to construct their own knowledge, incorporate various information resources, promote collaboration, and result in shareable artifacts that represent learning. However, WebQuests tend to be more structured than project-based learning and point students to the specific information resources they need to accomplish their tasks. They are a good way to get your feet wet before plunging into the deep end of the pool.

### Project-based learning resources

To learn more about implementing project-based learning with new technology tools, consult the following Web sites:

### Apple Learning Interchange

ali.apple.com

This site, sponsored by Apple Computer, contains a wide range of teaching resources and examples of exemplary projects involving technology use in the classroom.

### Buck Institute for Education

www.bie.org

This site offers access to professional development opportunities, articles, research, and resources related to project-based learning.

### Edutopia Online

www.glef.org

The George Lucas Educational Foundation sponsors this site that contains a myriad of resources related to project-based learning including lesson plans, interviews with teachers, examples of student work, and online videos of innovative instructional practices.

### Project-Based Instruction: Creating Excitement for Learning

www.nwrel.org/request/2002aug

This 2002 report, produced by the Northwest Regional Educational Laboratory, offers an introduction to project-based instruction; guidelines for planning, implementing, and assessing projects; profiles of schools that are implementing project-based instruction; and a list of resources for further reading.

### Project-Based Learning and Information Technologies

www.nfie.org/publications/ctb5.pdf

This is one of several white papers included in *Connecting the Bits, A reference for using technology in teaching and learning in K–12 schools*, issued by the National Foundation for the Improvement of Education.

## WebQuests

Bernie Dodge and Tom March originally developed the WebQuest model as "an inquiry-oriented activity in which some or all of the information that learners interact with comes from resources on the Internet" (Dodge, 1997). WebQuests are designed to make the most of students' time on the Internet by engaging them in authentic learning tasks that require the use of higher-order thinking skills to convert newly acquired information into more sophisticated understandings (March, 2004). They often entail collaboration among students who work with partners or in small groups to complete the given tasks.

A well-designed WebQuest incorporates various forms of scaffolding into the learning process—such as a challenging task, prompts, open-ended questions, performance tips, and links to content-rich learning resources—that enable students to perform at higher cognitive levels than they would normally do (March, 2004; Dodge, 2001). The six basic components of a WebQuest are:

1. An introduction that "hooks" the students by helping them to see the broader context for what they will be doing and how it relates to what they already know and are able to do;

2. A task that is achievable, motivating, and relevant to what students are learning in class;

3. The process or steps that students should follow to complete the task, along with questions to guide their research and thinking;

4. A list of resources, both online and local, that will be useful in completing the task;

5. Some guidance that offers helpful tips on completing the task and organizing the information acquired; and

6. A conclusion that allows student to share what they accomplished in the WebQuest and to reflect on what they have learned.

To encourage students to examine a topic from multiple perspectives, many WebQuests incorporate separate roles for each group member to play that emulate the work of adult professionals (such as an art historian, an art critic, a museum curator, a graphic artist, or a videographer). Some WebQuests include a teacher's page with advice on implementation, templates for student projects, graphic organizers to arrange ideas, rubrics containing assessment criteria, and extension activities for further investigation.

Owing to its authenticity and broad applicability, the WebQuest model has become one of the most documented strategies for integrating the Web with existing curriculum goals. There are literally thousands of WebQuests available on the Internet, created by teachers and students across the globe. However, as with any type of curriculum materials found online, the quality of the WebQuests you will find there varies widely. Some are little more than "worksheets with URLs" (Dodge, 2001, p. 7) and others "bear a superficial resemblance to real WebQuests" (March, 2004, p. 42). A key feature to writing a good WebQuest is to ensure that students have to transform what they learn online and from each other into new knowledge.

The best way to learn about WebQuests is to look at some examples and to actually work through one yourself. Once you see how valuable WebQuests can be for your students, you will probably want to create your own. Following are a number of examples to get you started. By searching the Web, you will discover many more.

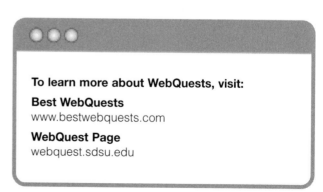

**To learn more about WebQuests, visit:**
**Best WebQuests**
www.bestwebquests.com
**WebQuest Page**
webquest.sdsu.edu

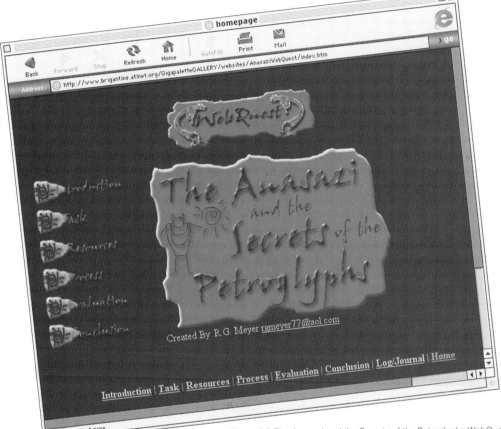

**Figure 9.3** The Anasazi and the Secrets of the Petroglyphs WebQuest

## The Anasazi and the Secrets of the Petroglyphs

www.brigantine.atlnet.org/GigapaletteGALLERY/websites/AnasaziWebQuest/index.htm

Ruthann Meyer designed this award-winning WebQuest that sends middle-school students on a journey into the past to live among the Anasazi people of ancient America (Figure 9.3). As members of a four-person exploration team, students must learn all they can about the Anasazi culture and the mysterious petroglyphs they left on cave walls. Students document their research in journals and then present their findings to the class, upon returning from their journey to the present day.

## Art Exhibit!

209.7.110.8/~cnolan/exhibit

Cathy Nolan designed this WebQuest that invites middle school students to become museum curators for a traveling art exhibit at their school. Their job is to research and acquire artworks for the show.

## Building an Ad Campaign

www.fullwood.tv/zip/wq.html

In this WebQuest, by Chris Fullwood, high school students explore the world of advertising art and build an ad campaign that they present to the class. In the process, they learn a bit of what it is like to work in a real advertising agency.

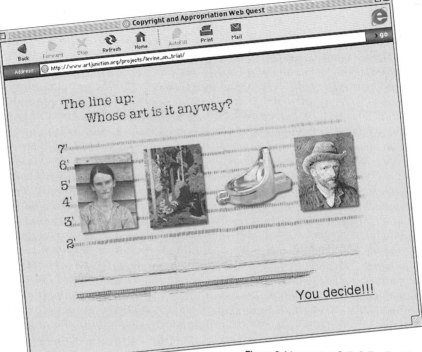

**Figure 9.4** Innocent or Guilty? The Deciding the Fate of Sherrie Levine WebQuest

## Creating a Sculpture Garden

www.geocities.com/arteacher03

In this WebQuest, by Judy Sears, middle school students are challenged to work together as a team consisting of a landscape architect, curator, docent, and model builder in order to create a sculpture garden for their school grounds.

## FreedomQuest: Monument to the Underground Railroad

www.undergroundrailroad.org/freedomquests/monuments

Created by the National Underground Railroad Freedom Center in Cincinnati, Monument to the Underground Railroad is an interdisciplinary WebQuest that encourages middle school students to plan and design their own monuments to honor and preserve the heritage of the Underground Railroad of nineteenth-century United States. School groups are encouraged to submit one chosen design to an annual contest sponsored by the Freedom Center.

## Innocent or Guilty? Deciding the Fate of Sherrie Levine

www.artjunction.org/projects/levine_on_trial

In this WebQuest, by Rachel Levy and Jennifer Roudebush, high school students form defense and prosecution teams to decide the fate of Sherrie Levine, a contemporary artist known for appropriating other artists' works (Figure 9.4). During the process, students explore issues regarding copyright, "fair use," and the role of originality in art.

## Missing Masterpieces

artsedge.kennedy-center.org/content/3645/webquest

In this WebQuest, by Rebecca Holden, middle school students work together to investigate a fictitious crime involving stolen art masterpieces and then return the stolen paintings to their owner. To solve the crime, students have to visit several online museums and galleries around the world and learn about painting styles, specific artists, and art history.

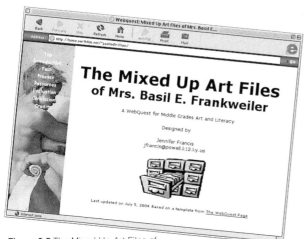

**Figure 9.5** The Mixed Up Art Files of Mrs. Basil E. Frankweiler WebQuest

### The Mixed Up Art Files of Mrs. Basil E. Frankweiler

home.earthlink.net/~paintedtrillium

Jennifer Francis created this WebQuest (Figure 9.5), inspired by the book of the same title, in which middle school students research famous artists and create artworks in the style of their chosen artists. Next, they work as a team to describe and compare the characteristics and purposes of works of art created by their team members.

### Picasso Style WebQuest

www.emints.org/info/south/webquests/picassowq

This WebQuest, by Nancy Benyo, encourages students in grades 3–5 to learn about cubism, Pablo Picasso's life, and what he contributed to the world of art. Students work in teams to gather information on cubism and Picasso, which they synthesize into a PowerPoint presentation. Each student individually then creates a cubistic-style portrait that becomes part of a schoolwide "Tribute to Picasso" exhibition.

### The World's Greatest Photographs

www.uvm.edu/~wcecil/PhotoFront.html

Bill Cecil designed this WebQuest that challenges high school students to work in teams to curate an important exhibition of the world's greatest photographs, which will tour high schools across the globe.

### Taking the plunge: Participating in a telecollaborative project

A telecollaborative project is an inquiry-based activity that often involves students in several different locations using networked technologies and resources to work together on a common goal (Harris, 1999). There are essentially two approaches to participating in a telecollaborative activity or project with your students. Either you can join an existing online project or you can start one yourself. If you are just beginning to explore the Internet with your students, participating in an ongoing and well-established project offers a convenient way to become acquainted with the logistical components of online collaboration. After doing so, you will be in a better position to consider what sort of telecollaborative activities you might initiate from your own classroom.

To find current and ongoing projects, refer to the list of organizational sites on page 191. Also, many projects have their own sites where you can familiarize yourself with the project's participation requirements and register your class if you decide to take part. Following are four ongoing art-related projects that your students can participate in.

### The Art Miles Mural Project

www.the-art-miles-mural-project.org

Joanne and Fouad Tawfilis founded the Art Miles Mural Project in 1997 with the aim of promoting world peace through children's art. The project invites children of all ages to work together to design and create murals based on a chosen theme, which the organizers will then attach to other murals created by children from all over the world. One of the project's goals is to set a Guinness world record for the longest painting in the world by producing twelve mile-long thematic murals. To see photographs of murals created thus far, learn more about the project, and find out how your students can participate, visit the project's Web site.

**Figure 9.6** The Community Stories Web site

## Community Stories

www.artjunction.org/projects/communitystories

This project encourages students to identify and investigate people, events, and other cultural influences that have shaped their communities, in the past or present, and to use this research as a springboard for producing works of art, Web sites, digital videos, or other creative expressions that tell the stories of their communities (Figure 9.6). These works can be shared with others through the project's Web site.

## Cultural Box Exchange

www.englishforeverschool.com/cultural.htm

The English For Ever School, in Santa Branca, Brazil, has posted an open invitation to other schools around the world to participate in a Cultural Box Exchange with their students. Cultural boxes contain various objects, images, and textual material that students select to represent their daily lives, their school, their community, and their culture.

## Global Youth Murals Project

www.ptpi.org

Students of all grade levels are invited to participate in People to People International's annual Global Youth Murals Project by creating artwork that illustrates our world's unique cultures and hope for friendship and "peace through understanding." Instructions for participating in this annual project are available on the site.

## Monster Exchange

www.monsterexchange.org

In this popular e-mail project, students exchange written descriptions of monsters they have drawn and then try to recreate each other's monsters based on the descriptions. Participants then upload the written descriptions, original monster pictures, and redrawn monster pictures to the project's Web site. Chat rooms and discussion boards are available for further conversation and feedback about the project.

## Projects from the past

Past projects that have been archived on the Web are another good source of ideas for telecollaborative art projects you might try with your classes. Here are three excellent examples.

### Art-e-bytes Virtual Gallery
www.education.monash.edu/old/resources/
peninsula/art-e-bytes

This site features a number of creative art collaborations between art education students at Monash University and other participants from around Australia and overseas. Several of the projects involve sequential creations with a range of technologies and media such as fax machines and e-mail (Burke and Jaeger, 2000).

### Exquisite Corpse Page
www.hfhighschool.org/hfmain/art/excorp/
excorp.html

Inspired by the Surrealist "exquisite corpse" parlor game, this digital version features collaborative figures created by students at Homewood-Flossmoor High School in Flossmoor, Illinois, and Amherst Regional High School, in Amherst, Nova Scotia. Templates and classroom handouts are available on the site.

### Portraits of Peace
www.artjunction.org/articles/komando1.html

In this article, Vivian Komando describes how her high school students collaborated via e-mail with students from other schools in creating mutual portraits of peace. Samples of students' completed works in both new and traditional media are included.

203

## Other collaborative prospects

Besides participating in a long-distance art project with another school, you should explore the possibilities of local collaborative arrangements with an art museum or an art professional working in the field. These joint ventures might include classroom visits to a nearby art museum or artist studio followed by students' constructing a Web site to report on what they have learned. Then again, you can use e-mail or videoconferencing to bring museum professionals or artists into your classroom, virtually speaking, to teach or mentor your students, to exchange ideas, or to collaborate with you and your students on a curriculum-based project.

Many art museums have turned to the Internet to expand their outreach to schools. In addition to providing online access to their collections and special educational resources, some art museums have established partnerships with local schools to support curriculum goals and enhance student learning. Formal and informal, face-to-face and online exchanges between students, artists, or other working professionals can serve to meld the classroom with the world outside of the school's walls, and are excellent ways to enhance your art curriculum with current information. The following projects exemplify this type of work.

### Dawoud Bey: The Chicago Project

smartmuseum.uchicago.edu/chicagoproject

This 2003 artist residency and exhibition, sponsored by the Smart Museum of Art, brought artist photographer Dawoud Bey and radio producers Dan Collison and Elizabeth Meister together with Chicago South Side teenagers who talked about how they represent themselves. Over the course of the residency, students explored questions of identity and photographic representation, curated an exhibition titled "Group Portrait," and developed "virtual books" for this site.

**Figure 9.7** The Day of the Dead Web site

### Day of the Dead

www.mexic-artemuseum.org/education/
dell-edu/home.html

This student-produced Web site grew out of a media workshop offered in 2001 at the Mexic-Arte Museum of Austin, Texas (Figure 9.7). Fifth grade students at Blackshear Elementary School in Austin researched five categories of information pertaining to the "Day of the Dead" celebration and then created corresponding Web pages and drawings to illustrate the categories.

### Family Portraits Project

www.tqnyc.org/NYC040609/fam.htm

In this twelve-week project, sponsored by the Bronx Council on the Arts, photographer Susan Farley collaborated with students at John F. Kennedy High School in New York in investigating their family histories through interviews, family documents, and Internet research. Students were trained in the techniques of photo essays as vehicles for digital storytelling, which resulted in a group exhibition at the Focal Point gallery in New York and on the Web.

## Interview with Jim McNeill, Tessellation Artist

www.art.unt.edu/ntieva/news/vol_9/issue3/inter.htm

Fifth grade students in Forth Worth, Texas, studied the tessellation work of New Jersey artist Jim McNeill and sent him a series of questions that he responded to through e-mail. The students then used McNeill's answers to write a collaborative article that was published online and in the January 2000 issue of School-Arts Magazine (Stephens & Walkup, 2000).

## Judy Chicago: Trials and Tributes

www.fsus.fsu.edu/educationcurriculum/tetac/chicago99

This site is a product of the collaborative efforts of staff and student volunteers/interns at the Florida State University Museum of Fine Arts, faculty and students at the Florida State University School, and contemporary artist Judy Chicago. Its main purpose is to expose a broad audience to a 1999 exhibition titled "Judy Chicago: Trials and Tributes" and to facilitate public dialogue about the artist's work and its social implications. The site includes a broad range of multimedia resources, curriculum materials, and background information on the artist for students, teachers, and individuals interested in learning more about the exhibition.

## Public & Artist Interactions

www.publicandartist.org

The Sackler Center for Arts Education's Public & Artist Interactions project invites visiting artists to collaborate on developing educational offerings at the Solomon R. Guggenheim Museum of New York. View the work of recent technology-based collaborations involving new media artists and local high school students on this site (Figure 9.8).

## Student Writings about Art

www.dia.org/education/edu.html

The Detroit Institute of Arts' Student Writings Project invites Detroit Public School students to view works of art in the museum's permanent collection and write poems or prose inspired by them. You can read the students' prose and see the works that inspired their writings on this site.

## Tim Rollins+K.O.S.: The Langston Hughes Project

www.ku.edu/~sma/online/rollins/rollins.html

Tim Rollins served as artist-in-residence at the Spencer Museum of Art of Lawrence, Kansas, in February 2002 where he collaborated with a group of twenty-four local middle school students in creating a major work of art based on the poem "A Dream Deferred" by Langston Hughes. Revisit the project through a day-by-day illustrated account on this site.

## Youth2Youth

www.youth2youth.org

On this site, teens in the Youth Insights program at the Whitney Museum of American Art share their knowledge and opinions on American art and culture with other young people around the world.

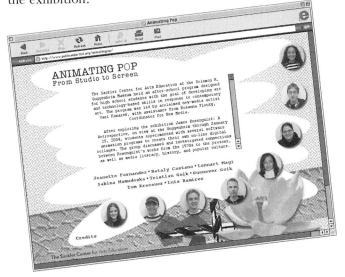

**Figure 9.8** Animating Pop: From Studio to Screen. High school students created their own animated digital collages, inspired by an exhibition of large-scale paintings on view at the Guggenheim by artist James Rosenquist

## Initiating a telecollaborative art project

Once your students have participated in an existing project, you may wish to design and implement your own online telecollaborative art project tailored to the needs of your students and your curriculum objectives. As with developing any unit of study or classroom project, it is important to take into account a number of aspects in order to provide a productive learning experience and to ensure that the logistical components of the project are manageable. Here are ten tips to consider when planning an online project.

1. **Keep your first project simple.**
   If you only have one computer with an Internet connection in your classroom, an e-mail exchange is a good starting point.

2. **Make sure that it is worth it.**
   Ensure that the learning outcomes of any planned online project correspond with your curriculum objectives and that they cannot be accomplished as well using more traditional teaching and learning tools.

3. **See what others have done.**
   Reviewing how other teachers have organized online projects can be helpful in your planning process.

4. **Consult local experts.**
   Seek advise from colleagues in your school who have done online projects with their students.

5. **Know your technology.**
   Make sure that both you and your students are familiar with the hardware and software that will be used in the project prior to its start.

6. **Talk with participating teachers.**
   Confer with teachers who agree to take part in the project in order to make certain of their intentions and that they do not anticipate any problems that might hinder their participation.

7. **Get assistance.**
   Recruit a responsible student or parent with Internet experience to assist in the project.

8. **Locate your resources.**
   Confirm the availability of any online and local resources (such as books, CD-ROMs, experts, Web sites, and so on) that your students will need during the project.

9. **Develop your assessment instruments.**
   Make sure that your evaluation tools are linked to your curriculum goals and state standards. Collect various forms of documentation such as students' reflections, plus images and video footage of students working on the project.

10. **Don't forget PR.**
    Inform school administrators and local news media about your students' accomplishments during the project. Plan to publish the results of the project on the Web if applicable.

## Some additional tips

Having a well-defined project is a key to success. The planning sheet on the next page provides a basic outline for writing up your project. Once you have determined the details of your project, post a "Call for Participation" on an art teachers' mailing list or one of the organization sites listed earlier in this chapter (page 191). Since school schedules vary considerably, it is a good idea to begin searching for willing participants eight weeks or more before the proposed starting date.

As you receive responses from potential participants, send each a copy of the project description you prepared and the deadline for registering by return e-mail. It may be useful to create a uniform registration message that asks for such things as the teacher's name, school name and location, number and grade level of students that will be involved, available technology, and any additional information deemed appropriate. Save this message on your computer as a Word document and then send it out as an attachment to interested teachers.

Before the project begins, you should confirm that all participants can do what the project requires. Do a test run in order to make sure of all participants' capabilities. Depending on the length of the project, consider sending out periodic progress reports and reminders of upcoming deadlines. Check often with the other teachers in the project to see how things are going on their end. Be open to unforeseen events and be willing to make adjustments if necessary. Inform everyone immediately of any changes you make in deadlines or requirements. If your project involves online discussions, try to keep the students on track and focused on the chosen topic or task. Send out thank-you messages freely. Include the names and e-mail addresses of every teacher involved in the project in any e-mail messages you send out.

Lastly, it is important that your project culminates with a final product of some kind (such as a virtual gallery, written report, traveling exhibition, or multimedia presentation) that you can distribute to all participants. After all the planning, collaboration, and hard work, there should be an opportunity for all participants to benefit from your collective efforts and to share the results with others in their particular locations. Lastly, be sure to allow time for a project wrap-up that enables everyone involved to communicate their perspectives on the project and to offer suggestions for improving the project if it is to take place again.

## Try This: Plan a telecollaborative project for your classroom.

**Project title:** Name of your project.

**Participants:** Indicate the ages or grade level of students that will be involved in the project.

**Project Overview:** Write a short description of your project that clearly communicates its essence to others.

**Timeline:** Break down your project into very specific steps with dates, including the starting and ending dates.

**Project Outline:** Describe your project in detail. Be specific regarding what you will do and what the other teachers and students will do. This outline should give participants a clear idea of what you will expect of them, and they of you.

**Plan for Announcing Your Project on the Internet:** Identify any mailing lists and Web sites where you can post your "Call for Participation."

**Educational Goals:** State what you expect students to accomplish by the end of the project. What will students understand and be able to do? What content and skills do you want students to understand or master?

**Colleagues Involved:** Will other teachers or staff members in your school be involved in the project?

**Project Coordinator:** Identify the contact person for the project along with an e-mail and mailing address.

**Number:** How many students will be involved in the project from your school? Will you limit participation to a certain number of schools?

**Tools and Materials:** What kind of hardware and software will students need to fulfill the requirements of the project (e.g., a Web browser, e-mail program, or digital camera)? Consider the logistics involved in giving students the Internet access they need to participate in the project. Will students need to turn in parental permission forms to participate in the project?

**Non-Internet Activities:** List the traditional classroom activities and tasks students will do as they participate in this project (e.g., creative writing, data collection, personal interviews, artwork production, and so on.)

**Internet Activities:** How will students use the Internet during the project? If students will be using specific Web sites as part of this project, list their titles and addresses here.

**Results:** Briefly describe how the project will end, including plans for how the results will be shared with all participants. How will students achieve closure for the project? Will they write a report, exchange summaries of their findings with other participants, or create a Web site to display their accomplishments?

**Assessment:** What evidence, methods, and criteria will you use to judge how well students have accomplished what you expected them to do?

## Conclusion

Collaborative learning and group work have become increasingly more prominent in art classrooms. Many art teachers now recognize that students benefit from activities that allow them to interact and work with others to achieve common goals. These shared experiences can help create a powerful learning community within the classroom, in which all members are considered valued contributors.

When we introduce the Internet into the art classroom, the opportunities for collaboration grow significantly. Technologies such as chat rooms, discussion boards, e-mail, instant messaging, videoconferencing, Web logs, and Web sites enable students to share their thoughts and artwork with others virtually anywhere around the globe. While these new technologies can help to build new bridges for communication and collaboration, it is the teacher's responsibility to ensure that their use by students actually enhances the art learning experience.

We have seen in this chapter how the use of online tools and resources is most effective when students are allowed to work collaboratively on challenging curriculum projects involving real-world issues and significant questions. In the next chapter, we will explore how students can use the Internet, both individually and together, to show the world what they think, know, and are able to do.

## Useful Web sites

### Concept to Classroom: Cooperative and Collaborative Learning

www.thirteen.org/edonline/concept2class

This site offers teachers a free online professional development workshop on how using small, cooperative groups can help improve student learning in the classroom.

### Electronic Collaboration: A Practical Guide for Educators

www.alliance.brown.edu/pubs/collab/elec-collab.pdf

This comprehensive teacher's guide, produced by the Education Alliance at Brown University, features an eleven-step process for making online collaborative projects successful.

### NickNacks Telecollaborate!

telecollaborate.net

This site is full of helpful strategies and resources for developing and participating in telecollaborative projects.

### What Is the Collaborative Classroom?

by M.B. Tinzmann, et al. (1990)

www.ncrel.org/sdrs/areas/rpl_esys/collab.htm

This article describes the characteristics of collaborative classrooms, summarizes relevant research, addresses issues related to changing student and teacher roles, and give examples of a variety of methods and practices that embody these characteristics.

# Student Publishing on the Web

## CHAPTER 10

In an era when students design Web sites and integrate video, graphics, and animation into multimedia presentations, art is fast becoming the new literacy of our times.

• **Jason Ohler (2000)**

This final chapter explores ways that art students can use the Web as a publishing medium to share their ideas, experiences, and creative work with others beyond the classroom and school. It provides guidance in planning, managing, and assessing projects that involve students in publishing their work online, and points to a number of exemplary projects that illustrate the potential of Web publishing in the art classroom.

## Why should your students publish on the Web?

Using the Web as a publishing medium offers several benefits for students.

- The Web's hypermedia capabilities and user-friendliness make it an ideal medium for students to publish their own artwork and research projects online. They can express their ideas and demonstrate their understandings using a variety of media formats including video, animation, graphics, audio clips, and text. Many students are quite adept at working with new technology tools, and often find the effort required to publish their creative endeavors online intrinsically rewarding.
- Art teachers have long used the recognition that comes with displaying students' work in public as a way to motivate students. The Web adds a powerful new twist to this traditional practice. Instead of the teacher being the one responsible for exhibiting students' accomplishments, the students themselves can use the Web to show the world what they know and are able to do. Knowing that people everywhere will see their work online inspires students to work hard at creating polished and professional-looking presentations.
- Allowing students to publish their work online enables them to shift from being *information consumers* to being *content providers*. They learn that the Web is not only a place where they can find information, but also is a place that they can contribute to as well. Such a change is an empowering step, providing a boost to students' confidence and their perceptions of their own self-worth.
- Lastly, publishing students' work on the Web builds a library of student-generated materials that can be especially useful for assessment and

instructional purposes. It provides a history of student achievement that teachers can examine periodically to evaluate the effectiveness of the art curriculum over time. It can also serve as an archive for future students to consult and study.

## Before you start

Before embarking on a Web-publishing project with students, consider the following:

### What is your school district's policy regarding publishing on the Web?

Be sure to review your school district's Acceptable Use Policy (AUP) regarding rules and procedures for publishing student work online. While these policies vary from district to district, they typically prohibit the use of students' last names and restrict publishing work or photographs of students online without written permission from the students and their parents or guardians. Most AUPs also stress the importance of abiding by copyright laws and forbid the publication of any material deemed inappropriate or unrelated to school activities.

**Hillsboro School District Web Publishing Guidelines & Policies**
www.hsd.k12.or.us/district/technology
This site explains the guidelines and policies for publishing materials on the World Wide Web used in the Hillsboro School District 1J of Hillsboro, Oregon.

Some districts require a school's Webmaster to review all teacher and student Web pages before publishing them online. Others allow students to publish

school-related materials on the district's Web server as long as a teacher first reviews and agrees to sponsor the pages. The point is that you need know, in advance of implementing a Web-publishing project with your students, what you can and cannot do in your district.

## How comfortable are you with using computers and the Internet?

You do not need to be a technology expert in order to implement a Web-publishing project with students. However, it is necessary to have some basic computer skills, such as knowing how to manage files on a computer, how to use a scanner, how to upload files to the Internet, and so on.

If students will be using a particular software program in the project, it would seem essential to learn how to use the program yourself beforehand. Most of the major software programs available today have online tutorials and books, which you can use to educate yourself. Ultimately, though, your own knowledge or experience with computers and the Internet is of less importance than your willingness to learn along with and from your students.

## How willing are you to allow students to make significant decisions about their work?

Web publishing holds the greatest potential for using the Internet as a tool to support active, constructivist learning in the art classroom, in that it requires students to assume responsibility for their own learning and the resulting products. When working independently or collaboratively on projects involving online publishing, students must demonstrate organizing, planning, and management skills. They must make critical decisions about what content to include, or exclude, and how to best present this material to their audience. In effect, using technology in this way can enhance students' self-efficacy, critical-thinking skills, and their motivation toward learning.

For this to happen, however, teachers must shift from their traditionally-accepted classroom role of content experts to become facilitators of learning. This means, in part, presenting students with choices about the topic and shape of their projects, plus involving them in goal setting and in determining criteria for assessment. When you share control of classroom activities with students, it is also essential that you divide long-term projects into small steps or proximal goals, closely monitor student progress, and provide assistance as the need arises.

Relinquishing the role of "expert" to become more of a facilitator of learning can be both liberating and challenging for teachers. It may seem daunting to facilitate a technology-related project when you have minimal knowledge of the specific tools used to carry out the project. Experience and practice will help you to overcome these fears. Meanwhile, enlist the help of tech-savvy students to assist you in managing certain aspects of the project such as designing Web pages or teaching other students how to use the software involved. Another alternative is to collaborate with your school's media specialist to prepare students to conduct online research or design their own Web pages.

When making use of powerful technologies, art students continue to require the supervision and support only a good art teacher can provide.
- **Michael Prater (2001)**

## What technology is available for student use?

The basic tools you need to get started on a Web-publishing project with your students include: a computer with an Internet connection, a Web browser, a digital camera or scanner, an image-editing program like PhotoShop Elements or PhotoStudio software, and a Web-authoring program like Web Workshop (for young students) or Dreamweaver MX software (for older students).

With some additional equipment and software, students can add multimedia to their Web pages. Young students can use KidPix Deluxe to create animated slide shows, whereas older students can use Macromedia Flash software to produce animated elements for their Web pages. With PowerPoint software, students can create interactive slide shows for the Web consisting of images, video clips, animated graphics, and text. Below are some additional software options.

### Animation software

**CoffeeCup Gif Animator** (Windows only)
CoffeeCup
www.coffeecup.com

**Flash MX**
Macromedia Inc.
www.macromedia.com

**Kid Pix Deluxe**
Broderbund
www.broderbund.com

**Toon Boom Studio**
Toon Boom Animation Inc.
www.toonboom.com

### Digital video-editing software

**Adobe Premiere**
Adobe Systems, Inc.
www.adobe.com

**Final Cut Express** (Macintosh only)
Apple Computer Inc.
www.apple.com

**iMovie** (Macintosh only)
Apple Computer Inc.
www.apple.com

**Movie Maker 2** (Windows only)
Microsoft Corporation
www.microsoft.com

**VideoBlender**
Tech4Learning Inc.
www.tech4learning.com

### Image-editing software

**Photoshop Elements**
Adobe Systems, Inc.
www.adobe.com

**PhotoStudio** (Windows Only)
ArcSoft Inc.
www.arcsoft.com

### Multimedia presentation software

**HyperStudio**
Roger Wagner Publishing Inc.
www.hyperstudio.com

**MediaBlender**
Tech4Learning Inc.
www.tech4learning.com

**MovieWorks Deluxe**
Interactive Solutions Inc.
www.movieworks.com

**PowerPoint**
Microsoft Corporation
www.microsoft.com

### Web-authoring software

**Dreamweaver MX**
Macromedia Inc.
www.macromedia.com

**Web Workshop**
Sunburst Technology, Inc.
www.sunburst.com

Digital video has become an increasingly popular way to engage students in Web publishing projects involving multimedia production. With a digital video camera and Apple's iMovie, Microsoft's Movie Maker 2, or Adobe Premiere video-editing software, students can work in collaborative teams to create clay animations or short subject videos that can be shown on the Web. While producing digital video is time intensive, the results are well worth the effort. For ideas and technical advice on how to plan and implement digital video projects in your classroom, visit the Web sites listed below.

### Digital video in the classroom

If you are interested in trying digital video with your students, check out the following sites for advice and project ideas.

### Adobe Digital Video Curriculum Guide

www.adobe.com/education/curriculum/dv_curriculum.html

This curriculum guide includes twenty-seven step-by-step modules designed to help high school and college students develop a solid foundation from which they can complete professional video projects.

### Center for Digital Storytelling

www.storycenter.org

The Center for Digital Storytelling is a nonprofit organization dedicated to assisting people of all ages in using digital media to tell meaningful stories from their lives. Their site includes case studies, articles, and the Digital Storytelling Cookbook, a comprehensive guide to using digital video as a storytelling medium.

### Clay Animation

www.yesnet.yk.ca/schools/wes/projects/claymation/claymation.html

This site, created by Crystal Pearl-Hodgins of Whitehorse Elementary School in Canada, describes the clay animation process in five easy steps and provides links to related resources and student-generated examples.

### Clay Animation Made Easy

education.wichita.edu/claymation

Tonya Witherspoon of Wichita State University created this site that includes helpful tips and handouts for teaching clay animation in the classroom as well as a number of clay animation videos created by students of all ages.

### Hidden Heroes

www.hiddenheroes.com

This project encourages young people to tell the stories of their local heroes through short video documentaries.

### Kids' Vid

kidsvid-dev.hprtec.org

This site aims to help teachers and students use video production in class to support project-based learning.

**A middle school art teacher describes how his students use the Web for research and digital video production to "Interview an Artist" . . .**

In 2001, I began teaching a digital video class to sixth graders so that my students could learn the latest video techniques. Having come from a traditional media background and seeing myself primarily as a fine arts teacher, I also wanted my students to learn more about art.

I found that an interview project is a perfect way to combine new technology and art history. The basic structure of this project is to have one student play the artist while a second student plays the host of a talk show and a third student is the videographer. During the project, students learn basic camera and interview skills along with art content as they "interview an artist."

The artist interview project begins with students selecting and researching an artist to interview. In order to give my sixth-grade students a good start, I set up a class resource Web page with links to sites providing information about artists. One of the sites, Factmonster.com, has a list that covers seventy-five painters and sculptors. This site is a great starting place for elementary and middle school students to research art history on the Web. Once students have selected an artist, they may use any of the links on my resource page to gather information about their artists. Students may also use a search engine to look for other sites that offer more information about their artists. An image of the artist along with an example of the artist's work is also required for this project. Many search engines have image-search capabilities that make it easy for students to find the images they need.

After the students have finished researching their artists, they begin developing questions and answers for the interview based on the information they gathered. I have found that students produce more informative interviews when they start with information they have learned themselves about the artists and develop their own questions based on that information. Once students have written and printed a script, they may then begin producing their interview (Figure 10.1).

In the future, I plan to expand the research aspect of this project by having students visit a museum Web site and select their artists from their virtual museum visit.

Harold Olejarz
Art Teacher
Eisenhower Middle School
Wyckoff, New Jersey

**Figure 10.1** Students set up a camera shot to do their interview.

See samples of Mr. Olejarz's students' "artist interviews" at:
http://www.wyckoffschools.org/eisenhower/teachers/olejarz/digitalvideo/index.html

## What resources will students need?
## Do they have permission to use them?

It is a good idea to pull together the information resources that you anticipate students will need to use before starting a project. These could include: relevant online resources like art history Web sites or digital image archives; multimedia products like CD-ROMs or instructional videos; print resources like books, magazines or newspapers; and human resources like experts available via the Internet or local persons that might come to class or that students might interview.

Then again, you may want to involve your students in determining what resources they will need to accomplish the project's goals. You can model valuable information-seeking skills by posing questions like "Where can you find the information you need for this project?" and "Which resources do you think would be most useful and why?" before students begin work on their projects.

Whichever approach you choose, it is important to teach students to abide by copyright laws and to properly cite the sources they use in developing their projects. Copyright applies to material published online, just as it does elsewhere. Thus, students need to be careful about using images or other content on their Web sites that they did not create themselves. While the doctrine of "fair use" permits limited educational use of copyrighted works in the classroom, it does not give students carte blanche to publish the work of others on the Web.

With the exception of works in the public domain, like the Mona Lisa, students need to obtain written permission before publishing any image on their sites that appears elsewhere on the Web or in print. In some cases, tracking down the original creator of an image or its current copyright holder presents such a formidable challenge that it is best to err on the side of caution and not use the image. Students may also discover that they have to pay a licensing fee in order to use certain images on their site. Still, many artists and photographers will grant students permission to use images of their work if asked. Typically, their only stipulation is to include an appropriate copyright notice that credits them as the original source somewhere near the image on the Web page.

In summary, if students are going to publish on the Web they need to know about copyright and understand why it is an important issue. They should be expected to observe the restrictions placed on the use of copyrighted material, to get permission when appropriate, and to provide citations for anything they use on their Web sites that was created or written by someone else.

---

### Copyright resources on the Web

Here are a few helpful resources for teaching your students about copyright issues.

### Copyright Kids

www.copyrightkids.org
The Copyright Society of the U.S.A. designed this site to teach students the basics of copyright law.

### The Copyright Site

www.thecopyrightsite.org
This aim of this site is to help educators understand and teach students about copyright law and issues.

### Copyright with CyberBee

www.cyberbee.com/copyrt.html
Young students can use this interactive activity to learn about the basics of copyright law.

### Copyrights and Wrongs

www.efuse.com/Plan/copyright.html
This easy-to-understand guide provides an introduction to copyright issues.

## What are the goals of the project?

Determining the goals of a Web-publishing project is the most important, yet also the most challenging, part of the planning process. Web-publishing projects typically occur over a longer period of time and often entail content and process goals that are more complex and varied than those of a typical art lesson (Moursund, 2003). They frequently involve students in learning that reaches beyond the art classroom into other disciplines or into the community. For example, let us consider the following project description:

In this project, students will work in teams to identify and investigate noteworthy individuals, important events, cultural influences, and other factors that have shaped or defined their local community, in the past or the present. From the insights gained through this research process, students will then use Web-authoring software to design a group Web site that includes works of art, photographic essays, writings, or other creative expressions that communicate stories of their community.

As this description illustrates, an "engaging project" is one that offers students a range of choices about what they will learn, encourages them to use their higher-order thinking skills, and results in products of learning that can be shared with others. If we take a closer look at the goals for this project, they indicate that students will study aspects of their community (content goal); work together to research their topic, synthesize their findings, and create artifacts of understanding (process goal); and use various media and tools to produce an expressive, final product—a Web site (technology goal).

In considering the goals of any Web-publishing project for your classroom, keep in mind that some will likely be more essential to the outcomes of the project than others. It is best to focus students' attention on the most salient goals, and allow the others to

become secondary goals in the project. When working with digital media, for example, it is easy for students to become so wrapped up with the novelty and capabilities of the tools that the substance of what is being communicated or expressed is left by the wayside. As art educators, we must not allow bells and whistles to distract students from the content of the project and overwhelm what it is they have to say.

## Will students work independently or together on the project?

Web-publishing projects can take several forms in the classroom. The most popular approach is to divide a class into teams of three to four students to work on designing group Web sites. Having students work collaboratively on a site adds an element of authenticity to the production process, in that professional Web designers typically work on projects in teams rather than individually. However, students will need guidance on how to work effectively as a group and to manage the various tasks associated with the project (see page 220). You will also need to monitor each group's progress closely to ensure that all of its members are contributing equally to the project.

Another approach is to make building a Web site a class project, with each student contributing something unique like a work of art or an artist report to the site. The advantage of this approach is that the teacher can handle the technical details like designing the Web page layouts, while the students focus on developing the content of the pages. The trade-off is that this approach tends to produce more work for the teacher and restricts what students actually learn about the Web as a publishing medium.

Still another possibility is to have each student design a Web site on a topic of personal interest. One advantage of this approach is that it usually requires less class time to bring a project to completion than when students work collaboratively. Another is that it enables each student to demonstrate proficiency in Web design. However, in order to implement this

model successfully, you need to have enough computers with suitable software available for each student to use during class—a situation that few art teachers find themselves in.

The important thing here is to choose an approach that makes the most sense given the goals of the project, the availability of suitable tools and resources, and your students' computer skills.

### What skills will students need to learn to carry out the project?

Students enter your classroom with a wide range of computer experience and skills. Some have their own personal computers at home with private e-mail accounts, whereas others do not. Some may have designed their own Web sites. Others may have trouble typing on a keyboard or using a Web browser.

It is important to ensure that all students have the opportunity to learn the technical skills required for any Web-publishing project assigned in class. To do this, you need to: (1) determine what kind of product the students will create; (2) identify the prerequisite skills needed to produce the desired product; and (3) devise a plan for teaching these skills within the context of students working on the project.

For example, a project in which each student produces a single Web gallery page featuring samples of his or her artwork and an artist statement might involve teaching students how to:

- use a scanner or a digital camera;
- use Web-authoring software;
- use image-editing software;
- use word-processing software;
- crop, resize, optimize, and save a digital image;
- type and save a text document;
- import an image and text into a Web page;
- use tables to format a Web page; and
- use basic design principles to compose an attractive and effective Web page.

The best way to teach students a technology skill is by providing a whole-class demonstration, followed up with individualized help as students try to apply the skill to their work. Another good approach is to use peer instruction in which you show a few students how to do something on the computer and then have each of them help others in the class learn the skill (Moursund, 2003).

Obviously, the range of skills students need to learn will depend upon the nature and complexity of the proposed project. It is best not to take on too ambitious a project for a first attempt. Figure out what you and your students can reasonably accomplish given your present resources and limitations, and save more challenging projects for later.

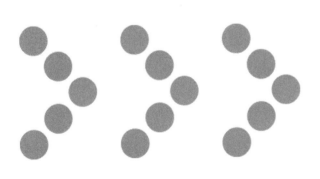

**ISTE's National Educational Technology Standards for teachers and students**

cnets.iste.org

The International Society for Technology Education (ISTE) developed these national standards to provide teachers, technology planners, and teacher preparation institutions with curricular frameworks to guide them in establishing enriched learning environments supported by technology.

# Web site design planning guide

Names of your team members: _____

**Directions:** The following guidelines will help you plan and design your Web site. Work with your team to complete as many items as you can, before you begin. Keep this sheet for future reference and fill in the additional items as you work on the site.

## Step One: Plan the content of your site.

1. What is the title of your site?
2. Describe the goal or purpose of your site and your target audience.
3. Describe the content of your site. What information will it include?
4. List external sites you will link to and why you selected those sites.
5. List several keywords or phrases that describe your site.

## Step Two: Plan the overall structure and look of your site.

1. Draw a site map or storyboard to show what pages you plan to include and how you will link the pages to each other.
2. Sketch out each page of your site on a separate note card to show what it will look like, its graphic layout, navigation bars or buttons, and so on. Be sure to keep the "look" of your site consistent throughout all of its pages.
3. List the types of graphics you will need to find or create for your site (e.g., a banner, buttons, animations, and so on).
4. List the photographic images you need to find or shoot for your site, along with any additional multimedia elements you plan to include (e.g., digital video).

## Step Three: Assign roles for each team member and create a timeline for completion.

1. What special skills or interests does each team member possess?
2. What tasks are involved in building the site? Who will:
   - conduct research
   - write text
   - take photographs and prepare them for the Web
   - shoot video
   - design graphics
   - create the Web pages
   - handle other tasks.
3. Identify the date when each task will need to be done and when the site will be finished and ready to upload to the Web.

**Step Four: Gather and develop the content of your site.**

1. Where can you find the information and graphics needed for your site?
2. Which information sources are the most reliable and best to use?
3. What content will you need to develop from scratch?
4. Be sure to credit all sources you use to develop the content for your site, and seek permission for any images you plan to use that were created by someone else.

**Step Five: Design the pages of your site.**

1. Design your pages, using Web-authoring software.
2. Consider how the use of different font sizes, colors, alignment, and white space can emphasize the most important content on your pages.
3. Design a navigation bar that helps visitors easily find their way through your site. Include this navigation bar on all your Web pages.
4. Be sure to properly optimize and save all graphics and images so they download quickly. Use thumbnails, when appropriate, to allow your visitors to decide if they want to download larger image files.
5. Include a statement of authorship, your school's name, date of publication, and a link to your school's homepage in a prominent place on your site.
6. How will visitors to your site be able to contact you or your teacher and provide feedback, if they wish? Before you include an e-mail address on your site, be sure to clear it with your teacher.

**Step Six: Upload your site to the Web, share it with others, and reflect on outcomes.**

1. Where will the site reside on the Web? What is the URL for your site?
2. Who will upload the site to this location?
3. How will you update or make changes to the site, if necessary?
4. How will you inform your target audience about your site?
5. Discuss the process of designing your site with your team members. What problems did you encounter along the way? How did you resolve those problems? What feedback did you receive about your site? How do you feel about this feedback? How do you feel about your final Web site design? What works especially well, and what would you change about it if you were to make improvements.
6. Use the rubric provided by your teacher (see page 223) to assess how well you met the goals of the project and worked together as a group.

## How will you assess student learning and performance during the project?

Web-publishing projects can be a great way to make learning meaningful to students by encouraging them to construct their own knowledge of important subject matter. In order to be successful, however, students need to know what you expect of them and how their work will be assessed.

To achieve this shared understanding, it is good practice to begin a project by discussing your goals with students and then jointly establishing the criteria for assessment in a form of a rubric. Basically, a rubric consists of a set of criteria and indicators that define a range of performance levels on an authentic task or project. For example, the rubric shown on the next page includes criteria that might be used in a project involving students designing their own Web sites.

By constructing a rubric together with students, you allow them to take ownership of a project and increase the likelihood that they will produce quality work. With the group-generated rubric in hand, students can self-assess their progress and set further learning goals. The rubric can also be used to guide peer assessments where students give each other feedback on the development of their project work. Additionally, upon completion of the project, both the teacher and students can use the rubric to critique the final products that are produced.

Monitoring students' progress throughout a long project and providing them with ongoing feedback is essential for their success, and this can be done effectively using various assessment methods—not just rubrics. For example, students might be expected to make daily entries in a project journal or complete periodic progress reports in which they reflect upon the work they have accomplished and what they have yet to do. Providing open-ended prompts like the following will help focus your students' thinking:

- Something I can do now that I could not do before is . . .

- Something I need to find out more about is . . .
- Something that went well today is . . .
- Something I need to work more on is . . .
- Something I contributed to our project today is . . .

The insights you gain from reading over students' self-assessments can help guide your decisions regarding "where you need to go from here."

The bottom line is you need to incorporate assessment strategies into a project's design that address both the learning that goes on during the project as well as the end products. Put another way, you need to view students as partners in the assessment process and provide them with multiple opportunities to exhibit and reflect upon their emerging understandings and skills throughout the course of the project.

---

### Rubrics on the Web

There are many online resources available to assist teachers in developing rubrics. Here are a few worth exploring:

### Kathy Schrock's Guide for Educators

school.discovery.com/schrockguide/assess.html
Kathy Schrock's site provides links to a wealth of assessment-related information on the Web, including a variety of sample rubrics.

### RubiStar

rubistar.4teachers.org
Teachers can use this free online tool, offered by HPR*TEC, to create and print out rubrics for use in the classroom.

### The Staff Room for Ontario's Teachers

www.quadro.net/~ecoxon/Reporting/rubrics.htm
This site includes links to a large assortment of sample rubrics in all subject areas.

| Criteria | Novice | Intermediate | Expert |
|---|---|---|---|
| **Content** | The site lacks a clearly stated purpose. Factual, spelling, and/or grammatical errors make it difficult to understand the text. Citations of sources are missing or improperly organized. | The purpose of the site is clear, but some parts seem unrelated. The text is generally accurate and easy to understand. Citations of sources are included, but one or two are missing or inaccurate. | The purpose of the site is clearly stated. The text is accurate and easy to understand. There are few, if any, errors. Appropriate citations for all sources used in developing the site are included. |
| **Use of Multimedia Elements** | Several graphics, photographs, video, or audio files need further editing, some fail to download, or seem unrelated to the purpose of the site. | Most of the photographs, graphics, video, or audio files are appropriately edited, download quickly, relate to the purpose of the site, and enhance the visitor's experience. | All of the photographs, graphics, video, and audio files are appropriately edited, download quickly, relate to the purpose of the site, and enhance the visitor's experience. |
| **Site Design** | Layout changes from page to page within the site. Many of the links fail to work properly. Visitors may become discouraged or lost. | Layout is generally consistent from page to page. A few links are difficult to find or fail to work properly. However, visitors should be able to find their way around the site. | Layout is visually appealing and consistent throughout the site. All links work and are clearly marked. Visitors can easily navigate back and forth through pages. |
| **Page Layout** | Pages have a cluttered appearance making it difficult to recognize important content. | Most pages are well organized and easy to read. On one or two pages, it is difficult to determine what is important. | All pages have a clear organization. It is easy to recognize important content. There is an effective use of all page elements. |
| **Team Skills** | Members function poorly as a team. One or two members do most of the work on the site. | Members generally work well together and are able to resolve disagreements. Most members contribute to the site. | Members show respect for one another, work well together, and share equally in contributing to the site. |
| **Authorship** | The site is missing a statement of authorship, the school's name, and date of publication. | The site includes a statement of authorship but is missing the school's name, or date of publication. | The site includes a statement of authorship, the school's name, and date of publication. |

**Table 10.1** Web Site Rubric

## What are some ways to get started with Web publishing in the classroom?

Classroom projects organized around publishing on the Web can be exciting additions to your art curriculum. Here are ten project ideas, from simple to complex, to get you started.

### Top ten list

Have students produce a hot list of their ten favorite art sites on the Web. Using criteria they generate themselves, students can nominate sites that are then voted on by the class. The resulting list can then be posted on the school's Web site. This project encourages students to explore the Web in a meaningful fashion and leads to the production of a useful online resource for other students.

### Virtual art critics

Have each student select for critical review an online exhibition currently showing on an art museum or gallery Web site. Before students begin working, discuss the role of the art critic, provide samples of critical reviews for them to study, and cover what might be included in their reviews. These reviews can then be posted online with links to the corresponding exhibitions for other students to read.

### Artist Web pages

Have each student select a notable artist (from a list that you provide), research the artist's life and work, and then write a personal commentary on what seems most interesting about the artist and his or her work. Allow students to use art history textbooks, CD-ROMs, and online resources to research their artists. Additionally, you might have them create portraits of their artists using traditional art media that can be digitized on an optical scanner. Students can then use this material to construct Web pages that include links to sites containing works by their featured artists.

### Animated moments in art history

Have students work together in teams of three or four to create clay animations inspired by famous works of art. Provide a list of works for students to choose from, such as Cassatt's *The Boating Party*, Dalí's *The Persistence of Memory*, Hokusai's *The Great Wave*, van Gogh's *Bedroom at Arles*, and so on. Students can go online to research the work they have selected and to download a copy of it to use in developing their animated features.

To create their animations, students need to: (1) brainstorm ideas for an animated story based upon their chosen work; (2) select their best idea, create a storyboard, and write a script; (3) re-create the work in relief or as a three-dimensional set, using colored clay and handmade props; (4) film the animation with a digital video camera; (5) edit the frames of their video, and add a title frame and an audio track with video-editing software; and (6) save their work on the computer, a Zip disk, or CD. All the final animations can be linked to a class Web page that includes an art history timeline and a description of the goals of the project.

**Figure 10.2** The Smithsonian's
Kids Collecting Web site

## Student art gallery

Have students work together to create an online exhibition of their own artwork. While you may be the one who actually uploads the gallery pages to the school's Web server, students can participate in the process of publishing their work online. For instance, students may be assigned different tasks like scanning or photographing their work, writing artist statements with a word-processing program, designing Web pages, and so on.

## Virtual museums

Have students become curators of a virtual museum by researching and preparing an online exhibition about a topic of study in the curriculum, such as some aspect of art history or visual culture. Constructing a virtual museum engages students in more complex learning than putting an art gallery up on the Web. Whereas a virtual gallery provides students with an opportunity to showcase their artwork and receive recognition for their accomplishments, a virtual museum requires students to explore a specific topic in depth; to locate, analyze, and interpret selected artifacts and information; and to synthesize their ideas and findings into a coherent, interactive presentation that can be shared with others. See the next page for a list of resources related to planning museum projects in the classroom.

## Museums in the classroom

Virtual museum projects offer intriguing possibilities for integrating art with other areas of the school curriculum, like social studies and language arts. They also can be linked to real-world learning experiences involving a field trip to a local art museum where students can learn how actual exhibitions are put together and get ideas for their own online exhibition. The many excellent virtual museums on the Web, including some designed by students, can serve as examples of how to organize a collection of artifacts around a particular theme. If you are interested in having your students build a museum in the classroom, check out the following helpful online resources for ideas.

### Art for Learning, Personal Museums

jordan.palo-alto.ca.us/staff/lgoldman/public/mmart3/class/

In this unit created by Leslie Goldman, an art teacher at Jordan Middle School in Palo Alto, California, students choose three pieces of artwork, research the works online, and create Web pages that explain the historical significance of each work.

### Creating a Classroom Museum

www.smithsonianeducation.org/educators/lesson_plans/collect/crecla/crecla0a.htm

This curriculum activity guide, from the Smithsonian Institution in Washington D.C., offers practical strategies and advice for planning a museum exhibition in the classroom using items that students bring from home.

### Discover the Wonders of Ancient Egypt

www.lakelandschools.org/museum/lobby.html

Sixth grade students at Lincoln-Titus Elementary School in Crompond, New York, created this virtual museum that provides a glimpse into the daily life, religion, leisure activities, art, and culture of ancient Egyptians.

### A Look in the Mirror—The Art of Self-Portraiture

teachnet-lab.org/santab/jessica/fridaweb/index.html

Jessica Rivera, a teacher at Taylor Elementary School in Santa Maria, California, created this site that includes a unit of study involving online research, e-mail exchanges, studio production, and the creation of an online mini-museum featuring students' self-portraits.

### The Museum in the Classroom

www.24hourmuseum.org.uk/downloads/mclass.pdf

This is another excellent curriculum activity guide, from the UK, that provides tips on setting up a museum in the classroom.

### Smithsonian Kids Collecting

smithsonianeducation.org/idealabs/collecting

In the IdeaLab, from the Smithsonian Institution, students can explore the riches of the Smithsonian's collections and read about how curators got their passion for collecting (Figure 10.2). They can also get expert advice about starting their own collections.

### Online newspapers and Webzines

Have students create an online newsletter or zine with feature articles on current art happenings in the classroom, school, and local community. Producing a newspaper or zine offers a variety of roles for students to assume and allows them to apply a wide range of real-life skills to publishing their work online including researching, organizing, prioritizing, editing, meeting deadlines, creative problem solving, collaboration, and more. Individual students or small groups can be assigned to write or create articles, local movie or art exhibition reviews, editorials, letters to the editor, crossword puzzles, classifieds, cartoons, illustrations, and more—all centered around their learning experiences in the art classroom. Check out the following online student publications for ideas.

## Student online newspapers and Webzines

Here are some examples of student online newspapers and Webzines.

**Barb Wired**

english.unitecnology.ac.nz/barbwired/home.php

Barb Wired is an online newspaper for New Zealand secondary school students, written by secondary students.

**eCampus News**

ali.apple.com/als/2ndweb/projects/3028.html

This unit plan, from Apple Computer, offers step-by-step directions and tips for implementing an online newspaper project in the classroom.

**Kids Online Magazine**

www.kidsonlinemagazine.com

A mom and her seven-year-old daughter created Kids Online to provide kids with a place to share their writing and artwork online.

**Meeting Point 2000**

www.meetingpoint2000.it

Meeting Point 2000 is an Italian-based Webzine issued by students for students all around the world. The editorial staff accepts student writings and artwork about their personal interests, done under the supervision of teachers.

**TIG Magazine**

magazine.takingitglobal.org

TIG Magazine is a compendium of the best artwork and creative writing from Taking It Global's online community initiatives. All artwork, writing, thought, and design in this publication was conceived by young people.

## Community treasure maps

Have each student create a map that will show others how to find a special place in their community—a place that has some personal, family, or cultural significance. If possible, students should visit these locations beforehand and record their observations (through sketches, photographs, and journal entries) regarding what makes the place unique and appealing. Along the way, they should also make note of landmarks and other "clues" that might be useful in directing others to the location. Using digital media tools and other art materials, students can then create Web-based maps of their "community treasures," which can be linked to a class page describing the goals of the project. For ideas, check out the following community mapping projects on the Web.

**Figure 10.3** The Green Map System Web site

## Community mapping projects

Here are a few examples of projects involving students in creating maps of their communities.

### Green Map System

greenmap.org

Green Map System is a global eco-cultural movement, energized by local knowledge, action, and responsibility. Green Maps tell an engaging story of a community's environment in a condensed and inviting way. Their site includes a classroom activity guide and examples of inspiring Green Maps created by kids all over the world (Figure 10.3).

### Here! Hear!! Parkville!!!

parkville.realartways.org

This site features a digital audio map of Parkville, a local community in Hartford, Connecticut, produced by local area youth who participated in a six-week workshop sponsored by Real Art Ways, a Connecticut-based nonprofit organization.

### Multimedia Maps

kidsown.ie/mmm/book

This site summarizes a three-year project, sponsored by Kids' Own Publishing Partnership, which put artists in school communities around Ireland to investigate the uses of new technologies as tools for creativity and exchange. The project encouraged the breakdown of barriers between communities through the process of the collaborative production and exploration of community mapping.

**Six basic elements of a Web-based electronic portfolio**

1. A "splash" page that includes the student's name, one or more images, and a "click to enter" button.

2. A "homepage" that includes an introductory statement and a menu of links to other sections of the portfolio.

3. An "about" page that includes background information on the student and provides a context for viewing the work displayed in the portfolio.

4. A "gallery" page that includes clickable thumbnail images with links to work samples from class projects completed throughout the year.

5. A "reflections" page that includes a written self-evaluation by the student of his or her work and progress over the year.

6. A "links" page that points to artist sites and online resources that served as sources of inspiration and research for the student.

## Electronic portfolios

Have each student create and maintain an electronic portfolio on the Web of his or her studio art production, research projects, and critical writing during the school year. Web-based electronic portfolios are an excellent means for students to document their accomplishments and growth as young artists. They can accommodate a wide range of media including writing, pictures, animation, video, and sound. They also have the benefit of being easily accessible to teachers, family, friends, and prospective college recruiters or employers.

Students can use any of the multimedia or Web-authoring software programs listed previously in this chapter (page 214) to produce their electronic portfolios. Above is a generic template for students to follow in organizing their portfolios, which can be modified to accommodate each student's work, personal interests, and style.

**Figure 10.4** The ePortfolios homepage for Hyde Middle School in Cupertino, California

## Try This: Examine student art portfolios on the Web

**Directions:** The sites listed here are just a few of those that showcase student art portfolios on the Web. Select two (or more) of these sites to compare in terms of the way in which student work is presented, the type and amount of information provided about each work, how individual pages are formatted, and how easy it is to navigate through the site. What ideas would you borrow from these sites if you were to do Web-based electronic portfolios with your students?

### Digital Art and Web Design Student Portfolios—West Hills High School

whhs.guhsd.net/digportfolios

The work presented here is by students who have completed their first semester in Digital Art and Web Design at West Hills High School in Santee, California.

### Hyde's Visual Art and Crafts ePortfolio Project

www.hydeart.com/eportfolio

This site features an innovative online portfolio project involving Visual Art and Crafts students at Hyde Middle School in Cupertino, California (Figure 10.4).

### Student Art Portfolios—Conestoga High School

www.tesd.k12.pa.us/stoga/dept/artwebpage/visualart/portfolios

View portfolios authored by art students at Conestoga High School in Berwyn, Pennsylvania.

### Student Portfolios—Germantown Academy

www.germantownacademy.org/academics/ls/lsa/lowerart/spindex.htm

This site features portfolios of intermediate art students at the Germantown Academy in Fort Washington, Pennsylvania.

### Student Portfolios—Highland High School Art Department

highland.k12.in.us/highland/pages/hs/art

Click on the link on the left-hand side of the page to view portfolios by art students at Highland High School in Highland, Indiana.

### Student Web Pages from the School of the Art Institute of Chicago

www.artic.edu/saic/art/projects/students

The work presented on this site is by undergraduate and graduate students at the School of the Art Institute in Chicago, Illinois.

### Web design competitions

Have students participate in a Web design competition, in which they work together to successfully build interactive Web sites that will serve as an educational resource for others. There are a number of popular Web design competitions that occur annually and draw thousands of student participants from around the world. The best of these contests, listed below, enable students and their teachers to engage in dialogue and collaborative work with their peers and colleagues from other schools around the world. Participation in one of these contests offers an exciting opportunity for your students to publish their work on the Web and contribute to the Internet's knowledge base.

---

**Site-building contests**

The following Web design competitions encourage teams of students to create Web sites that will educate and inform others around the world. You can view previous years' contest winners and learn how to enroll your classroom in the coming year's competition on each site.

**Global Virtual Classroom Contest**

www.virtualclassroom.org

Sponsored by the Give Something Back International Foundation, the Global Virtual Classroom Contest is an annual, international team cooperation and site-building activity for students from seven to eighteen years of age. To participate, teachers register their classrooms on the contest site and are assigned to a team consisting of three schools from three different countries. Using the Internet to communicate, each participating classroom builds a Web site based on a common theme chosen by their team. Upon completion, the sites are uploaded to the Web for judging.

**International Schools CyberFair**

www.gsn.org/CF

CyberFair is an annual, international competition, sponsored by the Global Schoolnet Foundation, which encourages students to work together to conduct research about their local communities and then publish their findings on the Web. After writing a project narrative and submitting their sites for judging, contestants participate in a peer review process that helps to determine the best projects in each of eight categories: local leaders, businesses, community organizations, historical landmarks, environment, music, art, and local specialties.

**ThinkQuest**

www.thinkquest.org

Sponsored by the Oracle Education Foundation, ThinkQuest is another popular site-building contest that encourages students, between the ages of nine to nineteen, to work in teams to create content-rich, educational Web sites. A team must include three to six student members, and one adult coach who is a teacher. ThinkQuest teams draw upon each member's individual strengths and skills to build an educational Web site that they research and design themselves. Teams upload their sites to the ThinkQuest Web server, which are judged by an international panel of professional educators and then made freely available for viewing and classroom use through the ThinkQuest library.

## What if I don't have Web-publishing capabilities in my classroom?

There are quite a few places where students can have their artwork published on the Web, without charge (see a list on the next page). Many of these sites allow students to submit their work directly online for exhibition. Others require teachers to first register on the site and then submit their students' work. If you lack the time, resources, or know-how to publish your students' work on the Web from your classroom or school, consider making use of the services available on one of these sites.

**Figure 10.5** Artsonia is the largest children's art museum on the Web.

# Student publishing sites

The following Web sites publish student artwork online, free of charge.

## Artsonia

www.artsonia.com

Artsonia (Figure 10.5) is the largest children's art museum on the Web, with thousands of pieces on display from over 100 countries around the world. Teachers can register on the site for a free membership, which allows them to set up a gallery space for their school with individual project pages. As an added feature, visitors to the site can post comments about individual works on display.

## Artworks for Peace

www.kidlink.org/KIDART/projlist/artworkspeace

Artworks for Peace is an online exhibition space created by KidLink, a nonprofit organization, to gather the emotions, the fears, and the hopes of students through the universal language of art and to help youth from all over the world to understand each other. Teachers must register their class on the site in order for students to submit their artwork for exhibition.

## Odditi Art—An Online Student Gallery

www.lilydale.tased.edu.au/gallery

Students at Lilydale District School in Tasmania, Australia, run this online student art gallery, which accepts submissions from students anywhere in the world. Directions for submitting work and the criteria used in the curatorial process are available on the site. Online forums are also available for students to discuss works exhibited on the site.

## PapaInk

www.papaink.org

PapaInk is a nonprofit organization dedicated to exhibiting the work of young people and archiving historical and contemporary collections of children's art. The site features various online exhibitions covering a wide range of themes such as the events of 9-11, home, human rights, ecology, self-portraits, and much more. Directions for setting up your own school collection as well as individual portfolios for your students are available on the site.

## The Worldwide Kids' Art Gallery

www.theartgallery.com.au/kidsart.html

The Worldwide Kids' Art Gallery is dedicated to celebrating the creativity of children by offering exhibition space for their artworks online. The site accepts submissions from teachers, parents, school groups and individual children who have parental permission to exhibit their work online.

## Conclusion

If you are just beginning to explore the learning potential of the Web in the classroom, the thought of arranging a long-term project in which students are responsible for publishing their work online may seem too ambitious—at first. However, if you spend some time browsing the following sites, you will discover that students of all ages are quite capable of constructing their own Web sites and pages.

### Artisan Teen NY

www.mediaworkshop.org/kidsinstitute/artisans

Six students who participated in the 2002 Kids Institute at Media Workshop, New York, created this site for teens interested in visiting New York City. It features highlights of the city's public art and cultural institutions.

### Artists Act Against Homelessness

bostonteachnet.org/troxell_lamothe_syms/sigproj.htm

This site represents an ongoing project involving Boston area high school students and teachers exploring issues of homelessness in their community. Students researched and discussed issues involving the homeless, staged a conference on homelessness, and worked in an after-school program for homeless children. Determined that their messages about homelessness be seen and heard, students produced graphic artworks, a video, and a Web site, confirming that young people can make a positive difference in their communities.

### KQED Youth Media Corps

www.kqed.org/youthmedia

Youth Media Corps (YMC) is an outreach project of KQED Broadcasting that provides San Francisco Bay Area youth with intensive training in journalism and media production through a Web-based curriculum. The result is an innovative series of media campaigns produced by YMC, using a combination of Web, video, and print media that advocate for issues directly impacting the health of underserved communities.

### New Media Collaborative

www.diacenter.org/prg/educat/nmcollab

Sponsored by Eyebeam and the Dia Center for the Arts, the New Media Collaborative is an annual, after-school outreach program that provides new media arts resources to teachers and students in one neighborhood public high school in Chelsea, New York each year. Participating students work with professional teaching artists and collaborate with their teachers to develop digital art projects in Web design, sound, performance, and video art.

### TeleCommunity Project

www.telecommunity.org

The TeleCommunity Project is a group of young people and volunteer teachers who meet regularly on the campus of Duquesne University in Pittsburgh, to collaboratively explore multimedia, computer graphics art, animation, and telecommunications.

### Unwrap the Mystery of Ancient Egypt

www.k12.hi.us/~kapunaha/student_projects/unwrap/welcome.htm

Fifth-grade students at Kapunahala Elementary School in Kaneohe, Hawaii, created this educational site about Ancient Egypt.

### Walking Animation Challenge

cghs.dadeschools.net/graphicdesign/walking

This entertaining site features Flash animations created by students in graphic design classes at Coral Gables Senior High School in Coral Gables, Florida (Figure 10.6). The work shown was a result of a challenge to students to create a walking animation that "beat's the teacher's example."

**Figure 10.6** The Walking Animation Challenge homepage

### Web Design Class—Aurora Middle School

www.esu9.org/~swegenas/webclass

This is a class Web site for an elective ninth-grade course offered by art teacher Sarah Wegenast, at Aurora Middle School in Aurora, Nebraska. On the site, you can browse through a collection of student Web pages based on the theme "My Middle School Years."

Perhaps seeing what other students have done on the Web is all the inspiration you need to take the necessary steps to introduce your students to publishing their research projects and artwork online. While there may be a number of obstacles to overcome—not the least of which may be convincing a doubtful principal of the need to purchase Web-authoring software for your classroom—your students will greatly appreciate and benefit from your efforts and the exciting opportunities offered by the Web for sharing their ideas, artwork, and learning experiences in the artroom with a worldwide audience.

## Useful Web sites

### Electronicportfolios.org

www.electronicportfolios.com

This site, developed and maintained by international portfolio expert Dr. Helen Barrett, provides a wealth of information, strategies, and links on electronic portfolios.

### Make A Web Site

www.kidcompute.com/makeawebsite.html

This site, sponsored by Kid Compute, provides step-by-step tutorials on creating a Web site from start to finish, in HTML code.

### Project Poster

poster.hprtec.org

Students can use this site, from HPR*TEC, to publish class research projects or reports on the Web. The resulting pages remain available on the Web for one month after the last revision.

### WebMonkey for Kids

webmonkey.wired.com/webmonkey/kids

This site walks students through the process of building a Web site using HTML. A teacher's guide is also available on the site.

235

# Epilogue

Our system of education is locked in a time capsule. You want to say to the people in charge, "You're not using today's tools! Wake up!"
• **George Lucas (2004)**[1]

The major aim of this book has been to explore ways that art teachers can use the Internet to extend their professional development, enhance their classroom instruction, and, more important, to provide their students with new ways to learn, to communicate and work with others, and to express themselves using digital media. Toward that end I have pointed to a variety of online tools and resources that art teachers can use to achieve their professional and pedagogical goals. I have presented examples of art teachers who have successfully incorporated the Internet into their classrooms, and offered many practical strategies and ideas to assist those interested in introducing its unique capabilities and resources into their art curriculums in authentic and meaningful ways.

Beyond the practical information this book provides, I have attempted to show throughout its pages that any attempt to integrate the Internet into an art classroom must be well grounded in challenging curriculum goals and sound art teaching practices. Use of the Internet alone will not ensure a successful art lesson, nor will it guarantee that students will be engaged in robust learning. It takes a well-trained, effective art teacher to make this happen, a teacher who has a basic understanding not only of the capabilities and workings of the Internet, but also of constructivist pedagogy and rich, substantial art content.

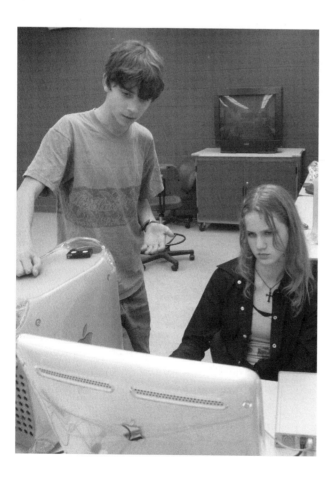

## Making a place for the Internet in your classroom

This book began with an examination of ways in which the Internet can be used to support the goals and practices of contemporary art education. We saw how many art educators today are interested in connecting what happens in the their classrooms to a broader real-world context and students' everyday lives. They are also concerned with fostering students' understanding of, and respect for, multiple perspectives or voices; and with building a classroom learning environment in which students actively construct meaning for themselves and with others. While the Internet provides an abundance of tools and resources with which to pursue these worthwhile goals in new and better ways, its use must not become a distraction or an end in itself. Integrating the Internet into an art classroom is not about the technology—it is mainly about the art curriculum and what students are actually learning and doing when they are online.

As with implementing any curricular innovation, examining your students' needs is an important part of deciding how, when, and why they will use the Internet in your classroom. We know that many students today are quite familiar with computers and the Internet. Online projects involving research, collaboration, and Web publishing may be effective ways to meet the individual needs and interests of these tech-savvy students who aren't so turned on by doing academic exercises with traditional art media. All things being equal, the more types of projects and media you can include in your art program the better it will be. It will be better because the chances are greater that each student will experience a mode of expression and learning that is appropriate for that individual child.

## Some final thoughts . . .

If the Internet is really going to have an impact on contemporary art education practices in schools, art teachers need to take ownership of the integration process. I know that this is easier to do for some art teachers than for others. We all face certain obstacles to effective Internet use in our classrooms that will challenge our good intentions. But I also know that art teachers are a resourceful lot, willing to take on any challenge if doing so will benefit their students.

So if you agree with the ideas in this book and are motivated to put into practice some of strategies I've proposed, where do you go from here? How do you go about personalizing the information this book provides, in order to make yourself, first, a better art teacher, and secondarily, a teacher who uses the Internet to teach art in ways that are comfortable and fruitful for both you and your students? At the risk of repeating myself, I will close with three suggestions.

First, remember that this won't happen overnight. Successfully integrating the Internet into an art classroom requires a long-term commitment of time, energy, and resources. The important thing is to take it one step at a time. Depending upon your previous experience with the Internet, you may need to first concentrate on developing your own Internet skills. In which case, seek out training opportunities, either in your school district or online, which will help you to make better use of the Internet in your classroom. Assess your preparedness to implement an online activity or project with your students. If your classroom's Internet capabilities are found lacking, create a workable curriculum-based proposal that will persuade your principal to purchase the hardware and software you need to put your plan into action. As an alternative, write a technology grant or arrange a local fundraiser that will enable you to get the technology you need. Meanwhile, get online and search for images of artworks and pertinent Web sites to include in your classroom presentations and lessons. Figure out what you and your students can reasonably accomplish in a school year, given your particular circumstances—and save the rest for later.

Second, seek out others who can help you to implement your technology plans. Get to know your technical support staff and inform them of your technology needs. Share your goals and plans with your school's media specialist and ask for assistance. Ask other teachers in your school who use the Internet in their classroom for ideas and advice. Talk with other art teachers in your district and share with them what you've learned in this book. Form a technology team of local teachers to share ideas, planning, skills, frustrations, and successes. Enlist the help of a tech-savvy parent or student. Develop an online partnership with a local art museum. Join an art teacher's mailing list, if you haven't already. The point is, there is no need to try to do this alone.

Finally, Internet technology continues to change so rapidly that it is hard to predict what its implications for art education will be in the years to come. The only thing that seems certain is that new hardware and software of potential use in the art classroom will continue to be introduced on the market as you and your students become accustomed to obsolete systems and old ways of working. As inviting as working with the latest technology may be, there is no need to wire your classroom to the rafters with every form of new electronic gadgetry that comes along. Much can be accomplished with a minimal amount of hardware and software. Remember that a quality art program is defined not by the latest technology, but by the aesthetic, critical, and creative sensibilities that students develop within it.

See you on the Net!

**Craig Roland**

# Acknowledgments

There are a number of people to thank, without whose support and contributions, this book would have never been written or published. I am especially grateful to David Coen, managing editor at Davis Publications, for his unflagging support and assistance throughout the writing and editing process. I also want to express deep gratitude to my colleague, Melanie Davenport, for giving me constructive criticism on early drafts of this book and for serving as a sounding board when I needed one. Others who provided valuable input by reviewing portions of this book in its early stages include Patricia Knott, Karen Monahan, Kevan Nitzberg, Harold Olejarz, Maria Rogal, Pam Stephens, and Michelle Tillander. All of these people helped to clarify my ideas and to make this a better book.

Special thanks to Marifely Argüello, Doug Barrett, and Tse-Ming Huang for their help with the design, graphics, and layout of this book. Thanks also go out to all the art teachers who shared their success stories involving the Internet and to those who allowed me to publish images from their Web sites in this book. There are many others who unknowingly, have contributed to this book by generously sharing their knowledge and best practices on the Web. While far too numerous to acknowledge individually here, I am grateful to all those persons who are responsible for the many online resources that I point to in this book, all of which make the Internet a better place for teachers and students to learn.

In addition to those I mention above, I gratefully acknowledge the financial assistance provided by The University of Florida's College of Fine Arts Scholarship Enhancement Grant Fund in the research and development of this book. Last, but not least, I owe eternal thanks to my wife, Sue, who has patiently endured the countless hours I have spent in front of a computer while researching and writing this book.

# Notes

### Chapter 5: Online Professional Development for Art Teachers

1. National Science Foundation Grants REC-9725528 and REC-0106926 to SRI International supported the development of Tapped In.

2. As of this writing, East Carolina University, Ohio State University, and Pennsylvania State University offer online graduate art education courses.

### Chapter 6: Bringing Web Resources into the Artroom

1. In addition to pursuing her art teaching credentials, Victoria Franklin-Dillon is a mid-career installation artist working in an assemblage visual culture vein. Her personal Web site is located at http://www.artranch.net.

2. Also see My Personal Museum at the Virtual Museum of Canada, My Met Gallery at the Metropolitan Museum of Art, and the Virtual Gallery at the Fine Arts Museums of San Francisco Web sites.

### Chapter 7: Promoting Your Art Program on a Global Scale

1. The term "public domain" refers to a body of intellectual property not protected by copyright laws and thus freely available for public use. This realm includes, but isn't limited to, original material that has been distributed freely by its creator with no restrictions on its use as well as original works for which the previous copyright or patent has expired and was not renewed.

### Chapter 8: Guiding Student Art Research on the Internet

1. See, for example, Walker & Stewart, 2005; Erickson, 2001; Walker, 2001; McKenzie, 2000; Wiggins & McTighe, 1998; Jacobs, 1997; Bolin, 1996; and Chalmers, 1996.

2. Source: Sanford, S. (September 2000). Terry Crane: Inspiring connections. *Converge*. Retrieved May 1, 2004 at http://www.centerdigitaled.com/converge/?pg=magstory&id=3374.

3. Source: The Big6 Skills Overview by Mike Eisenberg (2003). Retrieved March 31, 2004 at http://www.big6.com/showarticle.php?id=16.

### Chapter 9: The Art of Online Collaboration

1. See, for example, Taylor, 2002; Pitri, 2002; Fowler, 2001; Placky, 2000; Wallot & Joyal, 1999; Irvin, 1999; Yenawine, 1998; Hoglund, 1997; Hurwitz, 1993; Houser, 1991; and Hagaman, 1990.

2. Source: Electronic postcards link California & Texas schools, *ArtsEdNet Offline*, Los Angeles, CA: The Getty Education Institute for the Arts, Winter 1999, 11, 10.

### Epilogue

1. Source: Daly, J. (September/October 2004). George Lucas: Life on the screen. *edutopia*, 1 (1), 36–38, 40.

# Bibliography

Ament, E. (1998). Using feminist perspectives in art education. *Art Education*, 51 (5), 56–61.

Ascott, R. (1991). Connectivity: Art and interactive telecommunications. *Leonardo*, 24 (2), 115–117.

Berners-Lee, T. (2002). *The world wide web—Past, present, and future*. Japan Prize Commemorative Lecture. Retrieved May 2, 2004 from http://www.w3.org/2002/04/Japan/Lecture.html.

Blumenfeld, P., et al. (1991) Motivating project-based learning: Sustaining the doing, supporting the learning. *Educational Psychologist*, 26 (3/4), 369–398.

Bolyard, M. (2001). Art across america. *SchoolArts*, 100 (6), 19.

Bunner, C. & Tally, W. (1999). *The new media literacy handbook*. New York, NY: Anchor Books.

Burke, G. & Jaeger, N. (2000). *Collaboration: From analogue to digital & back*. Paper presented at the 1999 World Congress of the International Society for Education through Art (InSEA). ERIC Document Reproduction Service No. ED451081.

Bolin, P. (2000). Art education in and beyond the classroom. *Art Education*, 53 (5), 4–5.

————. (1996). We are what we ask. *Art Education*, 49 (5), 6–10.

Boughton, D. et al. (2002). Art education and visual culture. *NAEA Advisory*. National Art Education Association.

Bruner, J. (1996). *The culture of education*. Cambridge, MA: Harvard University Press.

Burns, M. & Martinez, D. (2002). Visual imagery and the art of persuasion. *Learning & Leading with Technology*, 29 (6), 32–35; 52–53.

CERN (2002). *The world wide web*. Retrieved April 15, 2003 from http://user.web.cern.ch/Public/about/achievements/www/www.html.

Chalmers, G. (1996). *Celebrating pluralism: Art, education, and cultural diversity*. Los Angeles: The J. Paul Getty Trust.

Chen, M. & Armstrong, S. (Eds.) (2002). *Edutopia: Success stories for learning in the digital age*. San Francisco, CA: Jossey-Bass.

Clarke, A. C. (1984). *Profiles of the future: An inquiry into the Limits of the possible*. New York: Holt, Rinehart and Winston.

Clark, T. (2000). *Online Professional Development: Trends and Issues*. Center for the Application of Information Technologies, Western Illinois University. Retrieved June 26, 2002 from http://www.dlrn.org/educ/prof_dev.pdf.

Computer Industry Almanac (April 24, 2001). *U.S. has 33% share of Internet users worldwide year-end 2000*. Retrieved April 5, 2003 from http://www.c-i-a.com/pr0401.htm.

Congdon, K. G. (1989). Multi-cultural approaches to art criticism. *Studies in Art Education*, 30 (3), 176–184.

Cotter, H. (2003, January 19). Doing their own thing, making art together. *New York Times*. Retrieved January 25, 2004, from http://www.rhizome.org/carnivore/press/cotter.htm.

Dalzell, S. (1996). *ACLU, et al., v. Janet Reno, 96-963 and ALA, et al., v. Department of Justice, 96-1458*. Retrieved April 15, 2003 from http://www.zaadz.com/quotes/authors/stewart_dalzell.

Dewey, John. (1916). *Democracy and education*. New York: The Free Press.

Dodge, B. (2001). Five rules for writing a great webquest. *Learning & Leading with Technology*, 28 (8), 6–9, 58.

————. (1998). *Schools, skills, and scaffolding on the web*. Retrieved March 9, 2004 from http://edweb.sdsu.edu/people/bdodge/scaffolding.html.

————. (1997). *Some thoughts about webquests*. Retrieved January 30, 2004 from http://edweb.sdsu.edu/courses/EDTEC596/About_WebQuests.html.

Doyle, A. (1999). A practitioner's guide to snaring the net. *Educational Leadership*, 56 (5), 12–15.

Duncum, P. (2001). Visual culture: Developments, definitions, and directions for art education. *Studies in Art Education*, 42 (2), 101–112.

Efland, A., Freedman, K. & Stuhr, P. (1996). *Postmodern art education: An approach to curriculum*. Reston, VA: National Art Education Association.

Eisenberg, M. B. & Berkowitz, R. E. (2003). *The definitive Big6 workshop handbook*. (3rd ed.) Worthington, Ohio: Linworth Publishing.

Eisenberg, M. B. & Johnson, D. (1996). *Computer skills for information problem-solving: Learning and Teaching Technology in Context*. (ERIC Document Reproduction Service No. ED392463). Retrieved March 5, 2004 from http://www.ericfacility.net/databases/ERIC_Digests/ed392463.html.

Eisner, E. (2002). *The arts and the creation of mind*. New Haven and London: Yale University Press.

Erickson, M. (2001). Images of me: Why broad themes? Why focus on inquiry? Why use the Internet? *Art Education*, 54 (1), 33–40.

Evans, R. (2001). *The human side of school change: Reform, resistance and the real-life problems of innovation*. San Francisco: Jossey-Bass Wiley.

Florida Department of Education (1996). *Sunshine state standards for the visual arts, preK–12*. Retrieved March 5, 2004 from http://www.firn.edu/doe/curric/prek12/frame2.htm.

Fowler, J. (2001). If the shoe fits, make it intro art: Sole-mates in collaborative learning. *Art Education*, 54 (5), 18–21.

Freedman, K. (2003a). *Teaching visual culture: Curriculum, aesthetics, and the social life of art*. New York: Teachers College Press.

————. (2003b). The importance of student artistic production to teaching visual culture. *Art Education*, 56 (2), 38–43.

Gablik, S. (1995). Connective aesthetics: Art after individualism. In S. Lacy (Ed). *Mapping the terrain: New genre public art*. (pp. 74–87). Seattle, WA: Bay Press.

George Lucas Educational Foundation (2001). *Project-based learning research*. Retrieved February 20, 2004 from http://glef.org/php/article.php?id=Art_887&key=037.

Gilster, P. (1997). *Digital literacy*. New York: John Wiley & Sons.

Grant, M. M. (2002). Getting a grip on project-based learning: Theory, cases and recommendations. *Meridian: A Middle School Computer Technologies Journal*, 5(Winter) Retrieved March 15, 2004 from http://www.ncsu.edu/meridian/win2002/514.

Green, C. (2001). *The third hand: Collaboration in art from conceptualism to postmodernism*. Minneapolis: University of Minnesota Press.

Greer, D. (1984). A discipline-based art education: Approaching art as a subject of study. *Studies in Art Education*, 25 (4), 212–218.

Gude, O. (2000). Investigating the culture of curriculum. In D. E. Fehr, K. Fehr, & K. Keifer-Boyd. (Eds.) *Real-world readings in art education: Things your professors never told you*. (pp. 75–81). New York: Falmer Press. Retrieved January 20, 2004 from http://www.uic.edu/classes/ad/ad382/sites/AEA/AEA_01/AAEA01a.html.

Hagaman, S. (1990). The Community of inquiry: An approach to collaborative learning. *Studies in Art Education*, 31 (3), 149–157.

Halsey-Dutton, B. (2002). A model of implementing technology into art history education: Artifacts in cyberspace. *Art Education*, 55 (4), 19–24.

Hamm, M., & Adams, D. (1992). *The collaborative dimensions of learning.* Norwood, NJ: Ablex Publishing Corporation.

Harrell, M. H. (2000). *Interactive technology: A tool for student-centered instruction in middle school art education.* M.A. Thesis. East Carolina University. (ERIC Document Number: ED 449 112).

Harris, J. (1999). First steps in telecollaboration. *Learning & Leading with Technology*, 27 (3), 54–57.

Harris, J. (1998). *Visual Architecture—Designing and Directing Curriculum-Based Telecomputing.* Eugene, OR: International Society for Technology in Education.

Hathorn, L. G., & Ingram, A.L. (2002). Online collaboration: Making it work. *Educational Technology*, 42 (1), 33–40.

Heise, D. & Grandgenett, N.F. (1996). Perspectives on the use of Internet in art classrooms. *Art Education*, 49 (6), 12–18.

Hofer, M. Online digital archives: Technology that supports rich, student-centered learning experiences. *Learning & Leading with Technology*, 32 (2), 6–11.

Hoglund, P. S. (1997). A river voyage: Collaboration, cooperation, and community. *SchoolArts*, 96 (9), 36–37.

Houser, N. O. (1991). A collaborative processing model for art education. *Art Education*, 44 (2), 33–37.

Hubbard, G. (1995). Electronic artstrands: Computer delivery of art instruction. *Art Education*, 48 (2), 44–51.

Hurwitz, A. (1993). *Collaboration in art education.* Reston, VA: National Art Education Association.

Irwin, R.L. (1999). Listening to the shapes of collaborative artmaking. *Art Education*, 52 (2), 35–40.

Jacobs, H.H. (1997). *Mapping the big picture: Integrating curriculum and assessment K–12.* Alexandria, VA: Association for Supervision and Curriculum Development.

Jonassen, D., Peck, K. & Wilson, B. (1999). *Learning with Technology: a Constructivist Perspective.* Upper Saddle River, NJ: Merrill.

Johnson. D. W. & Johnson, R. T. (1999). Making cooperative learning work. *Theory Into Practice*, 38 (2), 67–73.

Johnson, S. (1997). *Interface culture: How new technology transforms the way we create and communicate.* New York: HarperCollins.

John-Steiner, V. (2000). *Creative collaboration.* New York: Oxford University Press.

Jones, L. S. (1999). *Art information and the Internet: How to find it, how to use it.* Phoenix, AZ: Oryx Press.

Kiefer-Boyd, K. (1996). Interfacing hypermedia and the Internet with critical inquiry in the arts: Preservice Training. *Art Education*, 49 (6), 33–41.

Kilpatrick, W. H. (1918). The project method. *Teachers College Record*, *19*, 319–335.

Krug, D. (1998). Electronic learning communities in art education. *Arts and Learning Research*, *14*, 23–45.

Lai, A. (2002). From classrooms to chatrooms: Virtualizing art education. *Art Education*, 55 (4), 33–39.

Lawrence, S. & Giles, L. (1999). Accessibility of information on the web. *Nature*, *400*, 107–109. Summary retrieved March 10, 2003 from http://www.wwwmetrics.com.

Lévy, P. (2001) *Cyberculture.* Minneapolis, MN: University of Minnesota Press.

Lister, M. et al. (2003). *New media: A critical introduction.* London: Routledge.

Lovejoy, M. (1997). *Postmodern currents: Art and artists in the age of electronic media* (2nd ed.). Upper Saddle River, NJ: Prentice Hall.

Lyman, P. & Varian, H. R. (2000). *How much information?* School of Information Management and Systems, University of California at Berkeley. Retrieved March 12, 2003 from http://www.sims.berkeley.edu/research/projects/how-much-info.

Lynch, P. J. & Horton, S. (2001). *Web style guide.* New Haven: Yale University Press.

March, T. (2004). The learning power of webquests. *Educational Leadership*, 61 (4), 42–47.

March, T. (2001). *Working the Web for Education.* Retrieved April 15, 2004 from http://www.ozline.com/learning/theory.html.

McKenzie, J. (2000). *Beyond Technology—Questioning, research, and the information literate school.* Bellingham, WA: FNO Press.

McKenzie, J. (1999). Scaffolding for success. *From Now On*, 9(4). Retrieved March 10, 2004 from http://fno.org/dec99/scaffold.html.

McKenzie, J. (1998). Grazing the net, raising a generation of free-range thinkers. *Phi Delta Kappan*, 80 (1), 26–31.

McLuhan, M. (1964). *Understanding media: The extensions of man.* New York: McGraw-Hill.

Merriam-Webster (2003). *Merriam-Webster's Collegiate Dictionary* (11th ed.) Springfield, MA: Merriam-Webster, Inc.

Milbrandt, M. (1998). Postmodernism in art education: Content for life. *Art Education*, 51 (6), 47–53.

Moursund, D. (2003). *Project-based learning using information technology.* Eugene, OR: International Society for Technology in Education.

NetDay. (2001). *The Internet, technology and teachers: An executive summary.* Retrieved June 30, 2004 from http://www.netday.org/anniversary_survey.htm.

Ogle, D. 1986. K-W-L: A teaching model that develops active reading of expository text. *The Reading Teacher*, 39, 564–570.

Ohler, J. (2000). Art becomes the fourth r. *Educational Leadership*, 58 (2), 16–19.

Placky, R. (2000). On site: A residency with Tim Rollins/KOS. *Art Education*, 53 (4), 50–54.

Perkins, D. (1991). Technology meets constructivism: Do they make a marriage? *Educational Technology*, 31 (5), 18–23.

Peters, J. M., & Armstrong, J.L. (1998). Collaborative learning: People laboring together to construct knowledge. *New Directions for Adult and Continuing Education*, 79, 75–85.

Pitri, E. (2002). Project learning: Exploration, discussion, discovery. *Art Education*, 55 (5), 18–24.

Prater, M. (2001). Constructivism and technology in art education. *Art Education*, 54 (6), 43–48.

Rockwood, G. (2002). I learned online! *SchoolArts*, 101 (9), 33.

Rushkoff, D. (1999). *Playing the future: What we can learn from digital kids.* New York: Riverhead Books.

Schrage, M. (1995). *No more teams—Mastering the dynamics of creative collaboration.* New York: Doubleday.

Shiva, V.A. (1996). *Arts and the Internet: A guide to the revolution.* New York: Allworth Press.

Simpson, J. (1996). Constructivism and connection making in art education. *Art Education*, 49 (1), 53–59.

Slavin, R. (1988). Cooperative learning and student achievement. *Educational Leadership*, 46 (2), 31–33.

Smerdon, B. et al. (2000). *Teachers' tools for the 21st century: A report on teachers' use of technology* (NCES Publication No. 2000–102). Washington, DC: U.S. Department of Education, Office of Educational Research and Improvement, National Center for Education Statistics. Retrieved March 20, 2004, from http://nces.ed.gov/pubs2000/2000102A.pdf.

Smith, B. L. & MacGregor, J. T. (1992). What is collaborative learning? In A. S. Goodsell, M. R. Maher, & V. Tinto (Eds.), *Collaborative learning: A sourcebook for higher education.* (pp. 9–22). University Park, PA: National Center on Postsecondary Teaching, Learning and Assessment, Syracuse University.

Stankiewicz, M. A. (2003). Between technology and literacy. *International Journal of Art & Design Education*, 22 (3), 316–324.

Stankiewicz, M.A. & Garber, E. (2000). Cyberfaculty: An experience in distance learning. *Art Education*, 53 (1), 33–38.

Stephens, P. G. & Walkup, N. (2000). Connecting with an artist. *SchoolArts*, 99 (5), 46–50.

Stewart, M. & Walker, S. (2005). *Rethinking Curriculum in Art.* Worcester, MA: Davis Publications.

Sullivan, D. (2003). *Searches per day.* Retrieved June 15, 2004 from http://searchenginewatch.com/reports/article.php/2156461.

Tapscott, D. (1998). *Growing up digital: The rise of the Net generation.* New York: McGraw-Hill.

Taylor, P. (2000). The collaborative process of art making. *BCATA Journal for Art Teachers*, 40 (2), 4–10.

Thornburg. D. (1996). *Campfires in cyberspace.* San Carlos, CA: Starsong Publications.

U. S. Department of Education. (2002). *No Child Left Behind: A Desktop Reference.* Retrieved March 15, 2004 from http://www.ed.gov/admins/lead/account/nclbreference.

Vygotsky, L. (1978). *Mind in society: The development of higher psychological processes.* Cambridge, MA: Harvard University Press.

Walker, S. (2001). *Teaching meaning in artmaking.* Worcester, MA: Davis Publications.

Wallot, J. A. & Joyal, B. (1999). School-community collaboration and artistic process. In R. L. Irwin & A. M. Kindler (Eds.) *Beyond the school: Community and institutional partnerships in art education*, (pp. 29–35). Reston, VA: National Art Education Association.

Warlick, D. (1999). *Raw materials for the mind—Teaching & learning in information & technology rich schools* (2nd ed.) Raleigh, NC: The Landmark Project.

Web-based Education Commission to the President and Congress of the United States (2000). *The power of the Internet for learning: Moving from promise to practice.* Washington, DC: US Department of Education. Retrieved February 3, 2003 from http://interact.hpcnet.org/webcommission/index.htm.

Wiggins, G., & McTighe, J. (1998). *Understanding by design.* Alexandria, VA: Association for Supervision and Curriculum Development.

Williams, R. & Tollett, J. (1998). *The non-designer's web book.* Berkeley, CA: Peachpit Press.

Wilson, S. (2002). *Information Arts: Intersections of art, science, and technology.* Cambridge, MA: MIT Press.

Wrigley, H. S. (1998). Knowledge in action: The promise of project-based learning. *Focus on basics. 2*(December). Retrieved March 15, 2004 from http://www.gse.harvard.edu/~ncsall/fob/1998/wrigley.htm.

Yenawine, P. (1998). Visual art and student-centered discussions. *Theory Into Practice*, 37 (4), 314–321.

Zorpette, G. (1994). Dynamic Duos: How Artist Teams Work. *Artnews*, 93 (6), 165–169.

# Index